February
2016

THE COMPLETE
PORTRAIT
MANUAL

POPULAR
PHOTOGRAPHY

THE COMPLETE
PORTRAIT
MANUAL

weldonowen

CONTENTS

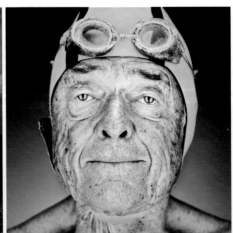

LIGHTING AND GEAR

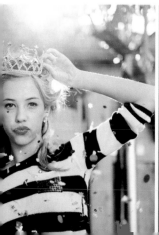
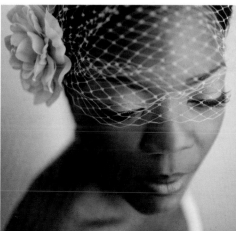
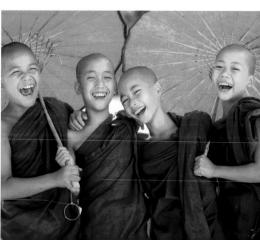

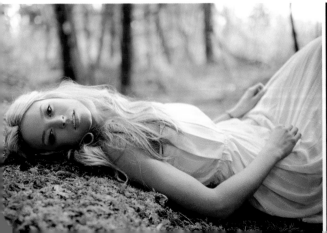

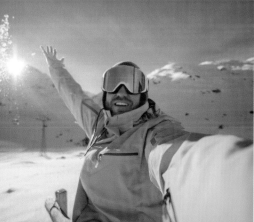

PHOTOGRAPHY
BASICS

001 MEET YOUR DSLR

There are tons of camera types on the market today—from cheap point-and-shoots to mirrorless interchangeable-lens (ILC) models, from tiny action cams to the camera on your smartphone. But for many dedicated shooters, the obvious first choice in equipment is a digital single-lens reflex (DSLR) camera. Why? First, DSLRs allow a shooter to frame pictures with precision fairly easily. Second, the sheer number of lens types available lets one camera perform many functions. Like any new piece of equipment, function and controls can take some getting used to. Here's an overview of the main controls, as well as a quick peak at what's going on inside the camera itself.

MANUAL FOCUS RING Don't want your camera to decide where to focus? Turn this ring. Want to make fine manual focus adjustments while using autofocus? Again, turn this ring.

ISO BUTTON This button essentially controls the light sensitivity of your camera's image sensor. If you're shooting in ultrabright light, use a low ISO (50–200), and increase ISO in lower light. FYI, the higher the ISO in use, the more noise—visual distortion, often in the form of grainy or blotchy appearance—your image may have.

ZOOM RING When your DSLR is fitted with a zoom lens, use this ring to adjust for desired focal length—and determine how close or far away a subject in your shot appears.

IMAGE STABILIZATION SWITCH Located on your lens or the body of your camera, this switch kicks image stabilization on and off. This function allows you to get sharper images of static objects without a tripod or in lower light than might be possible without it.

HOTSHOE While it sounds like a dated dance move, it's actually where you attach a flash or other accessory to your camera. A lot of times, DSLRs come with covers to shield the hotshoe when it's not in use.

MODE DIAL Use this dial to pick a shooting mode. Cede control of exposure settings to the camera in fully automatic mode, be a control freak in fully manual, or try one of the many preset program modes.

AUTOFOCUS BUTTON Press this button to tell your DSLR to pick which elements in your shot should appear the sharpest.

PENTAPRISM Not unlike the brain's visual cortex—the part of your brain that converts images your eyes see as upside down—this pentagon-shape prism flips an image out of reverse before sending it the viewfinder's way.

VIEWFINDER Peek through the viewfinder to make choices about how to compose and frame your shot. Through it, you'll see a corrected (read: right side up) version of the image that reflects off your camera's reflex mirror.

REFLEX MIRROR When an image enters a lens, it's upside down. The reflex mirror reflects that image through a focusing screen, in the direction of the pentaprism.

SHUTTER Essentially a mechanical curtain, the shutter serves as a movable barrier between a camera's image sensor and its lens. Open the shutter, and your camera's reflex mirror pivots up, allowing an image to hit the image sensor.

IMAGE SENSOR A device covered with pixels (light-sensitive cells), an image sensor measures the intensity and color of an image that has passed through the shutter. Last, the image sensor converts these measurements into digital form—ultimately capturing your shot.

LENS Detachable lenses change your camera's capabilities by narrowing or widening a circular opening—the size of which is called the aperture—to control the amount of light that enters. Light passes through the lens on its way to the reflex mirror.

002 GET TO KNOW YOUR CAMERA FUNCTIONS

We've already covered the anatomy of your camera; now it's time to dig a little deeper into a few standard functions and features of most DSLRs. Getting a solid grasp of these functions will only enhance your abilities as a portrait photographer. Of course, not all DSLRs have all of these features—and the ones that do can vary in location (touch screen options vs. external controls) and capabilities. When in doubt, consult your camera's user manual.

 IMAGE QUALITY AND RESOLUTION CONTROLS If you're taking candids at the beach or the park, save your memory card by shooting lower-quality images at higher compression settings. If you're shooting for art, save high-quality, low-compression images. This is also where you can choose to shoot RAW (capturing all the data in an image with zero compression for easier editing), JPEG, or RAW + JPEG.

 IMAGE SHAPE CONTROLS These controls adjust pretty much exactly what they sound like—the shape of your image. While most DSLRs have a default shape, use these controls to set a shape that fits your vision.

 AUTOEXPOSURE MODE A DSLR's program setting shifts responsibility for the three main controls of exposure (ISO, aperture size, and shutter speed) onto your camera based on a scene's ambient light. You can also take control of one or more of these settings, while autoexposure takes the reins on the rest. Two popular modes for portraiture are aperture-priority—which allows you to choose aperture while the camera picks shutter speed—and shutter-priority, which lets you control shutter speed while your camera sets an appropriate aperture.

AUTOFOCUS MODES Single mode is best for still subjects, while continuous lets you track those who are on the go. Use your viewfinder and LCD screen to select autofocus points.

AWB **WHITE BALANCE** Auto white balance tells your camera to dictate how whites look in certain lighting, adjusting all other colors appropriately. If you're shooting in mixed lighting, set a custom white balance.

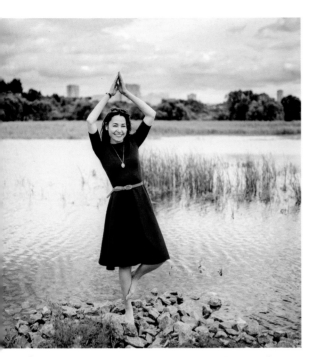

PORTRAIT MODE While your camera's exposure-mode dial contains options for shooting landscapes, close-ups, and action shots, the one you'll likely rely on when photographing people is called portrait. It tells your camera to use a short exposure sans flash for the most flattering results.

FLASH MODES When set to auto, your camera's flash will go off whenever light is low. To avoid washing out your subject in low light, it's probably best to turn it off or set it to manual.

AUTOBRACKETING This function lets you shoot a number of images at once, all with different settings (exposure, flash, depth of field, and more). Based on that group of photos, you can more easily choose the setting that's best for your scene.

POP-UP FLASH A lot of DSLRs have an onboard flash that's hidden while not in use. It can be great for packing light—or just using as a primary flash in the absence of an external unit.

LIVE-VIEW MODE Use this mode to preview how your shot will be framed and composed through your camera's LCD screen before you take a shot.

BURST MODE Trying to capture something fast-moving? Burst mode lets you program your DSLR to take a certain number of shots in succession with one snap of your shutter button. Save your finger the work.

CONNECTIONS TO PERIPHERAL GEAR Odds are, at some point in your portrait-shooting journey, you'll want to link your camera to a printer or computer. Consult the user manual for your camera to guarantee the smoothest connections.

SELF-TIMER Great for taking shots without the fear of blurring an image by shaking your camera. It's also useful for running into the frame during group shots or self-portraits.

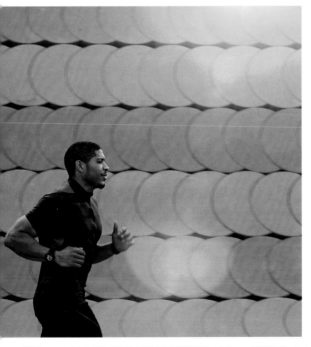

COLOR QUALITY SETTINGS A lot of DSLRs let you adjust colors from menu settings. While it's advisable, for the most control, to shoot RAW and adjust color later, it can't hurt to play around with your onboard settings.

003 UNDERSTAND THE BASICS OF EXPOSURE

A camera is basically a glorified box—one with a hole punched in one side of it, containing some sort of light-sensitive medium, be it film or a digital sensor. Letting light through the hole allows you to "take a picture"—leaving an image on the light-sensitive medium inside.

Not just any light will do. A shortage of light results in underexposure and a photo with details lost to darkness. An excess of light makes a desired image appear washed out from overexposure. The right exposure will result in a detailed image with a good balance of highlights, shadows, and midtones.

Exposure is ultimately determined by aperture (hole size), shutter speed (how long the hole is open), and ISO (sensor sensitivity). In general, think of exposure as a triangle: In order to maintain the same exposure, every bump or cutback in one element will require a decrease or an increase in one or both of the others (see #107).

Like many settings, you can let your camera perform the subtle balancing act between aperture, shutter speed, and ISO in automatic mode. Alternately, you can take full control in manual mode, or try modes somewhere in the middle—like aperture-priority and shutter-priority—that let you adjust one factor while the camera handles the other. Exposure compensation lets you do, well, pretty much exactly what it sounds like: Make incremental adjustments to compensate one way or another after you've already set your exposure.

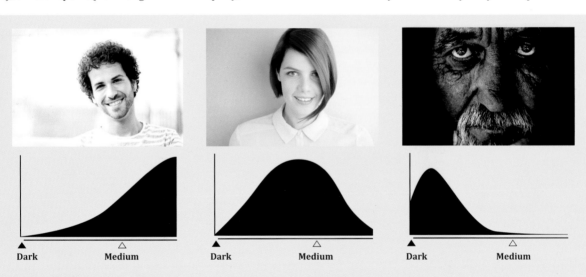

| Dark | Medium | Dark | Medium | Dark | Medium |

004 METER YOUR LIGHT TO DETERMINE EXPOSURE

To make the best-informed exposure decisions, first measure the amount of light in your shot—either with your camera or with a handheld light meter (see #132). If you're using a DSLR, you have a few options. Spot-weighted metering focuses on exposing a small portion of a scene, while center-weighted metering works great in settings with even lighting, and evaluative metering is ideal for shooting those with a broad spectrum of tones. Evaluative metering is often your best bet, but many photographers prefer spot-metering for portraits. Of course, you can always adjust exposure manually.

Your camera's histogram—a graph of the range of light in a scene, usually located on or near the LCD—will give you an idea of light levels from shadow (left side) to highlights (right side). For proper exposure, what you usually want to see is an even distribution from right to left with a peak in the middle. If you see peaks too far in either direction, you risk over- or underexposure. If you're using a handheld meter to measure reflected light, the meter itself will usually tell you what aperture setting and shutter speed to use to get the picture-perfect exposure.

005 CHOOSE THE BEST APERTURE SIZE

Aperture—the size of the hole that lets light into the camera—is controlled by your camera's lens. In other words, the diaphragm of a camera lens contracts and expands, regulating the amount of light that gets in. Aperture also has an impact on depth of field, the amount of distance in a photo that appears acceptably sharp, without seeming blurry or fuzzy. Where a smaller aperture captures a deep area of focus, a larger one results in a shallow area of focus, as in the portrait below (see #109 for more examples).

Aperture itself is measured in units called f-stops—the larger the number, the smaller the aperture (f/2 is actually a larger aperture than f/22). At any lens's smallest aperture, images tend to lose a bit of sharpness overall. If you're trying to get a soft look, more power to you. If a crisp shot is what you're after, instead try using apertures a couple of f-stops below the highest number.

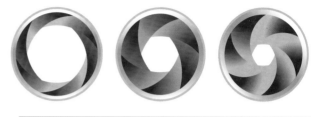

| Large Aperture | Medium Aperture | Small Aperture |
| f/2 | f/8 | f/22 |

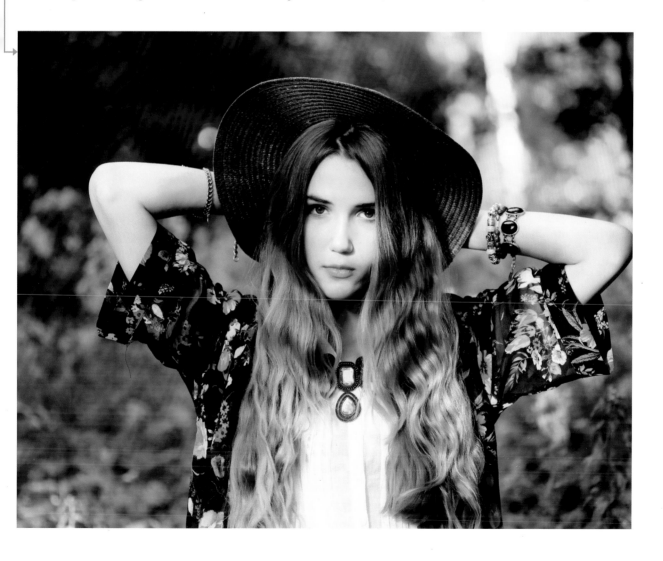

006 PICK AN APPROPRIATE ISO

Your camera's ISO setting is really a measure of how sensitive its sensor is. Most DSLRs have ISO settings that range from 100 up higher than 6400, with larger numbers corresponding to a more sensitive sensor. If you're shooting in low light, a higher ISO can help you achieve a better exposure in which more of a scene is visible, while lower ISOs work well in bright light.

As ISOs increase, digital noise—usually in the form of discolored dots or otherwise grainy appearance in shadowed areas—becomes a problem that doesn't really exist at lower ISOs. While you can try to remove some of this noise in image processing after the fact, a lot of time this tactic lowers image resolution. Your best bet is to keep ISO down as low as possible (400 or lower, if possible), and adjust aperture and shutter speed.

007 SET SHUTTER SPEED

You camera's shutter is the mechanism that opens to allow light into your camera. Measured in seconds, the shutter speed essentially refers to the duration of time that the shutter stays open—how long light is allowed to reach a camera's sensor during an exposure.

How you choose to set a shutter speed (or how your camera does) depends on the amount of light available (as well as aperture and ISO). For example, if you're shooting outside on a bright, sunny day, your shutter probably only needs to open for a small fraction of a second (1/60–1/1000 sec). In dim light, slower speeds are necessary to allow sufficient light to enter.

Of course, slower speeds also translate to greater motion sensitivity. If you're shooting at slow shutter speeds and your subject moves (or if you move your camera), the resulting image may appear blurry. Unless blurry is the look you're going for (see #110 and #193–195 for examples of deliberate blur), consider using a tripod and/or your camera's image stabilization system (see #137) to better keep things in focus. You might also set a superquick shutter speed to freeze action (see #192).

008 BETTER YOUR EXPOSURE

Nailing exposure usually takes some practice. When you're just getting started, here are a few tips to get you moving in the right direction.

SHOOT RAW Capturing RAW files rather than JPEGs gives you the most power to alter your images. While the files take up more room and can make your camera a little slow, the RAW format saves every iota of detail in the photo, without compression or data loss. It's especially useful for adjusting exposure after capture.

AUTOBRACKET A lot of cameras come equipped with an autobracketing setting. Autobracketing essentially takes a series of photos in rapid succession, each using different exposures. From that small sampling of photos, you can choose the exposure that you like best.

USE HDR Rather than nailing that perfect one shot, high-dynamic-range (HDR) imaging merges multiple images into one—either multiple distinct images or an individual RAW file captured at different settings. While this may seem like cheating (and hey, maybe it is), HDR allows you to get a broader range of tones than any individual shot could—making tough-lit scenes appear almost natural and already gorgeous without a great deal of postprocessing, like the image above.

009 WRAP YOUR HEAD AROUND FOCAL LENGTH

Lenses concentrate light to a point—in the case of cameras, onto film or an internal sensor. Without interchangeable lenses, you can only do so much to alter the appearance of your photos. Move closer. Move away. Repeat. Since interchangeable lenses let you change a camera's focal length, the photgraphic possibilities increase dramatically.

The focal length of your chosen lens can have a big impact on how your images turn out. For example, wide-angle lenses—lenses that take in a broad view of a scene (see #117 for a sample image)—have short focal lengths, while telephoto lenses have a much longer focal length (check out #198). Lenses with long focal lengths magnify distant objects in a frame, making them appear closer to you, as well as closer to other elements within an image. This sort of magnification also significantly reduces an image's depth of field.

A pretty standard focal length for a full-frame DSLR is 50mm (a little longer than the diagonal measurement of the camera's image sensor, typically 24 by 36mm). All "standard" really means is that, using a 50mm lens, a pretty average picture—not a close-up, not a distant shot—would come out fine. Of course, not all cameras contain the same size image sensor; account for this when selecting lenses (see #011).

010 COMPREHEND LENS SPEED

Lenses have two notable dimensions: focal length and maximum aperture size. Maximum aperture size basically refers to the largest size you can make the hole that lets light through a lens. "Fast" lenses are those with large maximum apertures (f/2.8 and below). They're called fast because, well, they are quite literally fast: Large-aperture lenses allow more light to enter than their smaller-aperture brethren, allowing you to achieve the same exposure with a faster shutter speed. Fast lenses are useful for shooting in low light, as well as for limiting a photo's depth of field.

Have a zoom lens? A lot of DSLRs sold in kits come with them, often with a range of maximum apertures, something like 18–55mm with a f/3.5–5.6 designation. Basically, this means that the maximum aperture of the lens changes depending on how close or far you're zooming. At the lens's shortest focal length (18mm), the maximum aperture is f/3.5; at its longest focal length (55mm), the maximum aperture is f/5.6. Check out #112 for examples of varying focal lengths at work.

| ████ Full frame | ████ APS-C | ████ Four Thirds | ████ Large compact cameras | ████ Small compact cameras |

011 MATCH YOUR LENS TO YOUR CAMERA'S SENSOR SIZE

When choosing a lens for your camera, be sure to take into account the size of your camera's sensor, which is measured on the diagonal. Depending on the sensor size, what might serve as a lens of "normal" focal length on one camera could functionally be of exceptionally long or short focal length for another.

Typically, DSLRs contain, from largest to smallest, a full-frame sensor, APS-C-size sensor, or a Four Thirds sensor. ILCs (mirrorless interchangeable lens cameras) usually have an APS-C-size sensor or a Four Thirds sensor. Smaller sensors capture smaller amounts of a

scene; if you had two cameras side by side—one with a small sensor, another with a large—and wanted to take roughly equivalent photos of the same subject at the same distance, lenses would have to make up the difference (see the diagram above). To broaden the view of the small-sensor camera, you would want a lens with a short focal length. To narrow the view of the large-sensor camera, you'd want a longer focal length.

Last, besides optimizing lens choice for your sensor size, save yourself a headache: Make sure the lens you're buying has the right mount for your camera.

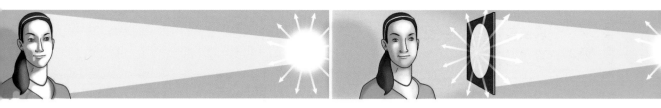

012 SEE HARD AND SOFT LIGHT

If cameras are glorified light traps, without light there is no photography—and not all light is created equal. Different types of light play off a subject in different ways. No matter where the light comes from—a candle or a flashbulb or the afternoon sun—it helps to think of it as falling into two broad categories: hard and soft. There's no right or wrong type for portraiture, though you should use one or the other appropriately.

Hard light creates sharp, relatively clear lines and shadows, like the shadow on the wall in the diagram at top left. Shooting with hard light, contrast is sharp—there is no real fuzz or "gray area." You can achieve these effects by focusing light into a beam (see #169 and #175), or moving the light away from the subject. When seen from the side, hard light emphasizes texture.

Soft light, on the other hand, results from diffused light—the more scattered and spread out, the softer its appearance. Unlike the sharp lines hard light produces, soft light minimizes shadow and texture, as in the right half of the diagram. You can soften light by using a broad light source, putting your subject close to a light source, or shining light through something translucent—say, clouds if your source is the sun, or fabric if your source is artificial.

013 KEEP LIGHTING NATURAL

Natural light is widely regarded as the most flattering, no-fuss illumination source for portraits, but it poses its own challenges. For instance, the sun doesn't always cooperate when you're looking for a specific angle of light—and sometimes it rains. Minor inconveniences aside, the sun can still provide the most flattering light around. Here are a few things you can do to use natural light to your photographic advantage (see #125–130, too).

GO GOLDEN Picking the best time of day is crucial. The so-called "golden hours"—the period shortly after sunrise or before sunset—creates the most flattering light.

USE SIDELIGHT While the age-old wisdom is to shoot with the sun at your back, many portraits are better served by being lit from the side. Shooting with the sun off to one side can add character, sharpening lines and contrast.

SOFTEN SHADOWS If you're looking for soft light, wait for that cloud to roll in. If there's no overcast weather in sight, put a diffusion panel between your subject and the sun.

REDUCE CONTRAST Too much contrast for your liking? Lessen contrast by using a reflector to bounce some sunlight into shadowed areas.

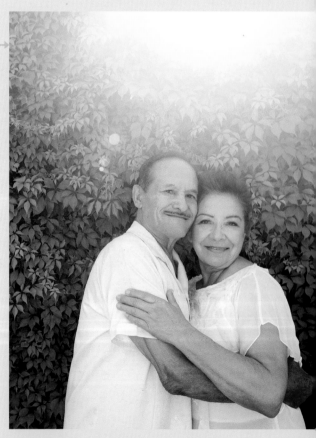

014 MASTER THE FLASH

As with any new skill, mastering the flash takes practice. The built-in flash on your camera is a good starting spot when it comes to owning your lighting. Beyond the built-ins, there is a pretty good range of flash options. From an accessory flash attached to your camera's hotshoe, to a sync cord- or remote-triggered off-camera flash, to a flash unit whose head turns or tilts, each option will give you a lot more control over the direction and intensity of light in your shots (see #139).

As far as when to use a flash, it's probably wise to avoid putting it to work in low-light settings. Doing so can create serious shadows or overwhelm your subject with bright white light. If you must shoot in low light with flash, scatter it with diffusers specific for the task—or go DIY with some rubber bands and white paper (see #144 for another great flash-modified DIY). You might also try bouncing light off ceilings or walls to soften it.

Consider using your flash during the day. Shooting with flash under the sun can add fill light—illumination that doesn't really change the character of the main light source but does soften otherwise harsh shadows caused by your main light.

015 KNOW WHEN TO GO WITH STROBE OR CONTINUOUS LIGHTING

When you're shooting under the sun, you can generally count on a pretty steady stream of light—even if it's intermittently obscured by passing clouds. With handheld or other portable lighting devices, the choice is up to you whether to mimic that steady stream—called continuous lighting—or to use strobe lights.

Where continuous lights stay on for as long as you leave them on, strobe lights snap into action alongside your shutter, much like the flash on many cameras, from disposable cardboard to DSLRs with built-ins. Continuous light gives you the advantage of seeing how your subject looks under your setup without the pause between strobe blasts. If your subject isn't moving, continuous lights—also called hot lights, despite also including cool-temp LEDs and fluorescents—allow you to easily adjust brightness and position as necessary.

If your goal is to capture some action, strobes are the best way to add enough light for the right exposure with a fast-acting shutter. Strobes work with static subjects, too; just be aware that you won't have quite the same ability to make subtle tweaks as you do with continuous light sources.

016 COMMUNICATE WITH COLOR

In portraiture, as in all photography, color—our visual perception of a variety of light types—matters. From serene teals and blues to the boldest and brashest reds, different colors connote different feelings and cue different emotional responses. Together with tone (how dark or light the shade of a color is), color is a powerful tool in crafting an image's message—from bright and cheerful to grim and dark and everything in between.

The easiest way to make the most of shooting color is to leverage the capabilities of your equipment. Shooting with a DSLR allows for myriad color-capturing options. From mimicking different types of film or film-processing methods, to controlling color intensity by adjusting saturation levels, your camera can give you somewhat supernatural capabilities when it comes to capturing the natural.

Of course, there is more to color than simply adjusting camera levels or shooting in sepia. The real challenge—and opportunity—comes from capturing true hues au naturel. Try using neutral settings and shooting modes, capturing and storing images as RAW files. Doing so prevents your camera from compressing images as you shoot, preserving all the color data your camera's color sensor takes in. Ultimately, using neutral settings offers the most control over the final product. After all, you can always make adjustments later with software.

017 GO BLACK AND WHITE

It's been said that not everything is black and white. While nobody takes issue with the statement's underlying truth, in the world of portraiture, it can be. Converting to monochrome can give an image an old-timey feel, mask clashing colors, or even cover up some common "flaws" like wrinkles or acne. But shooting in black and white is also a great way to highlight pattern, line, texture, and shape. Last, both very low- and very high-contrast lighting (which results in a small range of tones, or a very large range of bright and dark tones in an image, respectively) tend to look better in black and white. See #220 for guidance on how to convert color images to black and white in postprocessing.

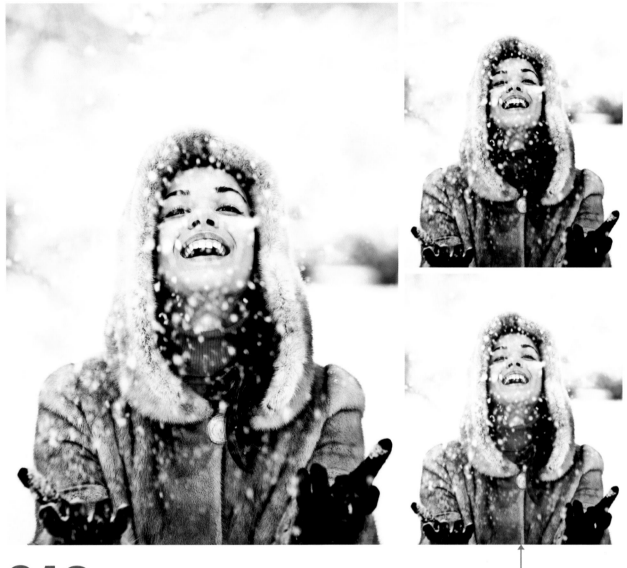

018 WORK YOUR WHITE BALANCE

All light has color. Where midday sunlight appears white, it's actually close to blue, and it takes on a reddish hue around dawn and dusk. Indoors, an office building's fluorescents appear almost green, while tungsten bulbs throw off yellows. We measure light's temperature (color) in degrees Kelvin, with warm colors falling on the low end (1,200–6,000 K) and cool ones on the high end (10,000–15,000 K) of the scale.

Our brains are pretty efficient when it comes to adjusting to differences in color temperatures. Your camera, on the other hand, needs guidance—especially when shooting predominately white scenes, such as

the snowscape above. Enter the white balance setting, which adjusts the colors your camera sees and renders them as close to what your eyes see as possible.

While you can use auto white balance, setting it yourself gives you real control. Whether you choose from presets like daylight, overcast, shade, tungsten, or fluorescent, or if you adjust white balance manually, you'll be able to alter or enhance the color of that light—giving a warm glow to a variety of skin tones or exaggerating the harshness of artificial light. To achieve a custom white balance, fill your frame with a white napkin and take a photo, and then use it to define white for your scene.

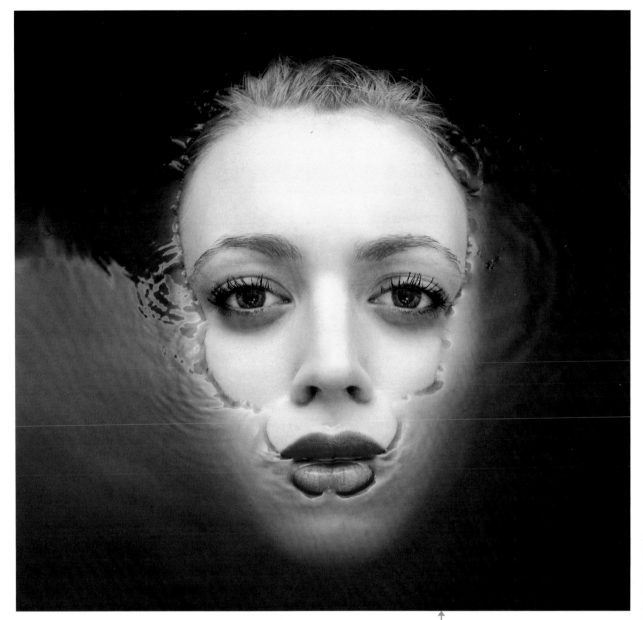

019 FILL THE FRAME FOR DRAMATIC COMPOSITION

When it comes to composition, one solid rule is to fill your frame with your subject's face. It's easy: Step closer to your target (or zoom in with your lens if that makes him or her more comfortable), or shoot wide and cut off any excess image later in postprocessing.

Another neat tactic is to frame with other captivating visual elements that might add life, color, or visual balance to your shot. For instance, get up close on a child peeking through the stair banisters, or ask a subject to stand close to a plant so its foliage borders his face. While some visual elements can add to the story you're trying to tell, others can get in the way. If all else fails, crop these weird pieces out later.

Finally, every rule has exceptions. When used artfully, negative space—the space around your subject—can make a portrait pop and draw a viewer's gaze. Here, the photographer's use of dark water as negative space is especially intriguing.

020 ACE THE RULE OF THIRDS

Want to create visual tension and interest in your portraits? Consider the rule of thirds: a guiding principle in composition in which important features fall along certain off-center points within the image's frame, creating a classically eye-pleasing ratio of background to subject.

To begin, either set your camera to superimpose a nine-square grid on your frame or shoot while imagining a tic-tac-toe-like board overlaying your shot. Forget the squares themselves; just think about the lines. Shoot so that important features—your subject's eyes, in particular, if you're up close—land on or near those lines. If you're farther away, allowing your subject's face to land on the intersection of a vertical and an upper horizontal line can force a viewer to scan the background and absorb more context.

021 MAKE THE MOST OF LEADING LINES

Beyond imagined guidelines, the actual lines that fall within your frame have an effect on the way a viewer will see an image. Different types of lines tend to guide a viewer's eyes in different ways. For example, hard diagonals can pull a viewer's attention straight into a shot, whereas softer curves may encourage a reader to wander. Structural elements like railroad tracks, walls, or natural lines in a landscape can gently prod viewers to focus their attention on a particular subject. Be intentional about the ways the lines in your shot frame your person of interest.

022 GIVE IMAGES DEPTH

Photographers, in a way, are magicians—creating the illusion of three dimensions with only two. Unless flat is the vibe you're after, you'll want to use your powers to create a sense of depth.

ZONE THE ACTION For environmental shots, try to include a visual element in the foreground, middle ground, and background. The viewer's eye will hop between these elements, leading him or her deeper into the image.

SHOOT IN PORTRAIT Photographs in a landscape orientation tend to emphasize elements that are the same distance away, while the portrait orientation naturally invites the eye from the foreground all the way through to the background.

GET LOW If you position your camera close to the ground and shoot up at an angle, you'll make objects appear to get smaller as they recede into the background behind your subject, exaggerating your image's sense of depth and dimension.

023 SHIFT YOUR POINT OF VIEW

Shooting a subject straight on is all well and good; it's how class pictures and department store portraits have been shot seemingly forever. While simple to execute, straight-on portraiture can get pretty formulaic (read: boring). So change your vantage point. Move around a bit. Experiment with the different ways shifting your perspective impacts a shot. Notice how shooting from the ground can make something toddler-small look lumberjack-large, or how shooting from on high can make the mighty appear minuscule. You can also create dynamic diagonal lines by holding your camera at a tilted angle (called a Dutch or canted angle by those in the know). Give a new perspective by taking your camera off the tripod.

024 SEE THE BEAUTY IN REPETITION

The human eye loves repeating shapes, colors, and lines—when presented in a regular pattern, these elements provide comforting rhythm and order in an otherwise chaotic world. In portraiture, repetition can help in many ways. When you're working with a group, repeating colors and patterns in wardrobe and propping will unify the crowd, while lining up the individuals in slightly different poses makes for an eye-pleasing array of similar shapes. Meanwhile, when working with solo subjects, background patterns will make a simple wardrobe pop. Beautiful backgrounds can come from some of the most banal of places; you'd be amazed at what you can do with a chain-link fence or planted rows of crops.

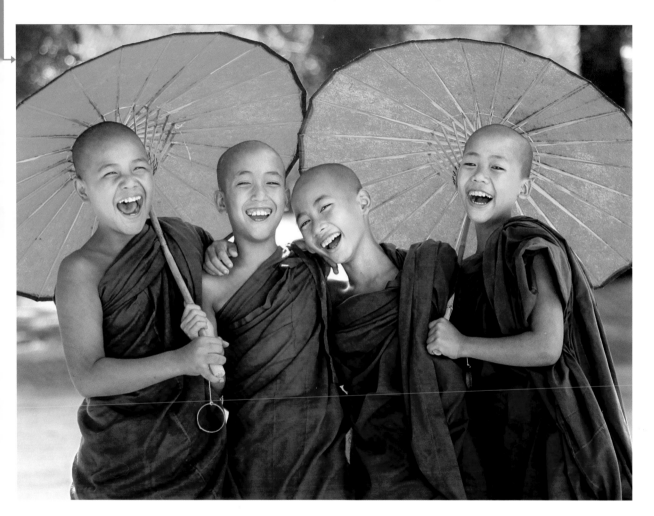

025 LEARN ABOUT BASIC SOFTWARE TOOLS

From sweeping changes to barely noticeable tweaks, photoediting software is equipped with tons of tools that let you control color, composition, contrast, exposure, resolution, sharpness, and image size—all after you've composed and captured your shots. Here's a quick overview of some of the main image adjustment tools in Adobe Photoshop, one of the most popular photoediting programs.

 NOISE REDUCTION While the wide range of ISO options most new DSLRs have makes shooting in low-light situations easy, it also can make photos look grainy or "noisy." Use the Luminance slider in the plugin Adobe Camera Raw to soften or eliminate noise from your shots.

 SHARPENING While light sharpening can help better define the lines and edges in an image, oversharpening can create unwanted noise. Use the sharpening tool with care.

 IMAGE SIZE If you're trying to share portraits digitally, you may end up wanting to shrink them. Ideally, to preserve image quality, be sure to shoot for the right size to begin with. In general, 72 pixels per inch is ideal for computer screens, 300 ppi for printing.

 SELECTIONS Photoshop's selection tools let you grab certain areas of an image to adjust separately from the remainder. The Rectangular Marquee tool is probably the most basic, allowing you to select four-sided regions of an image. Quick selection lets you "paint" a certain area to select. Finally, the Magnetic Lasso lets you rope a portion of an image, automatically finding prominent lines.

 CONTENT-AWARE PATCH, FILL, AND MOVE Have something unwanted in your shot? Content-aware Patch, Fill, and Move tools can help you seamlessly remove unwanted elements—with the software automatically re-creating a believable patch or fill—and rearrange wanted ones.

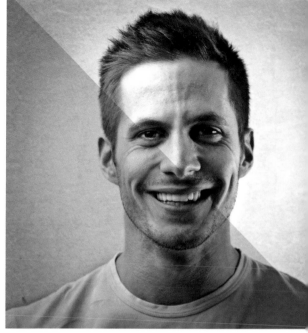

 CONTRAST The Contrast tool lets you make broad changes to an image's range of tones. It can change a portrait's mood completely—say, from moody to sunny, and back again.

 SPOT HEALING BRUSH A quick way to mask faults, this tool samples pixels then matches their lighting, transparency, and texture to pixels that need help. For more-precise control, try the main Healing Brush tool.

 CLONE STAMP Great for duplicating objects or removing flaws, use this tool to paint part of your image over another section of the same image, or one layer over another.

 CROP The Crop tool is invaluable for getting the best possible composition and aspect ratio in your shots, letting you snip in straight lines. Before you crop, keep one thing in mind: You do lose some resolution.

 LIQUIFY Like Dali gone digital, the Liquify filter lets you distort an area of an image, making it great for simple retouches and pushing an image toward the abstract.

 BLUR Three image-smudging tools can turn your simple shots into impressionistic works of art. Field Blur blurs an entire photo. Tilt-Shift lets you create a targeted blurring effect like a tilt/shift lens might (see #114). And Iris Blur sharpens a selected area while fuzzing out the rest.

 MAGIC WAND The Magic Wand tool lets you select areas of an image with a similar hue so you don't have to trace each outline. For images with a lot going on, it might be best to use a more-precise selection tool.

 EYEDROPPER If you need to replicate (or even just easily identify) a single color, go with the Eyedropper tool. It lets you select down to a single pixel—and then use that color to paint other areas of your photo.

 GRADIENT Either using preset gradient fills or creating your own, this tool lets you smooth by blending colors. Careful: If you don't select a specific area first, Gradient will apply its fill to the whole active layer.

 PAINT BUCKET Paint Bucket lets you fill large swaths of an image in a color of your choosing. Simply select a color that you like and the Bucket will fill up adjacent pixels. You can use Paint Bucket at low or high tolerances, allowing you to give Photoshop a better idea of which pixels to fill.

 COLOR Color-management tools give you the power to create monochrome, sepia, and split-tone versions of your images. For more-refined adjustments, you can also remove, reduce, or add color casts; adjust saturation; add warmth; and adjust tones.

 RETOUCH Retouch tools are designed to tackle myriad common image problems, from lens dust marks to red-eye elimination, and from shifting depth of field to fixing lens distortion.

POSING & WORKING WITH SUBJECTS

026 PUT SUBJECTS AT EASE

Some people love the camera; others need a little coaxing to get comfortable in front of the lens. Regardless of which camp your subject falls into, here are some useful tips for making people feel great—and look amazing.

BE CONFIDENT Projecting assuredness is the most important determinant of how a portrait session will go. If subjects see you falter, they'll start to lose faith and think that they don't look good in the images. Get your gear set up ahead of time to minimize fussing with it in front of your subjects, communicate your plan so that they get excited about your vision, and relax and speak in a self-assured manner throughout.

DISH UP A NICE COMPLIMENT The best way to beat jitters is to tell your subjects how great they look—and mean it. Show them your LCD screen or monitor and point out something fantastic that you see there: graceful hands, a dramatically furrowed eyebrow, or a beautiful burst of natural laughter. This tip will boost confidence and also help subjects work their best assets. It also helps convince them that you'll be able to translate their beauty into a photo.

MAKE A TRUE CONNECTION People look their best when they're engaged, so it's your job to draw them out and get that sparkle in their eyes. Talking with your subjects about their passions, hobbies, and loved ones will make them relax, lighten up, and start to have fun with you—crucial for a great shot.

KEEP IT POSITIVE Your subjects are like sponges: They'll absorb anything you put out there, so keep it upbeat. If you see an improvement that needs to be made (either a pose or an expression, a camera setting or a lighting angle), phrase it as a new thing to try, as opposed to an error to correct.

GIVE GOOD DIRECTION Don't leave your subjects all alone out there without a sense of what works. Start them off with simple poses and expressions, and then guide them through minor variations. Try teaching them a trick or two—such as bringing their ears forward to beat double chins, or lifting their lower eyelids for a smoldering look—so they feel like they're in control.

027 ESTABLISH CONTROL

Just who is in charge at a portrait shoot? The photographer? The subject? Or a third party, whether it's an art director on a commercial shoot or the bride's mother at a wedding? In a perfect world, all parties work harmoniously together, sparking ideas off one another. But in reality, you'll likely need to define your role to ensure that the shoot goes off without a hitch.

Go over any concepts and wardrobe in advance with your subject so there are no surprises on shoot day, and greet the subject as he or she arrives to establish an immediate rapport. If you can, clear the room while you're shooting so that your subject isn't distracted by other opinions, or at least ask the peanut gallery to give you a chance to get the individual warmed up before piping in.

028 WORK AROUND INSECURITIES

Everyone has a physical feature that they don't particularly love about themselves: a crooked nose, prominent beauty mark, childhood scar, less-than-full hairline. While you're not required to cater to subjects' every insecurity, they'll likely be happier if you bank several shots of their best sides and favorite poses before exploring ideas that make them more apprehensive—regardless of whether you're taking photos of loved ones or clients.

It can be hard to guess what a subject might not want featured in a photo, so share a few early shots to get a reaction about what he or she might want de-emphasized, and try to work around that trait. Then switch it up and find a way to make that large nose appear elegant, or that balding head seem stately. You may just end up surprising a subject with a beautiful new view of a once-loathed "flaw."

029 GET FAMILIAR WITH STANDARD PORTRAIT TYPES

When you're first starting out, your portraits are likely to be candids: off-the-cuff, in-the-moment snapshots of friends, family members, or strangers in an interesting setting. Even though it's unlikely that you're shooting in a formal studio, it still helps to understand the most popular formats for standard studio portraiture, as these basic, tried-and-true crops and angles are all good starting points for casual poses. They'll also help you craft situation-appropriate portraits, even when you're shooting in the wild.

FULL FACE Also called a headshot, full-face portraits get up close and personal with the subject, often with the nose pointing straight at the viewer and with more or less even light on both sides of the face. Sometimes photographers include a hint of the shoulders, or intentionally crop off at the forehead for a tighter look. The eyes are the main focus in the full-face portrait. The vibe tends to be intimate, either for casual or commercial purposes.

HEAD AND SHOULDERS To deliver slightly more context about the subject, opt for the classic head-and-shoulders shot. A go-to for official corporate and high-school senior portraits alike, this style often incorporates a slight angle of the shoulders—either two-thirds or three-quarters. Just make sure your subject doesn't rotate so far that his nose "breaks" the line of his cheek, making the nose look large. Also, avoid an awkward crop at the elbow joint.

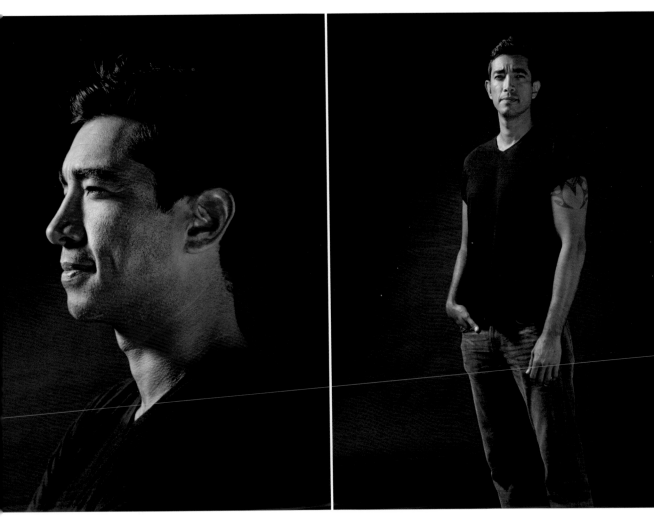

PROFILE Any time the person in front of the lens rotates a full 90 degrees from the camera's imaging plane, you lose one side of the subject's face, highlighting the shape of the brow, nose, and chin. For this reason, it's best to make sure your model has a strong line from hairline to clavicle. This portraiture style can often feel introspective or mysteriously focused, as the subject's gaze is directed outside of the camera frame.

THREE-QUARTERS TO FULL BODY This type of portrait showcases a subject from at least the knees up, focusing on the overall physique instead of the face. Once a favorite among royal portraitists, it tends to convey status. Long portraits can use the real estate to include a hint of the environment, which provides clues about the person. Be sure to fit in all the appendages—avoid cutting off at the ankle or the knee, or clipping the feet or hands.

030 GET ON A SUBJECT'S GOOD SIDE

You look at your own face in the mirror (and dozens more on the street) every day. But seeing a face as a photographer does—and therefore understanding how to show it best—takes a little training.

It may be a cliché, but it's true that most people have a "best side." Typically, it's the view of the face that has a larger eye, more defined jawline, fuller cheek, and stronger brow. To find it, ask your subjects to angle their heads slightly one way, then the other. Look at each feature of the face—eyes, nose, forehead, mouth—and notice when each looks its best.

031 EXPERIMENT WITH CAMERA ANGLES

How you position your camera in relation to your subject is, simply put, everything. While the end result is also shaped by the portrait format—whether it's a full-body, seated, or headshot view—here are some guiding principles that should help you put people in perspective.

HOLD IT HIGH When working up close with a subject, shooting with the camera held above the eyes will provide a nice trick of perspective—it minimizes the body and puts the emphasis on the face. Careful, though, as it can also mess with proportions, making the head seem unrealistically large or the body too miniature.

KEEP IT EVEN For a perfectly balanced, no-frills shooting angle, hold the camera at the same height as your model's eyes or slightly lower. This tactic is great for straightforward portraits (think senior photos or official portraits for professionals).

SHOOT LOW Most photographers tend to avoid shooting up-close portraits with the camera held dramatically lower than eye level, as it can exaggerate the size of the chest and shoulders (as well as provide a possibly awkward up-the-nose angle). But when done right, shooting up can also create a sense of power or prestige.

032 POSE TO CONCEAL SO-CALLED FLAWS

Using nothing more than some basic poses and savvy camera angles, you can help downplay some of the attributes that people get most anxious about. (For info on which gear and camera settings to use to best present skin, see #152.)

DE-EMPHASIZE A BALD SPOT To distract from a man's receding hairline, work your camera down low so less of the top of his head is visible. Consider cropping in at the crown, too. It also helps to have a little powder on hand.

TUCK A DOUBLE CHIN Instead of asking a subject to bring the chin forward and up, which can result in a slightly strange, turtle-necked effect, suggest that he bring his ears and jawline forward toward the camera. Shooting with a slightly raised camera height will define the jawline, creating a strong shape.

MINIMIZE BIG EARS You can go with a profile pose and completely skip the problem, or arrange the subject in a three-quarters pose to conceal the far ear and make the near one seem flat against the side of the head.

DOWNPLAY A LARGE NOSE Shooting the face straight on will minimize the shadows—and thus the apparent size—of a large nose. Lowering the camera and tilting the chin upward slightly should help, too, as long as you avoid shadows under the nose. It's best to skip a three-quarters view, as well as any angle that allows the nose to break the cheekline.

PACK AWAY EYE BAGS Most of us have them, even when we've gotten plenty of sleep. Slightly lift your camera and encourage your model to turn her eyes up toward the lens while keeping her chin down.

033 ENCOURAGE AMAZING EXPRESSIONS

When faced with a camera lens, most of us instinctively flash a smile—the result of years of "say cheese" conditioning, no doubt. But the face is an exquisitely lively and mobile part of us; it's the screen on which we project to the world our surprise, joy, concern, sorrow, humor, boredom, and everything in between. Learning to coax a wide range of expressions out of people will surely introduce more variety to your portraits. It'll also help you learn to look for moments of beauty that you might never have noticed before.

NATURAL SMILE A classic is a classic for a reason: We smile when we're happy, and so we're wired to like the way happy looks. But it may take a little effort to go beyond the stiff grin that an uncomfortable subject may offer up. The remedy? Take a few moments to get them laughing and talking about what they like— which will naturally lead to a great smile.

SOFT LOOK To capture a sense of introspection, encourage a soft face: slightly opened lips that just barely show the teeth, and eyes aimed either slightly downward or to either side. Ask the subject to make small tweaks to this pose as you shoot, such as tilting his or her head from side to side, lifting or lowering the chin, and shifting the shoulders for variety.

FRAMING WITH HANDS A great trick for creating visual interest in a tight head-and-shoulders shot is to add arms. It can be awkward at first, so start with one hand—it can stroke the jawline, lightly tug on a curl, touch an earring, or massage the back of the neck so the arm creates a nice angle. Encourage relaxed fingers with space in between them, with the entire hand rotated so you see the more slender view.

MOODY SQUINT One tip that headshot artists swear by is to ask the subject to slightly raise their lower eyelids for an intriguing, somewhat pinched look. It may take a little practice, but the result is an expression of intense focus, with a compelling hint of attitude, skepticism, or even sass. Try pairing this trick with a slight pout, strongly angled jawline, or saucy close-lipped smile.

034 ADVISE ON WARDROBE CHOICES

While the old adage "the clothes make the man" may be an overstatement, it's true that clothing choices can make or break a portrait. Here are some tips.

KEEP IT CLASSIC Avoid clothing that overpowers the person wearing it, or dates so rapidly that the style will lose its appeal over time. Opt for neutral styles like T-shirts, button-downs, V-neck or crew sweaters, simple dresses, and basic jackets. To keep viewers' eyes on the face, choose long pants, shirts with sleeves that go at least to the elbow, and skirts that reach the knees. When working with teenagers (like the moody squad here), don't fight their choices or insist on an ironing board—they'll be much easier to work with if comfortable.

GO FOR SOLIDS While bold patterns can be eye-catching, they can also distract from the human underneath. Solid colors in muted shades are beloved for creating a subtle palette that makes the subjects

both stand out from and complement the background, as in this image. (Bonus: Wearing similarly subdued hues on top and bottom will balance the body.) Some photographers, however, love bringing in a pop of color for visual variety or to focus attention on one spot. Black or white are less-preferred options—unless you're exploring low- or high-key images (see #153–154)—and most folks find primary colors to be overkill.

BRING OPTIONS Encourage subjects to pack a few wardrobe changes. You can also ask to see layers, which can yield multiple looks without the costume changes. Scarfs, hats, and jackets can also work as props.

KEEP ACCESSORIES MINIMAL No need to pile on every bauble. Edit accessories to those that enhance the person's story: the bold red glasses that he wears daily, grandma's truly exquisite locket, a tiny glimmering earring that echoes the catchlight in the subject's eyes.

035 COORDINATE COLORS

If you're shooting a group, avoid the dreaded "matchy-matchy." Instead, pick one to three colors in the same palette to create harmony, and allow subjects to wear something within that color family. (You can also try a small print in a related color, as long as the person wearing it isn't stationed front and center.) If there are pairs in a group that are likely to stand out together—the two tallest kids in the class, or a mother holding her baby—encourage them to wear different tones within the palette and to vary the styles of their shirts.

037 CONSIDER HAIR AND MAKEUP

You can skip tediously removing blemishes, dark under-eye circles, and other skin flaws in post-processing by making a subject's skin look great before he or she walks on set. While some may object (especially men), everyone benefits from a moisturized, primed face and a simple coat of foundation. Even more crucial is a healthy layer of colorless, translucent, matte-finish powder, which will even out skin, reduce pores, and minimize shine. Keep this powder on hand for touch-ups during a shoot. (Just skip any shimmer products, as they will render oddly in flash photography.)

For a natural look, most makeup artists will also apply a lip and blush color one shade darker than the natural hue. Make sure your subject's brows are well maintained so you don't have to spend hours digitally "plucking" stray hairs. And, if you can't have professional hair or makeup artists present, have a comb and hair spray or gel on hand.

036 LAYER PATTERNS FOR INTRIGUE

Every rule exists to be broken. While most photographers shy away from patterned clothing, sometimes it can give your shot a much-needed dose of depth and dimension, as it does here. The trick is in going with small, organized prints—such as stripes, plaids, and chevrons—that don't overwhelm. Wearing a small print close to the face—say, in a scarf or in the shirts you see here—brings attention up to the eyes, which is always a plus in portraiture.

It helps to keep the rest of the image pretty tame. Situate your models in front of a plain background, and make sure the rest of their clothing choices are solid colors. Another tip? Avoid patterns in high-contrasting hues and instead go with soft neutrals. Or convert your image to black and white (see #220) to keep it graphic but harmonious.

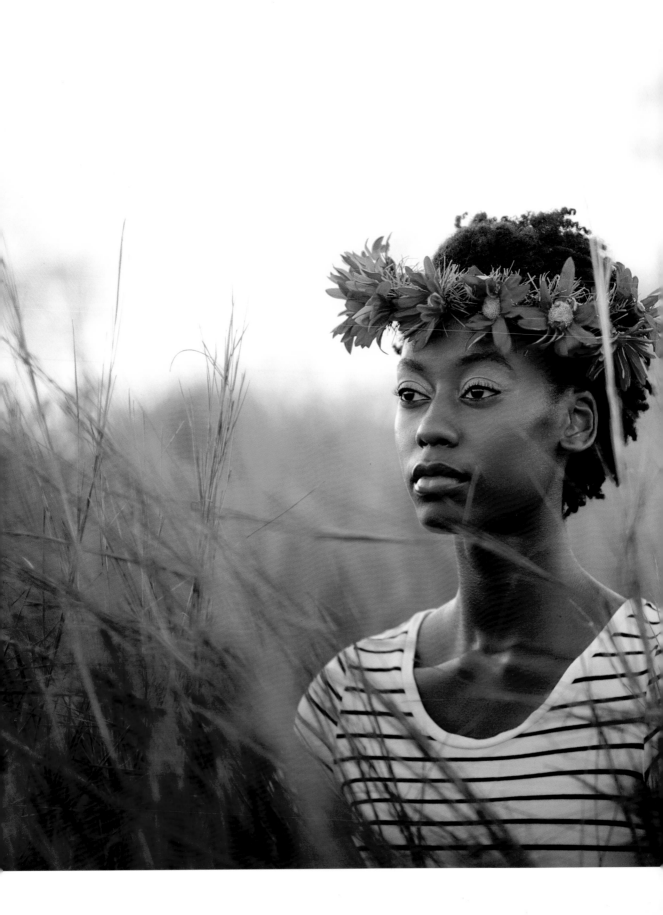

038 BRING IN SIMPLE PROPS

Propping portraits can be tough—one false step and you find yourself in the land of campy, oversize lollipops and ill-advised hats. That may be why many photographers today view props as a crutch; most opt instead for natural, candid portraits sans accessories.

Sometimes, however, a prop can elevate a basic scene (as the flower crown does here), help communicate a subject's passion, or give fidgety subjects something to do. Here's how to integrate them expertly into your photos.

MAKE IT PERSONAL Resist the urge to stock a prop closet with gimmicky stuff. Instead, help your subjects select a personal possession that says something about them. Maybe it's a vintage camera that belonged to the subject's grandmother, or an athlete's worn-out baseball glove. The more authentic the relationship between the subject and the prop, the better.

KEEP IT SIMPLE Props can busy up a scene, so go for clean backgrounds and harmonious color choices. Here, the flower crown almost blends in with the oranges and reds of the sunset-lit field, making it feel at home in the setting.

DON'T BE TOO LITERAL Often what makes props seem silly is the context in which they're used. The setup can be too forced, as in a guitarist serenading the viewer directly while pretending to strum his instrument. Instead, try to use the prop in a new way. Just be careful you don't veer into nonsensical territory.

WATCH FOR INTERACTION Props often help subjects focus on an activity instead of squirming or getting that dreaded "deer in headlights" look; this can be especially true shooting a group that doesn't know how to interact. Photographing family members as they play a board game or children as they hula hoop can provide a bit of much-needed distraction— and photogenic fun.

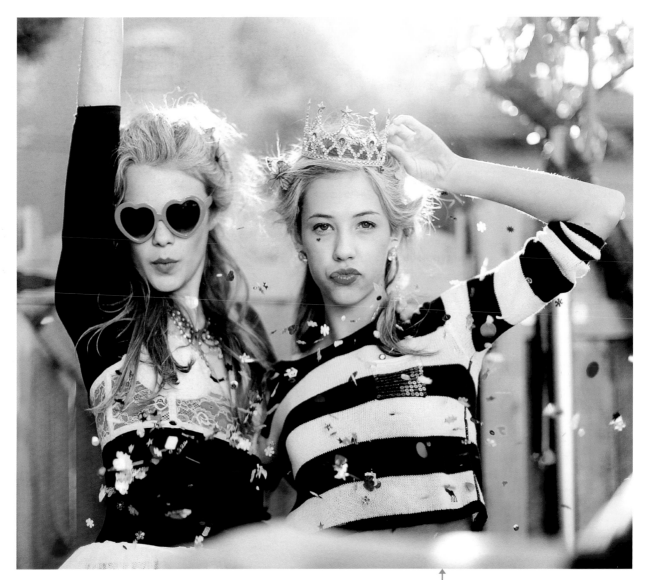

039 GATHER INSPIRATION FROM THE WORLD AROUND YOU

You've likely heard the old adage that "Talent borrows; genius steals." What this means is that genius takes something and makes it one's own. It's not an homage or an imitation or a quote—it's original work. You may not think of yourself as a genius, but if you start behaving like one, you may be pleasantly surprised.

Where and when, though, do you start your life of photographic larceny? The answer is simple: everywhere and all the time. You can look at movies, comic strips, television, ancient etchings, billboards, paintings, sculptures, advertisements, war memorials, music videos, old album covers, dusty tomes from used

bookstores, stained-glass windows in a church. For example, this image takes styling cues from Sophia Ford Coppola's 2006 film *Marie Antoinette*: The toy tiara, gray-powdered hair, vaguely French clothing choices, and saucy expressions all give a nod to the famed teen queen, as well as the film's let-them-eat-cake insouciance and mix of contemporary pop culture and late-1700s influences.

So what's inspired you lately? Isolate an idea or two that you find especially intriguing—an eye-catching palette, a compelling prop, dreamy lighting, or clever framing—and translate it into a portrait all your own.

040 SET OFF A SMOKE BOMB

As a general rule, props should feel natural in a portrait—unless, of course, your goal is to use one as a total wild card. Take, for instance, a smoke bomb, which was ignited to add colorful plumes and intriguing haze to this otherwise unsurprising portrait of a couple by a lake.

While the aesthetic is unique, there are a few obvious risks to incorporating pyrotechnics into a photo shoot. For starters, you should only use cool-burning smoke bombs, and subjects should hold them at their own risk. Stock plenty of water and keep a fire extinguisher on hand to put your smoke bomb out. And be sure to use them far from dry or windy areas and flammable materials. Also be aware that the colored smoke may leave stains, and remind all on set to try to avoid inhaling huge clouds of it. Otherwise, let it rip—and encourage your subjects to interact with the smoke to create more dynamic images: spinning or running through the wafting plumes, letting it mysteriously encroach from off set, or gazing intently through the colored fog at the camera.

QUICK TIP

041 SURPRISE WITH PROPS

Smoke bombs aren't the only ingenious way to create surprise in an image, especially if you're looking to distract self-conscious subjects with a truly fun experience. Turn on the sprinklers and invite subjects to run through them, or ignite a sparkler and watch people light up with genuine joy. If you'd like to safely add smoke to an image, light a stick of incense just off camera and set up a fan to angle the smoke toward your subject. Another tactic is to start a flour fight—the dense white particles will create fascinating, billowing clouds around your subjects. Of course, getting people on board with these concepts is key, but the effects can be dramatic and downright dreamy.

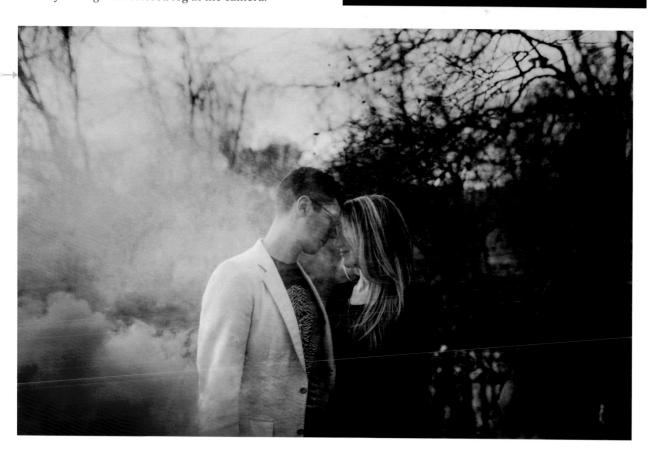

042 CHOOSE A GOOD STANDING POSE FOR MALE SUBJECTS

The challenge with posing standing men is preventing the dreaded "security guard" stance: two feet stapled to the ground at shoulder's width apart, the hands clasped defensively just below the waist, squared-off shoulders, and a steely gaze. To break this mold, you've simply got to get them moving—get the feet off the floor, the shoulders raised at different heights, the arms doing things that make sense, and the head tilted and rotated toward the light. Here are some specific poses that will make male subjects seem natural and not overdirected.

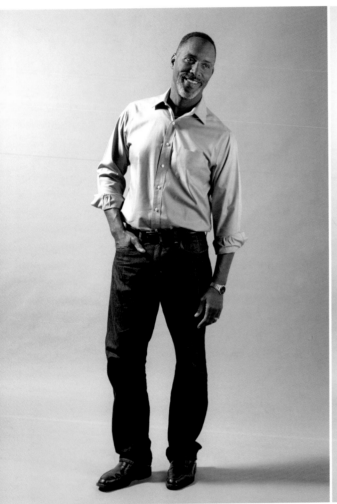

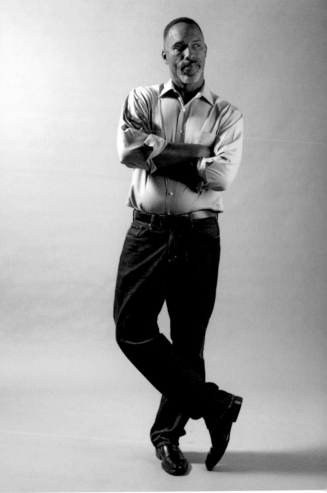

CONTRAPPOSTO First, ask your subject to stand with one foot only slightly behind the other and shift his weight to his back heel, bending the front knee a little. Try a number of arm gestures—the hand in the pocket is a classic that sets many at ease. Meanwhile, his slightly higher right shoulder creates a diagonal line, preventing the body from seeming too stocky.

CROSSED LIMBS A strong and authoritative yet fairly casual pose, crossing both the arms and legs creates dynamic angles and provides an unsure model with something to do with his limbs. Make sure his weight is on his back foot (rather than precariously balanced between both feet).

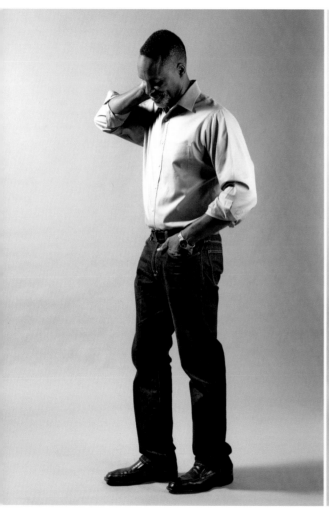

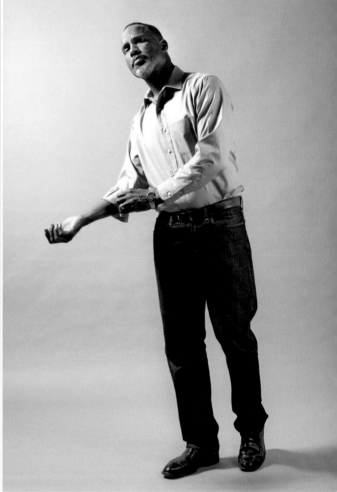

EQUAL WEIGHT Men often look powerful with their weight evenly distributed between their feet, but mix it up by asking your subject to turn to one side for a less aggressive stance than the typical front-and-center view. This rotation also presents a great opportunity for a profile view, with the eyes aimed up or down for a more pensive vibe.

IN MOTION Movement can be a real game-changer in a standing portrait—as can wardrobe adjustments. If a subject seems a little frozen, have him walk around, roll up a shirt sleeve, add or remove a jacket, and generally loosen up for the camera. The trick is to go slow and have him repeat gestures so you can stumble across (and tweak) one that works.

043 PICK APPEALING STANDING POSES FOR WOMEN

While many men are sensitive about looking cheesy in posed portraits, some women stress about how to stand in a way that flatters their physiques. As with all standing portraits, the old motto "If it bends, bend it" works well here, as creating angles with the arms and legs introduces visual interest and balances the body—regardless of figure type. Avoid a boxy shape—with feet, hips, and shoulders squared off toward the lens, accompanied by arms dangling loose by the sides—and embrace rotated, bent, and intersecting limbs.

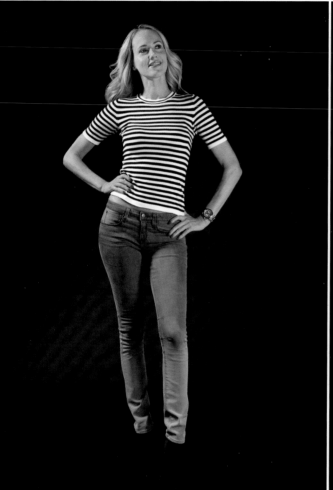

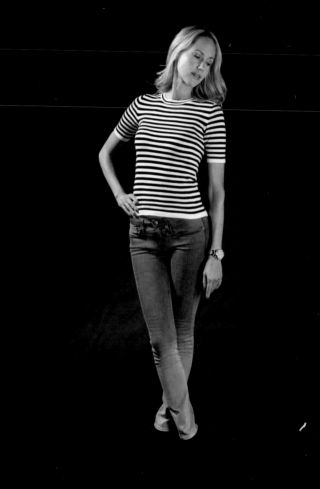

CONTRAPPOSTO When you shoot at full length, ask your model to turn slightly toward your camera and place most of her weight on one (usually her back) leg. This technique animates her posture and makes her seem slimmer by twisting her waist and hips. And maintain some space between her arms and torso so her form remains well defined.

CROSSED LEGS To emphasize the legs and make them look long and lean when you're shooting head-on, encourage your subject to cross her legs at the ankles—it will create a tapered shape and make the hips appear slender, too. A slight arch in the back can help create helpful curves in the torso, too; just be mindful not to overdo it.

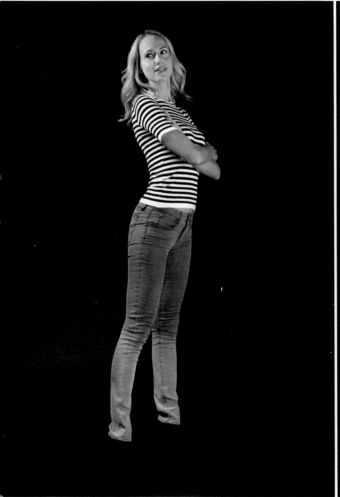

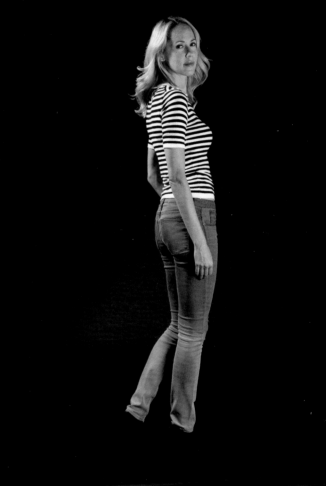

WIDE STANCE Experiment with a so-called "power pose": Have your subject stand with her feet at shoulder's width apart on one plane and cross her arms or place both hands on her hips. Known for projecting confidence, this pose may be more favorable and slenderizing at a slight angle.

OVER THE SHOULDER This pose offers a nice break from the traditional forward-facing fare. Asking your subject to walk across set and look back over her shoulder at a two-thirds or three-quarters angle will result in a nonchalant "who me?" look. Bending the elbow in the back will help give the torso shape. Bonus points for a little movement in the hair!

044 RELAX INTO RECLINING POSITIONS

We're often at our most tranquil when we're lying down—whether it's to sleep, enjoy some quiet time with a book, or share private moments with a lover. To capture this sense of quiet intimacy, try reclining poses.

PROVIDE CONTEXT Most people don't just lie on the ground for no good reason. It helps to have an environment that makes sense for the body position, such as a living room couch, a picnic blanket in a field, or even a comfy patch of moss, as you see here.

PLAY WITH ANGLES Asking the subject to arrange herself so she's parallel to the camera's imaging plane can create a long and flattering line. Another good tactic is a trick of perspective: Encourage the subject to recline with her head close to the camera, and extend her body back on a slight diagonal. This makes the back and legs recede into the background, appearing smaller.

BREAK UP THE LEGS If your model is resting on her side, try bending the top knee and crossing it over her bottom leg to create a dramatic taper down to the knees. Avoid shooting the legs together; it has the tendency to make them look wider. Popping up the back leg is also a good trick for separating and defining them.

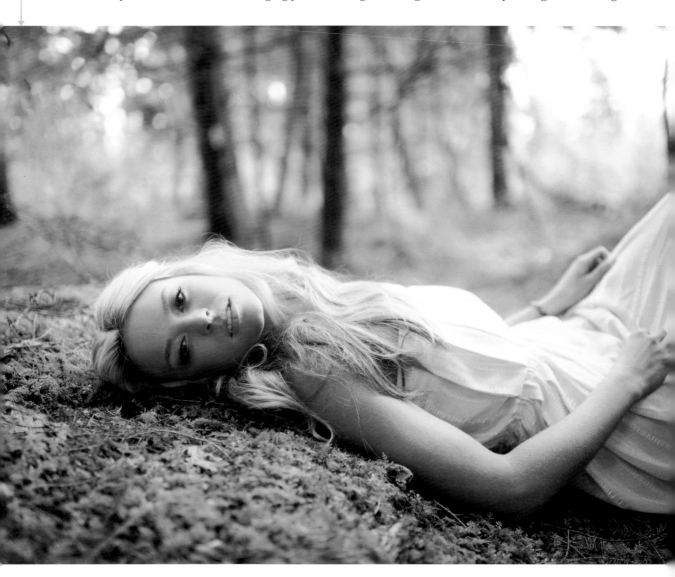

045 HIT THE DECK WITH KNEELING POSES

Full-length standing portraits pretty much guarantee you a skinny, vertical image with dead space on the sides. Try putting models on the ground to create dynamic shapes and to fill your camera's frame.

TAKE A KNEE A classic pose, bending the front knee while putting the weight on the back one can come across as casual or powerful. For a strong presence, have the subject square off toward you and lean in.

GET ON BOTH KNEES Ask the subject to sit so that his bottom rests on his heels, then pose the upper body. A good start is to lean back at an angle and place one hand on the floor, lengthening the torso. Play with lifting onto both knees and hooking a hand in a pocket, too.

HAVE A SEAT Sitting on the floor frees up the limbs for interesting shapes. Moving the legs in front of the body will help mask a wider bottom, and crossing them at the knees or the ankles creates nice angles. Another trick is to fold one leg as a base, while stretching out the second for a long, lean accent leg, as in the image above.

QUICK TIP

046 WATCH WEIGHT DISTRIBUTION

When posing seated positions, be mindful of how people's flesh naturally spreads out a bit when they put their full weight on it. (To see what we mean, take a seat and look down at how your thighs and bottom push out to the sides, regardless of your size.) To beat this simple fact of nature, try having your model distribute his or her weight so it rests on a bone: leaning over on the side of a hip, sitting high on the sit bones, or resting his or her weight on an elbow. This gets the fleshier part of the body off the floor, creating a leaner silhouette.

047 FLATTER WITH SEATED POSES FOR WOMEN

In general, grabbing a seat takes the weight off the feet—and the pressure off the portrait, as people naturally relax and needn't fret about their entire body featuring so prominently in an image, as it does when folks are standing. Still, going into a shoot with a seated subject has its own considerations. First, people tend to slouch a bit more when they find themselves in a chair, so encourage good posture: straight spine, shoulders back, and head held high. With female subjects, keep an eye on the leg position to keep it classy but dynamic.

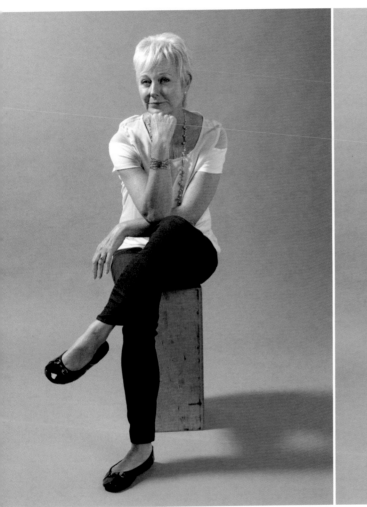

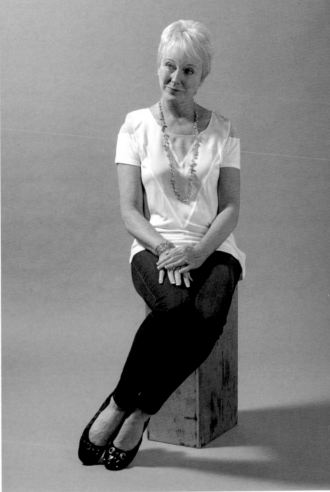

FORWARD LEAN When done right, crossing the legs in front of the body blocks a straight line of vision to the rear. Leaning toward the camera helps slim down the torso, too. Just be sure to position the knee so it provides coverage, and encourage a confident, knowing facial expression. While propping the chin on a fist is almost always cheesy, here it makes sense—and looks self-assured.

SLANTED LEGS As always when posing a model, you're after angles that provide energy and leading lines to your subject's form. Here, pressing the legs together and folding them to the side makes for a dramatic 45-degree slant, while perfect posture and hands folded in the lap create a demure impression. Feet looking awkward? Try propping them on the toes to continue the legs' lean line.

OPEN LIMBS Posing women with their lower limbs opened up can be tricky—it's really best to keep legs pointed away from the camera. Extending one of her legs makes for a slender silhouette, while the popped knee gives her shape a satisfying bend. Note how the hands on the knees draw attention to her upright posture, and the downward glance gives the image a near-noble sensibility.

CROSSED LEGS Sitting with the legs crossed and turned to the side may be the most comfortable of all positions for women. An unavoidable fact of perspective is that whatever body part is closest to the camera will look the largest, so consider crossing her back leg over the front, if it's more eye-pleasing. Leaning back a bit will continue the lean line, while toying with a necklace gives a sense of playfulness.

048

PICK SEATED POSES THAT WORK FOR MALES

For self-conscious models who struggle to stand in a natural pose, sitting down in front of the lens can be a relief, as seated poses often provide less contrived ways of positioning the arms and legs. Pro tip: If you're still struggling to get an anxious or a stiff model to relax, introduce a chair with a back or arms or a bench instead of the usual stool, as they'll present their own posing opportunities. You can also try seating a model at a table, masking the bottom half of the body and bringing the focus up to the arms, shoulders, and head.

SQUARED OFF In general, a seated pose with the feet apart and the weight evenly distributed comes across as masculine. It can read "executive" (think hands clasped behind the head), or it can feel more casual and inviting—here, the forward lean makes the sitter seem engaged and sensitive. Propping the forearms on the legs is a relaxing stance for most; just make sure the back is straight. Try a variety of handholds, but aim to capture the more slender side view.

CROSSED AT THE ANKLES Here, extending one leg over the other at the ankles creates a jaunty bend in the back limb, leaving the straight front leg (or accent leg) free to create length. Try this pose with the subject rotated at various angles away from the camera to find the most flattering view, and invite different head tilts and gaze directions. Placing the hands somewhat forward on the thighs will further elongate the body.

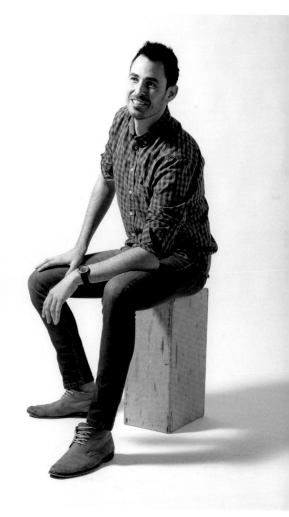

CROSSED AT THE KNEE Another comfortable staple, crossing one leg over the other leg's knee creates a nice slanted line and lends an active shape to the body. A head-on position helps the subject appear attentive, too, while also preventing one thigh from seeming large due to its proximity to the camera. For more flattering folds, ask your subject to cross his arms over his chest, suggesting a strong, assured character and leading the eye up to his face.

SIDE LEAN Try asking your subject to rotate his body into a profile position and then angle his shoulders toward the camera. This pose introduces a visually interesting twist between the legs and the torso, and—as a bonus—it often results in a slightly raised, more dynamic back shoulder, too. Keeping the feet separated breaks up the legs, providing effective angles and a platform for the more relaxed arms to rest on.

049 GET THE DROP ON BACKDROPS

While shooting in a scene in or near your home is usually best for casual portraits, sometimes a native setting just won't do—especially if you're looking to create studio-style portraits in a controlled space. Unless you have a plain white or black wall to work with, you'll need to explore one of these options.

FABRIC Definitely the most portable, inexpensive, and easy-to-store option, a fabric backdrop can be as simple as a bed sheet or seamless drop cloth in a color that you like (you can even dye it). You can also experiment with more textured textiles (such as velvet or sheer) or patterns that make your subject pop (stripes or dots). Just be prepared to steam them each use.

SEAMLESS PAPER This studio standard comes in huge rolls, typically 9 feet (2.75 m) wide and up to 100 feet (30 m) long. It's clean, easy to use, available in a wide range of colors (though white, black, and fashion gray are the most popular for a reason), and disposable: Just tear off soiled or crumpled paper. It can be unwieldy and surprisingly expensive, however.

FLATS These rigid panels are made of plywood or foamcore. Join multiples together to provide a bigger background, and paint them whatever color you like for multiple uses. When not being used as a drop, a black side can be used as a gobo to block light or cast defining shadows, while a white side makes a nice reflector.

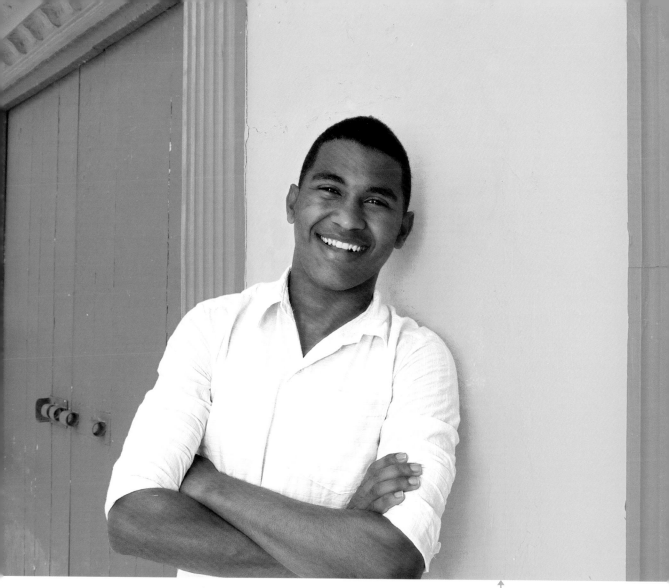

050 SCOUT FOR LOCATIONS

When you're photographing people, the location is almost as important as the subject. You don't want the background to dominate the individual, but you also don't want a scene so drab and unintentional that it distracts from your model. You can always sidestep the issue with a shallow depth of field (see #109), or do what the pros do and hunt down the perfect venue.

BANK GOOD SPOTS Chances are, there are great portrait settings all around your town—from a rustic cabin covered in ivy to a vivid, funky mural down an alley, from a classic colonnade by the lake to the rooftop bar of a slick downtown high-rise. When you're out and about, take test shots of these photogenic sites, noting when the light was best and the foot traffic (aka, the risk of photobombs) was minimal. Just be sure to inquire if permits are necessary and, as always, you—and your model—trespass at your own risk.

SHOOT AT HOME If home is good enough for the heart, it'll certainly do for your camera—and it'll make your subject more comfortable, too. Do a walk through to find a quiet, uncluttered corner with good natural illumination. Bonus points if you can get your subject seated on a couch under a meaningful piece of art or standing in front of a bookshelf brimming with his favorite books. These creature comforts speak volumes about the subject, even if they're not the image's focus.

051 REVEAL WITH A CUTAWAY SET

Cutaway illustrations never fail to fascinate, and applying the cutaway design principle to a photograph adds a realistic (if ambitious) edge. It also amuses, as is evident in this diorama of a trailer family with the trailer cut open. Talk about giving viewers a behind-the-scenes look into ordinary life!

To craft this "slice of life," conceptualize around the container you can slice into. The photographer of this image used the popular website Craigslist to source this vintage trailer with awesome woodwork and wallpaper, but you could build a similar idea around an old car, a child's playhouse, a tool shed, or a tent—any space small enough that you can fit it into the frame and inexpensive enough that you don't mind cutting it up. And if you've got the skills, you might even be able to build a small enclosure to mimic a room.

From there, the staging should be easy. Add a few props (again, eBay and Craigslist are your friends), find a simple but dialed-in location to give context to the cutaway, and have your models bring apparel that matches the overall vibe. (This couple brought their own tracksuits!) The result? The photographer put a little color (and a lot of humor) where things might otherwise be as mundane as Monday.

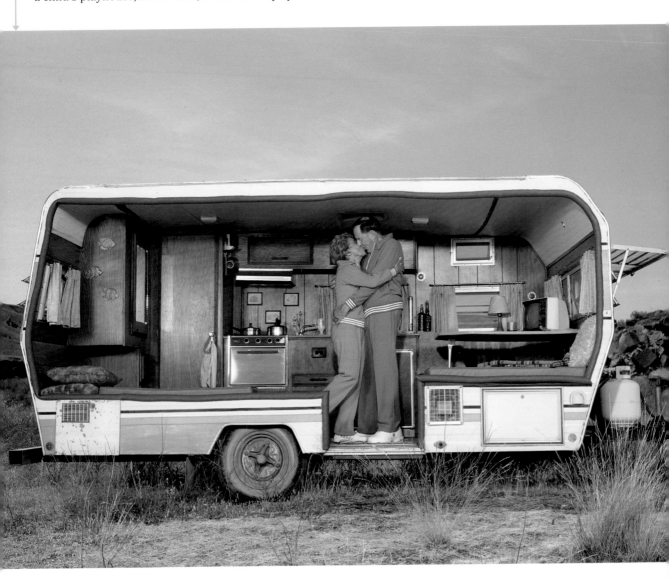

052 CURATE A HUMAN WALL DISPLAY

Behind every life, there's a potential exhibit—a collection of personal artifacts that tells a subject's tale. These objects give us a glimpse into what matters to a person; they can show off a side of a subject's personality that might not be so clearly evident otherwise. And, in the case of the portrait shown here, personal items can also provide insight into what tools, decorative objects, and memorabilia define a generation. It's one-part still life, one-part environmental portrait, and one-part time capsule.

You can try your own hand at "exploding" the environmental portrait by asking your subject to round up a selection of his or her own meaningful objects and then arranging them as if they were in a museum display or on a home's gallery wall. Mix up the mundane with the memory-laden, the useful with the merely decorative. Adding a pop of freshness (such as the flowers and hot-out-of-the-oven bread seen here) will keep your image feeling lively and current.

As will, of course, your subject. Finding a way to include your featured person—say, by mounting a chair into the exhibit wall for her to sit on—surprises viewers by breaking the norms of the typical wall display. What other ways can you think of showcasing a person with his or her most intimate belongings in a way that elevates and shows respect? (See #064 for another take on this idea.)

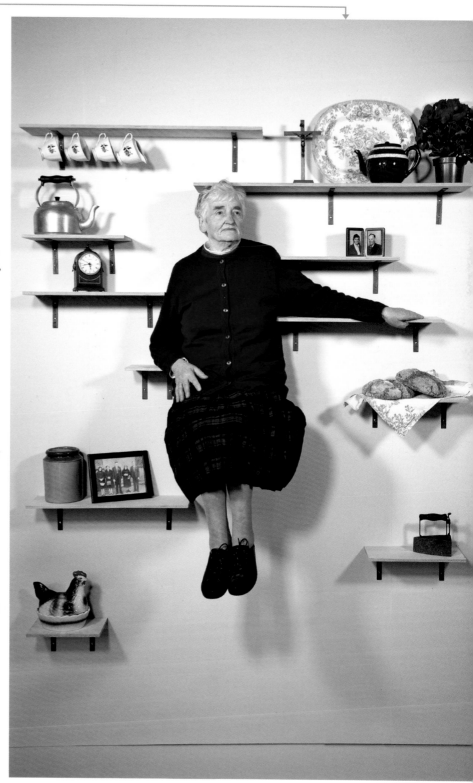

053 DIRECT SOME DYNAMIC DUOS

This hilarious double portrait of Lena Dunham and Judd Apatow (the creator and producer of HBO's hit series *Girls*, respectively) owes everything to its sassy interaction and surprising setting. But these moments don't just happen—they result from clever scripting, hands-on directing, and effective stage setting.

STUDY THE RAPPORT Before you shoot any pair, consider their relationship. Are they business partners? A mentor and a mentee? Competing athletes? Then find an interesting way to convey that relationship. Here, setting comedic insiders Dunham and Apatow in a gossipy salon puts them in cahoots—and makes readers chuckle at a man under an old-fashioned hair dryer.

GIVE DIRECTION When working with two people, their interaction is typically what makes the photo a hit. Come up with a few loose scripts to help your subjects connect, then ask them to act out those ideas until they start running with it. Otherwise, they may end up just staring at you.

OFFER VISUAL CUES You can use body position to hint at the dynamic. Here, Dunham and Apatow share center stage and are shot head-on as equals, but you could also layer the pair so that one is more prominent. The limited wardrobe palette also helps harmonize the duo. Even lens selection can create hierarchy: When shooting with a wide-angle lens, for example, whoever is closer to the camera will dominate.

CONSIDER ORIENTATION When shooting a horizontal, your subjects might drift away from each other in the frame, which can drain intimacy and energy from their rapport. This horizontal is successful in that it keeps Dunham and Apatow close, engaged in the lively banter for which they're so well known.

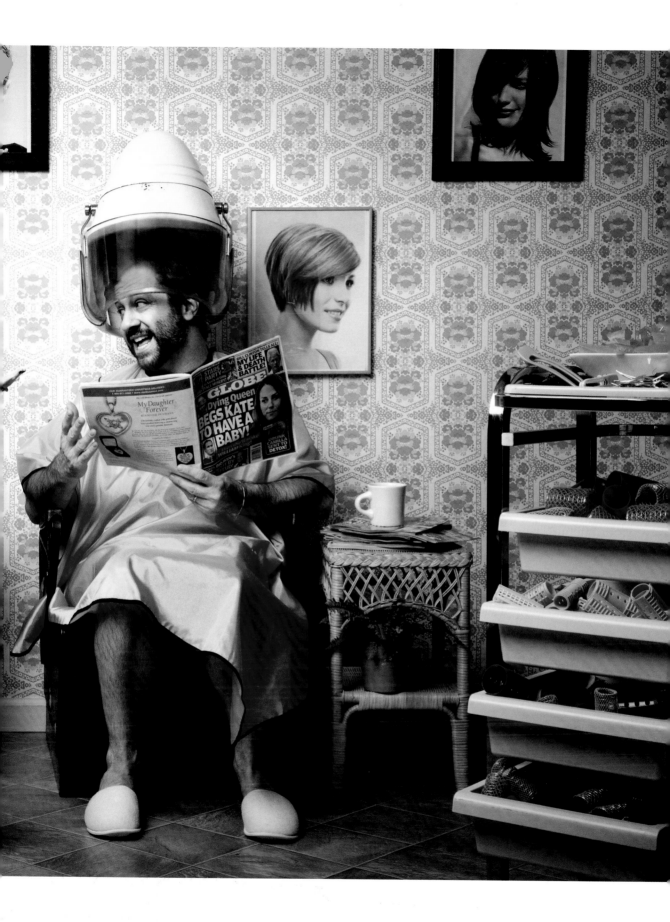

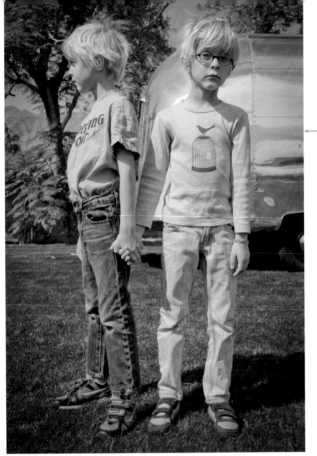

054 EMBRACE AWKWARD KID CANDIDS

Some of the most visually appealing images aren't posed or planned at all. Natural body language and poses that might even seem awkward at first can make for attractive portrait fodder, especially when they don't smack of micromanagement. While it's important to take control sometimes, other times it's best to just be observant—to wait, watch, and let the scene's dynamic reveal itself.

Wrangling kids can be its own special challenge. Sometimes, instead of trying to force their frenetic energy into a calm, collected, and politely positioned configuration, just roll with whatever they toss your way. Take, for instance, these striking preteen brothers, who were running around like crazy in the yard of their trailer park until their father suddenly shouted to them. In that one second of calm, the photographer snapped this spooky still, complete with a pose so odd and intriguing that you just couldn't make it up.

055 KEEP SHOOTING DURING IN-BETWEEN MOMENTS

Have you ever wrangled your subjects into perfect poses, under perfect light, against a perfect backdrop, only to have the accidental shot you fired after they relaxed far outshine the images from the rest of the session? It's no surprise, as that's when a subject will unclench what was perhaps a stiff smile or let the tension in the shoulders go, or—even better—trade a sly glance, quick giggle, or supportive squeeze with their partner. So next time you think you've "got" a shot, keep snapping in the instants after you call it a wrap. You may just end up with a more natural capture of the couple—and perhaps of a more special, intimate gesture than you could have ever asked them to serve up.

You can also fabricate a similar effect by asking subjects to look away from the camera in between shots from time to time—it will provide a break from gazing at the lens and result in more thoughtful, natural eyes.

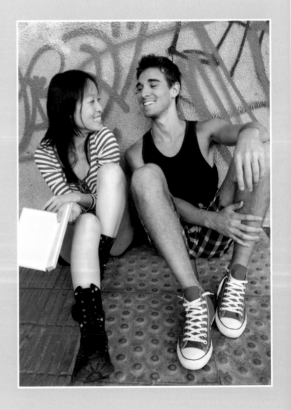

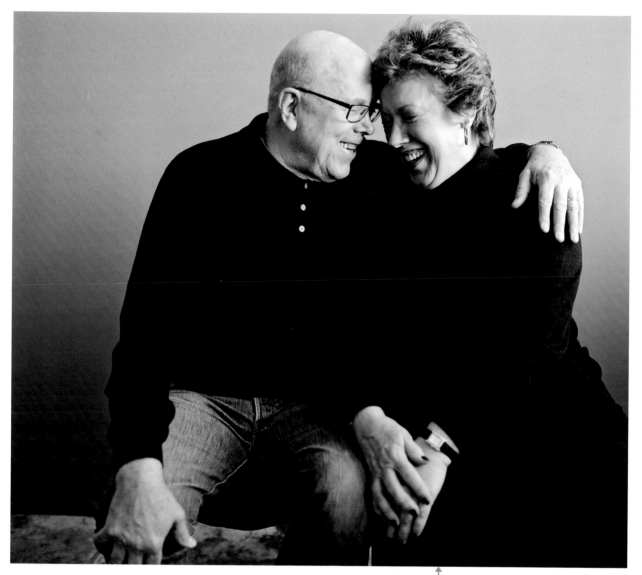

056 CONVINCE COUPLES TO COZY UP FOR THE CAMERA

Shooting couples is more than taking a picture of two individuals side by side—the pair's story should come out in a meaningful way. Draw out the warm, comfortable energy that makes for a memorable image.

GET THEM TALKING Break the tension by encouraging your subjects to focus on each other. Ask them how they met—or how they felt the first time they saw each other. The more your subjects think about their partners—and the less they think about you—the more authentic emotion will show up in your photos.

ENCOURAGE TOUCH Having couples touch each other releases them from the formality associated with

portraits, and it signals that they can express their love and intimacy. Plus, it calms shoot-day jitters. Have your subjects sit down, lean their heads in, and hold hands.

MIX UP ANGLES Experiment with how their bodies are oriented. Try having the taller partner wrap an arm around the more petite one while he or she leans in. The shorter partner can then turn her back toward him, allowing him to hug from behind. Keep switching it up.

DIRECT THE GAZE There are tons of options in where the pair can look. Try a few shots with them gazing at each other and then directly at the camera, and then a few where they're looking in different places.

057 POSE LONE RANGERS

Not every group portrait is a touchy-feely session—sometimes you're working with near strangers who have landed in a scene together. In this scenario, try posing each person separately, almost as if you were going to crop them into single portraits later.

Before placing the subjects, observe them to discover which poses they're completely relaxed in—if they aren't going to interact, it's important that they be comfortable. Try busying the hands: Holding a lasso gives the scene context, but even putting their hands in their pockets or leaning on one palm against a wall makes these cowboys seem at home on the range.

Of course, you'll still want to keep the overall image coherent. Geometry comes to the rescue here, with the two tallest cowboys functioning as anchors in a triangle while the shortest man gets a boost from the horse and forms the triangle's peak.

QUICK TIP

058 BEAT THE BLINK

Shooting on a tripod is essential if you want to be able to swap out faces digitally—which is a mighty crucial ability when you're shooting portraits of large groups, when the law of averages ensures that someone in the frame is likely to blink.

After you shoot but before you tell your models to relax and break set, scan the image on your camera's LCD screen for any squints or any other awkward expressions. If there are gaffes, quickly reshoot so you can replace heads later in postproduction.

059 LINE THEM UP RIGHT

While triangular groupings tend to activate the eye, a wall of carefully posed people can create an even power dynamic and subtle visual variety.

As you begin to place your subjects, mix up clothing styles, colors, genders, races, heights, ages, and poses. Avoid lining up heads at the exact same height or angle, and switch up shoulder alignment so that no two people are aimed alike, directing some subjects to twist toward and some away from the group's center. It also helps to make sure that some people on the left side of the frame are turned toward the right, and vice versa.

Mind the details, too: Don't let two adjacent subjects cross their arms, put their hands on their hips, or make other similar gestures. Don't forget the feet, which should be a mix of crossed, rotated out or in, and toe-forward.

060 ARRANGE KIDS IN A TRIANGLE

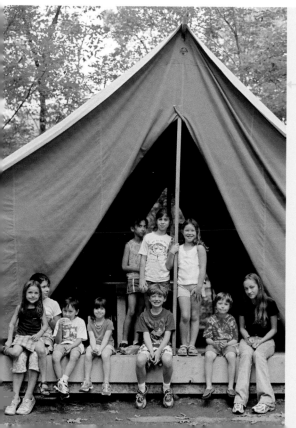

When composing a group portrait of kids, pose the most restless—in other words, the littlest—as your last step. When you're shooting twelve people, you don't want to cope with twelve constantly shifting elements, so focus first on arranging older children, who can hold their poses longer. Then position the youngest and wiggliest kids around them.

A simple geometric shape, the triangle is a great guide in kid-portrait compositions. Position a big kid to "anchor" each of the three points: one at the apex, the others at the lower points. Ask them to pose, and take a few reference shots to ensure they're in frame. Then bring in the little guys and let them interact naturally with their elders (this photographer even had one "anchor" kid hold a squirmy small one on her lap). Keep talking and directing, and don't let the kids zone out as you shoot. And relax: Children are less self-aware than grown-ups and are willing to goof around and play with one another. See #72–75 and #179–184 for more tips on photographing children.

061 COMPOSE A CROWD

Photographing a group of thirty-odd people all in one go would make any pro break into a sweat—it's daunting to carve a space to showcase every person, not to mention dreaming up all those poses. Here are some tips for shooting supergroups.

BREAK IT DOWN This warehouse's scaffolding divvies up neatly into a system of squares. Instead of posing the whole crowd at once, tackle small groups of three or four in individual zones to keep poses varied and provide a sense of order.

STACK SUBJECTS With a crew this large, you need to use the vertical space to fit everyone in. Pose people on benches, boxes, chairs, ladders, and whatever you have on hand to create a pleasing rise-and-fall rhythm.

CREATE DEPTH For leading lines that move the eye through the image, compose your crowd in a corner rather than against a wall.

MAKE A MAJOR COMPOSITE To avoid using a wide-angle lens to fit everyone in, step back, mount a normal lens, and make side-by-side exposures of the left and right sides of the group, then composite in postprocessing.

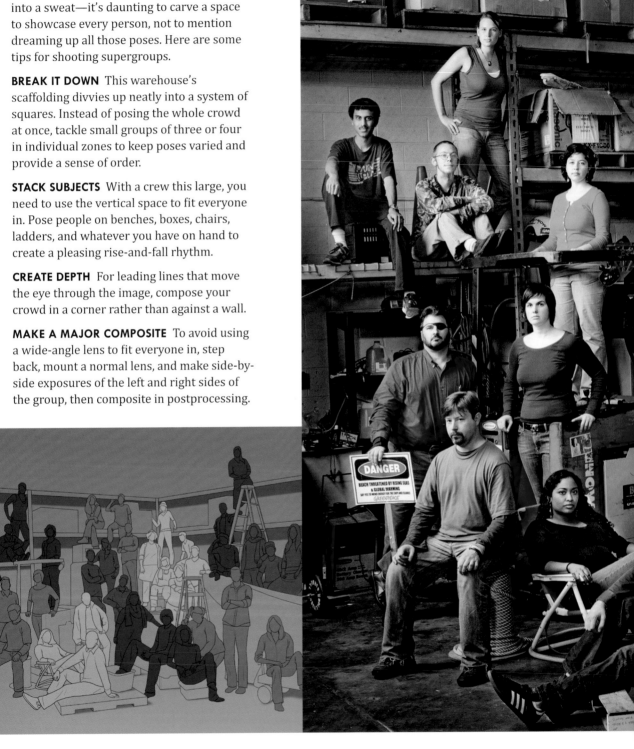

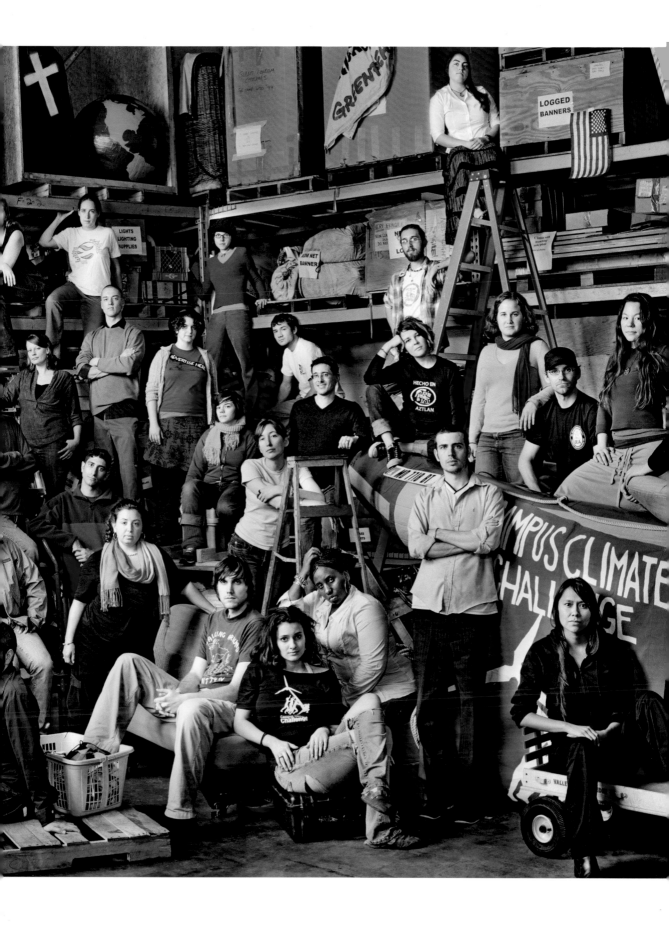

062 SHOW SOME SHOES

"Eyes are the window to the soul" is the mantra of many a portraitist. But why not the feet? Shoes express a whole lot about a subject's character, self-image, and even what he or she does all day. So turn your camera downward and capture a subject's feet—on the street or in the studio—to get a quirky and telling portrait.

Outdoors, plant yourself on a busy plaza or sidewalk and start scanning shoes. You'll be amazed at how many fascinating ones walk by. Even at 9 AM on a Monday, some funky footwear will pass: morning-after platforms, maybe, or supershiny first-day-on-the-job loafers, or conservative sandals with neon-painted toenails. Look, too, for interesting contrasts, such as highly tailored businesswomen in smushy old sneakers.

Work with the lens wide open and use the fastest camera speed your DSLR can manage. Keep your eyes low and shoot when the lighting, timing, and stride are right. Photographing feet "makes me focus on bits and pieces of things outside their context," says one shoe-portrait master. "When you narrow in on something within a larger frame, you find interesting details."

063 CAPTURE A REAR VIEW

We form most of our impressions of people based on what they look like from the front; in particular, their facial expressions and the way that they interact with the world in front of them. But you can learn a whole lot from the flip side as well. From how people carry themselves to the slogans and imagery emblazoned on the back of their T-shirts, people on the street leave a trail of fascinating intel behind them as they go.

To explore subjects from this more surprising angle, seek out individuals who use their backs as billboards. It helps to hang out near good backgrounds (like this vivid red wall) so you're ready when the perfect T-shirt-wearer walks by. A bonus? People relax when they hear you don't want to photograph their faces, and they feel complimented for their style choice.

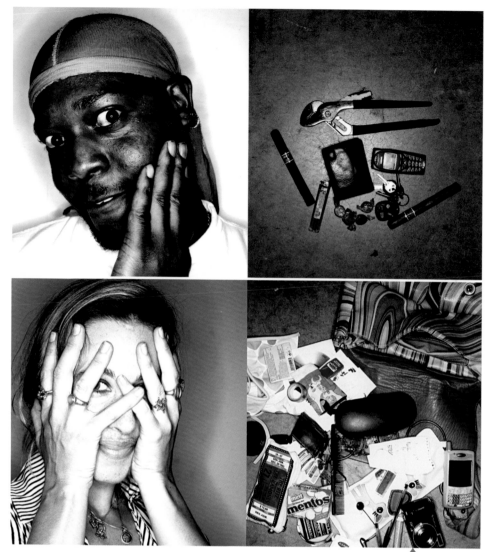

064 MAKE A POCKET PORTRAIT

Surprise your next subject by asking him to empty his pockets. (If the model's a woman, get her to dump out her purse.) If he's like most people, there will be all manner of things in there, from coins and crumpled receipts to broken eyeglasses, old ID cards, and detritus that fell off the car's door one dark night.

Arrange the objects into an interesting composition—perhaps a circle with the oddest stuff in the middle and the predictable things outside—on a tabletop, stand above it, and shoot it from directly above. Use a ring light or spotlight to add dramatic glow to the shot.

Then, to pair with your portrait of his pocket life, take a photo of the subject himself. Make it a facial close-up. If he often uses one of the pocket items, such as earbuds or a cigarette, you can include that in his portrait, too. Display the two photos side by side for an intriguing view of your subject's interior and exterior lives.

Try this creative experiment with a friend first. Are the results intriguing? Then expand your field of vision and, if you dare, ask strangers or coworkers to dump their stuff for you. The things they carry can become revelatory portraits.

066 SHAKE UP URBAN SCENES

Some of the realest street photos aren't posed or pristine but encapsulate some of the living, breathing movement of a place. So don't be afraid to shoot on the go, letting the camera be jostled as much as you are as you weave through the crowd. You can even hold the camera at odd heights—like shoulder level, as shown here—to slice scenes into intriguing fragments. Practice panning (see #190) to capture sharp shots of passing subjects against a blurred background, giving a sense of the city's bustle.

065 SHOOT FESTIVITIES IN THE STREET

Drag queens, soldiers, and sousaphone players—you can find just about any character at a street festival or marching in a parade somewhere. For photographers, these events offer a continuous stream of eye-catching subjects. A huge variety of events occur every year, from pious religious processionals to neighborhood block parties that anyone can join.

DO YOUR RESEARCH Find out all the practical details you can about the event you want to photograph: the starting time and location, whether there are related events scheduled, and where the participants will prepare. Scout the parade route or event site for the best vantage points and sites in advance.

GO INCOGNITO Plan your outfit so that you can blend in and make people feel at ease with your photographing them. Weather pending, you may need to shoot from sheltered areas or bring protective gear.

GET UP Look for a high place to shoot from so that you can capture the whole event or parade pouring through the street. For this shot, the photographer climbed onto a flatbed truck—one supporting a platform from where the rebbe was to speak. He then watched the crowd as they began to turn their faces toward the arriving rebbe, capturing their rapt faces from above.

067 MAKE PORTRAITS OF BUSKERS

Some people relish the pounding rhythms of heavy metal or the twang of old-timey country; others thrill to the soulful sound of a violin concerto. Whatever the music, the best way to experience it is to hear it performed live—and capture the highlights in photos. Performance shots may be silent to the ear, but they can speak volumes about musicians. (See #138, too.)

Large concert halls and outdoor festivals have no exclusive claim on music—particularly the gritty and raw. Sometimes you can find diamonds in the rough at impromptu performances on subway platforms and outside shopping malls. You can generally photograph street musicians and buskers any time and with any type of camera, so that's probably the easiest way to catch musicians in action. Ask first, and be sure to toss a little something into the hat or guitar case.

Of course, anyone can photograph a street performer from a distance, but interpretive portraits come from taking time to connect with your subject one-on-one. You're more likely to find meaningful, unique angles to photograph. And, when you treat subjects like the people they are, they are far more likely to collaborate with you to get your shots just right. Of course, not everyone wants to be photographed. Be respectful of people's boundaries and aware of your surroundings, especially when you're shooting in an unfamiliar place.

068 USE A SERIES TO TELL THE MASSES' STORY

One portrait may not a story make, but a whole series of related shots can string together a narrative. Mass behaviors—anything from book reading on public transportation, staring deeply into smartphone screens while walking down the street, or driving with copilot dogs—can serve as great material for a portrait series.

CAPTURE POETRY IN MOTION Sometimes there's a story hidden in everyday events like the morning commute, last call at the bars, or the exodus from a church service. Seek out motion wherever people rush in or out of structures (train stations are a good bet).

FIND A LARGER NARRATIVE When you look around these sites, you'll see repetitive actions: hailing cabs at rush hour, hugs good-bye at the airport, or mixing sugar into morning coffee. Find a way to capture those moments so that they cumulatively express something about people's rituals, comforts, and escapes.

QUICK
TIP

069 SNEAK A SMARTPHONE SNAP

Too shy to ask strangers for a shot? Choose a subject, switch on your smartphone's camera, and pretend you're deep in conversation as you aim, frame, and fire. For many smartphones, you can use the "up" volume button on the side of the hardware piece to trigger the shutter, or press the same button on a pair of earbuds. Of course, if a person detects you and asks you to stop, please respect the request.

070 LOOK IN FROM THE OUTSIDE

Composition is one of the most important aspects of street photography. Choosing what to include in your image frame is a way of drawing out the patterns and narratives that seem random at first. Look for elements that contrast with, mirror, or engage each other. Seek out the juxtapositions and interactions that we usually pass by without noticing. While many street images have an off-the-cuff, candid air about them, another popular approach is to pause individuals for portraits against a wall.

Pay attention to what's happening in the background and the near foreground. Windows, balconies, and storefronts can hold a lot of visual intrigue from the outside looking in. Take, for example, this little girl in her Easter Sunday dress, looking down on the parade passing by in the street below. When you go out to shoot, see what the scene looks like from a low angle, or get up high and look down.

Street photography is mostly about people, and every photographer has to develop an ethical approach to them. Remember that the goal is to enlighten—not to exploit.

071 CROWDSOURCE A PORTRAIT

Remember that wedding game whereby the hosts leave disposable cameras around so guests can take pictures of one another? You can deploy the same tactic to "crowdsource" highly original street portraits, following this game plan sketched out by street pro Katie O'Beirne:

STEP 1 Buy inexpensive disposable cameras, as you'll lose a few. At home, punch holes in the packaging and tie a long piece of string to it. Stick them all in a backpack, along with a few squares of posterboard, a marker, and tape.

STEP 2 Wait for a sunny day, and take the cameras to a few well-trafficked areas in town (think pocket parks where people eat lunch or plazas where shoppers cool their heels). Tie each camera to a bench or low branch.

STEP 3 Use posterboard to write out brief instructions to passersby: Tell them to use the camera to snap candids or posed shots of themselves, and note that you'll return later to collect and develop the images. Tape up the posterboard sign near each camera.

STEP 4 Later that day, round up the cameras and develop the film. Some shots will be dopey or dull. Others might be rude. But each time you play this game, you'll find a few gems: inventive and moving self-portraits crafted by strangers you've never even met.

072 COVER THE BASES IN A KID'S LIFE

The big game, the dance recital, the birthday party—as an aspiring portraitist (and possibly a parent), it's your job to photograph these events. Here's how to capture the moments you most want to remember.

TAKE THEM OUT TO THE BALL GAME To nail the best game-day portrait, learn the rules of your kid's game. That will help you predict the best shots—when your daughter's standing on first, for example, and you spot the team's best hitter at bat, you can anticipate the moment she'll spring off for second. Befriend the coach so you can shoot the action close up and capture the emotions of your player. Shoot the whole play: When your son hits a home run, record the entire loop around the bases—along with his grin— as he crosses home plate. (See #190–199 for more tips on shooting sports.)

MAKE OVATION-WORTHY RECITAL PICS If your dancer is a tiny one still developing her skills, zoom in on facial expressions and hand gestures. For older performers whose technique has evolved, focus on pointed feet, straight legs, and clean poses. Predict action by watching the knees—when they bend, that's your cue to shoot as the dancer jumps. You can't use flash in theaters, so to cope with low house lights, use shutter priority or manual, start at ISO 1600, and dial up to reach a shutter speed of at least 1/160 sec.

CAPTURE A BIRTHDAY CELEBRATION Prep the party space by clearing clutter to keep the focus on the kids. Plan party games for areas that receive nice light, and hold outdoor activities in the shade. Alternate between high-energy and quiet games so you'll capture a multitude of facial expressions. And break through children's innate shyness by hanging out at the edge at first, moving closer when the kids are used to your presence and camera. If your child is the guest of honor, let her play, and the moments you want to record will emerge naturally.

073 KEEP A CHILD SUBJECT HAPPY

When children can display the essence of their goofy, happy personalities, they're the best portrait subjects around. To help little people relax and be themselves in front of your camera, there are several reliable guidelines.

LET 'EM LOOSE If children want to run around the portrait setting—whether it's the room of a house, your studio, or an outdoor space—let them do it. A kid in motion is a happy kid, and all that motion just might result in a great shot.

EMPLOY TOYS Ask the child to bring along a favorite toy or two as a prop. Even if it won't appear in the final portrait, that teddy bear or race car will help a shy kid feel at home.

GET A CASE OF THE SILLIES Engage your little subjects by asking them to tell you their favorite jokes, sing a funny song, or act like their favorite movie character.

AVOID PITFALLS Photograph infants after their nap, not before it, and use a gentle voice with kids of any age. Avoid complex backdrops, lighting, or poses, and ask kids how they'd like to stand in their portrait. This will give them confidence—and you a natural image.

074 MAKE KID SHOTS TAKE FLIGHT

Having your subjects jump is one way to break tension during a photo shoot and produce an unconventional portrait. In fact, Philippe Halsman, one of the twentieth century's top portrait artists, posed dozens of his celebrity subjects in midair. Jump shots are also great for the expressions they produce, especially with kids. Here are some tips for capturing jumping juniors.

LOOK FOR CONTRASTING BACKGROUNDS You want the jumping figure to pop out of the scene. That won't happen if the child and the background have the same tonalities.

HAVE THE CHILD COUNT TO THREE . . . and jump! Try to capture the expression as the child forms the word "three."

KEEP SHOOTING The moments after the child lands often produce the best smiles.

075 TAKE A NEW ANGLE ON CHILDREN

For a fresh and funny twist on a group kid portrait—like the ones you take at birthday parties and family reunions—try shooting them from above. Arrange the kids in a circle, set them up with snacks or a board game, and then prop a ladder nearby. (No ladder handy?

Shoot from the stairs down into the hall or from the porch onto the lawn.) Zoom wide, wait until the kids are happily talking together—don't fuss with the camera for long, or they'll wiggle out of frame—and then ask them to look up. When they do, grab the image.

077 COAX SENIORS BEFORE THE LENS

When shooting older folks, particularly the uneasy, take some time to make sure everyone is comfortable. Consider "warming up" by shooting elements of the scene—their home, plants, or framed photos. Doing so can help anxious elders grow accustomed to the camera. Once subjects get used to the idea of being photographed, they start to reveal their true character. Besides, a relaxed subject is a lot more likely to give you natural gestures than someone who is stiff.

Instead of asking older subjects to pose, strike up a conversation. Focus in on your subject's expressions—from wrinkles and lines to sparkling eyes. If your subjects have a hobby like knitting or playing chess, ask to see their finished handicrafts or challenge them to a game. These "action shots" are often livelier than staged ones. Bringing grandkids into the equation is also a pretty surefire way of teasing a smile out of a proud grandparent.

076 WORK WITH TOO-COOL TEENS

Teens can be somewhat reluctant creatures in front of the lens. Still figuring out who they are, and not quite yet entirely comfortable in their own skin, teenagers are not always the most forthcoming when it comes to the camera. Here are a few things to consider when working with these emerging adults.

SHOOT WILD In some ways, photographing teenagers uses a lot of the same skills as wildlife photography—particularly for reticent subjects. Hang out with them and "hunt" expressions they offer up, such as this fleeting hint of a smirk.

DON'T BE COOL Whatever you do, don't slip into whatever parlance you think might be hip with teenagers at the moment. Odds are it's not. And if there's one way to alienate a group of adolescents, it's to try to be one. Speak to your teenage subjects like the adults they want to be treated as.

GET MOVING If all else fails, try your best to catch an unguarded moment by creating one. Encourage your subject to move around, even jump up and down, to create a sense of spontaneity in the frame.

078 FRAME THE FAM IN CANDID SNAPSHOTS

The best portraits share a sense of personality, character, mood, design, and place, all without the "say cheese" artificiality. Catching all of that in one family photo is no easy feat. Here are a few ways to snare some of the more precious, candid moments among kin.

SEEK INTERACTION Picture your loved ones as they are enjoying themselves. From jumping on the bed to running through sprinklers to coming together to finish the Thanksgiving dishes, shooting family members in moments of togetherness can be wonderfully revealing. And your best shots usually come when family and friends are talking, laughing, and reacting to each other.

BE UNEXPECTED Unposed candids can move viewers with colorful action, facial expressions that show mood and personality, and interactions that reveal relationships, subtexts, and hints of narrative angle or story line. For this shot, the photographer wanted to capture a conversation between his sister and his son without disturbing the spell. To get it, he snuck up behind them before quietly taking a few shots.

SHOOT AT HOME People are often the most relaxed at home, so it's a great place to shoot—even more so if there's a social event going on that makes folks concentrate on each other and not the click of the shutter. Scout around for the best lighting and backgrounds, and take a few moments to clear up clutter; it can really detract from your shot. It also helps to compose with your feet and your back: tiptoeing, stooping, bending, and reaching to showcase the subject and omit distractions.

KEEP SHOOTING Sure, you have to shoot a lot more frames to find a keeper compared with posed portraits. But it's actually a benefit: Usually, the more you shoot, the more relaxed and natural friends and family will become, and the more likely you will capture those prized, unscripted moments and connections.

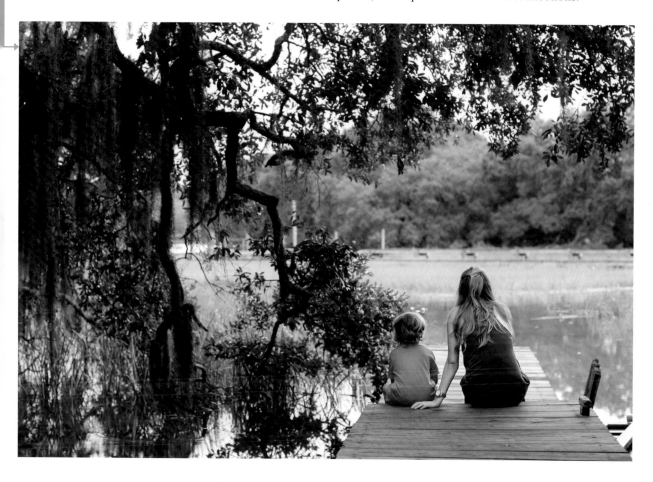

079 CAPTURE GLOBAL CELEBRATIONS

There's more on the holiday calendar than Christmas, Easter, and Thanksgiving—in fact, a whole world of remarkable, visually arresting occasions (religious and otherwise) awaits your lens.

EMBRACE COLOR AT HOLI When rainbow-hued clouds of powdered paint fill the air at this Hindu spring festival, choose a fast prime lens for close-up portraits, or home in on paint-covered hands or faces. Protect gear from the color storm: Use a rain cover (see #209), and avoid switching out lenses or batteries.

HALLOWEEN Pumpkin night is all about cute-kid images—and shooting in the dark. Avoid harsh flash, increase ISO, choose a large aperture, and slow your shutter speed. Try posing your little monster with his face half-lit by his jack-o'-lantern and then fill your frame with the two faces.

SHOOT DIA DE LOS MUERTOS Held in early November, the Mexican "Day of the Dead" is famous for its revelers in full-on skeleton makeup and elaborate costumes. Try shooting wide at the candlelit procession as it goes by, or make environmental portraits of people in front of altars they've crafted for deceased loved ones.

EID AL-FITR When you gather for the "sugar feast" marking the end of the Ramadan fasting period, the lavish spread of food and the ring of family faces make prime portrait-taking territory.

080 CREATE A CLEVER HOLIDAY CARD

For some, the annual family holiday card is a dreaded chore, complete with matching sweaters, mistletoe, and impossible lighting (those merry Christmas lights aren't so easy to expose). For some photographers, however, crafting a festive holiday card allows them to flex their storytelling muscles—and make something memorable.

GO FOR LAUGHS Pack your card full of strange, fun, and true details. Such little things bring humor to the card and bring out the personality of each family member. Show a teenage brother terrorizing the house on his just-unwrapped scooter, for instance, while mom tries to get some peace on the couch with a cup of tea.

SCAN THE HEADLINES Stumped for a concept? Borrow one from the year's events: a probe sent to Mars, funny hats at the royal wedding, or a viral sports blooper.

MAKE A LIST . . . AND CHECK IT TWICE As a family, track ideas that made you laugh over the year. When it's time, decide what can be represented visually and in a holiday context. Play to the themes: Show kids sneaking into presents, cousins in a dreidel-spinning contest, or Grandpa stealing Santa's cookies.

GET THEM PRINTED Don't just send your great photo as some ecard. Go the extra step and invest in quality paper and printing.

082 SEE VANISHING WAYS OF LIFE

Good travel photography is all about telling the story of a place and its people—and depending on where you visit, those stories may be on the verge of becoming rare. Take, for instance, this image of one of South Korea's *haenyeo*: female free divers who plunge into the cold ocean to harvest seafood. As more young women leave the small coastal towns for tourism jobs, the haenyeo tradition has become threatened. Should you find yourself face-to-face with a similarly endangered tradition, here's how to maximize your moments behind the lens.

VISUALIZE YOUR SHOT Don't go in blind. Have your ideal image in mind ahead of time. For this shot, the photographer knew she wanted a single image to tell the tale of the dying haenyeo tradition: a tight headshot of a diver in her wetsuit and mask.

BREAK THE LANGUAGE BARRIER Try to approach people in a disarming and polite way. A smile and a giggle or laugh goes a long way—especially when you don't speak the same language. Rely on simple gestures, too; in this case, holding up the camera and extending a single finger to indicate "just one photo" helped the photographer convince the subject.

TAKE NO FOR AN ANSWER No matter how nice or talented you might be, not everyone wants to be a subject. When someone turns you down, thank him or her, smile, and move along—there's plenty to see.

081 KEEP YOUR GEAR SAFE ON THE ROAD

For the most part, people are good and the world is a friendly place. Still, some folks do steal stuff. Here are a few things you can do to up the chances your gear will return with you.

MAKE A RECORD Before you travel, make a list of all your gear—makes, models, and serial numbers. If it turns up at a pawnshop or police station, it'll be a lot easier to make your case if you have these details.

GET DIRTY Shiny new camera bags can be targets for opportunistic thieves. Use an old bag, purchase one that looks just like a normal backpack, or scruff up the one you have to deter would-be criminals.

BE ALERT While it can be easy to get sucked into a shot, keep an eye out for unsavory behavior. Trust your gut; if something doesn't feel right, keep moving.

BACK UP YOUR WORK Pull images off your SD card and back them up frequently. It's not a bad idea to save a copy in the cloud; that way, you still have it should something unfortunate happen to your computer.

ROTATE CARDS Rather than use a small number of cards with large amounts of memory, consider using a bunch of smaller cards, stashing them in different places. If one gets stolen or damaged, you haven't lost all your work.

083 SHOOT LIKE A LOCAL

In a new country, try to think like a photojournalist, not just a traveler who happens to have a camera.

DON'T PLAY TOURIST Whatever you do, leave the Hawaiian shirts at home. Remember, you are not a tourist, so avoid tours and well-trafficked sites. Instead, hire a local guide to take you to out-of-the-way places.

KNOW THE CUSTOMS Research local etiquette: Know how to dress, how to greet people, if it's okay to talk to women, and, of course, if photos are permitted at all. If, after shooting, a small tip is customary, oblige. Let people see shots in your LCD as you work. If people ask you to mail photos after you return, keep your promise.

LEARN SOME LINGO Even if folks have agreed to let you take their photo, many are still apprehensive in the process. Learning a few words of encouragement in your subject's native tongue can help put them at ease—try "beautiful" or "cool" so your subjects know you admire them and are crafting flattering photos.

SHOW GENUINE INTEREST Chances are, there's a reason why you're after a photo of certain subjects—maybe it's something they're making or their pet. Ask them questions, and they may just let you take a portrait.

LOOK FOR AUTHENTICITY Every place has something it's known for: Mariachi performers in San Diego taco shops, fashionistas stalking outside the Louvre, sherpas packing llamas along Peru's Incan trail. Research where you're headed and look out for those quintessential scenes, then find ways to depict it in a whole new light.

085 HONOR AN EVERYDAY HERO IN THE FIELD

The world is full of unpaid heroes—from those who volunteer to fight forest fires to doctors battling disease overseas. And for the women and men who put themselves in harm's way for the world's good, the work is often its own reward.

But documenting these humble do-gooders in the environment in which they crusade can raise awareness. Here, a volunteer firewoman surveys the charred trees of a blaze that she fought to contain just the week before. To communicate her heroism, the photographer stationed himself below her and shot up, capturing her resolved stance, her ax at the ready, and her eyes trained on the horizon for the next time she's needed. What local heroes could you highlight, and how?

084 JOIN THE WORKING CLASS

Work has countless aspects. On one end of the spectrum, there's the dignity of an honest day's work for an honest day's pay. On the other end, there are boring desk jobs or—worse—the misery of back-breaking labor. Whether you're documenting the shoe-shine boy, the Oscar-winning actor, the president, or the nanny, your subject's job and the way you choose to present it will speak volumes.

GET A GOOD VIEW When photographing a person on the job, show enough of the workplace to make it clear what the subject does for a living. This will be easier in a garage than in a generic office. Sometimes you can use shorthand—for example, a line of burgundy law books behind an attorney seated at her desk.

CONDUCT AN INTERVIEW The best way to figure out what to highlight is to ask your subject, "What's the most typical thing you do?" Then shoot the subject engaged in that act or holding props that are associated with the job (try a financial magazine for a currency trader).

LET THEM GET CAUGHT UP A good tactic is to fade into the background and watch the work take over. Shoot your subject shouting on the phone, welding in a torrent of sparks, or giving someone a massage. Train your lens on your subject's focused expression and capture the gestures that best convey the spirit of the work—and the worker.

086 PORTRAY AN ARTIST IN THE STUDIO

A subject's workplace is full of telling details: well-used machines, abandoned prototypes, safety gear, rough sketches, to-do lists, and inspiration boards, to name just a few. And artists' workspaces are often the most visually rich of all, as their tools, materials, and works-in-progress offer up fascinating forms, colors, and textures to support their image. Here's how to give a glimpse into a creative's process and outlook.

FIND YOUR MUSE Documenting an artist at work begins with finding an inspiring one. Attend gallery events and open studios in your area so you can discover and meet with local up-and-comers. If you hit it off with one whose art speaks to you, ask permission to shoot him or her at work in the studio.

GIVE BACK Offering to share images with your chosen artists is always nice—and likely to make them want to collaborate with you.

GO WIDE Once in the studio, take a number of shots that show the scene in its entirety, as does this portrait of designer and artist Elle Luna surrounded by stacks of her own paintings, an array of paintbrushes, and even a whimsical swing.

DELVE INTO DETAILS Get in close to frame an artist as she lobs on paint with a palette knife, cuts clay with wire, or hangs a print to dry. Capture the specificity of the work itself: the drips and dabs, the paint-specked brushes, the texture of the canvas.

SHOOT THEM IN DEEP THOUGHT—AND IN PLAY
Photographing an artist in the act of creating is a must, but be sure to explore the more introspective side, too. Look for quiet moments in which your subject is gathering inspiration, having a break-through moment, or just taking a playful pause to recharge creative impulses, as here.

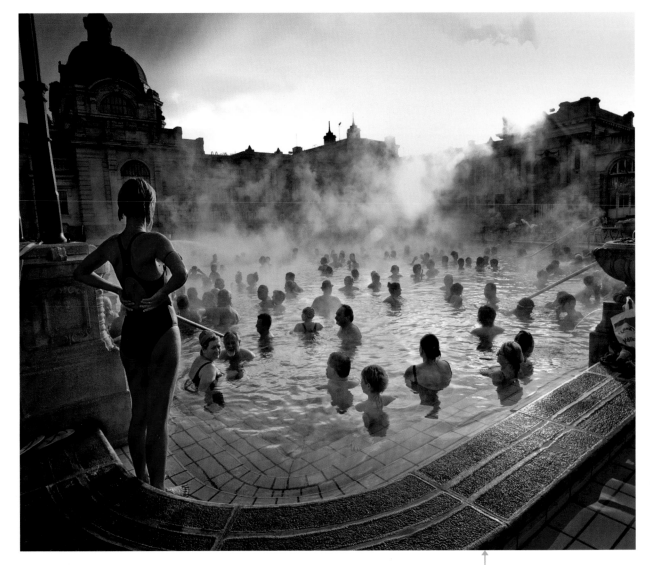

087 RELAX SUBJECTS WITH THE SPA TREATMENT

One of the most elusive things to capture in an image is the authentic characters, emotions, and energies of a location—particularly if the locale in question is supposed to be leisurely and relaxed, and if you're from out of town. Not everyone loves being photographed; in fact, some folks tense up at just the idea of being scrutinized behind a lens. When the photographer is a stranger and the subjects are in their bathing suits, those anxieties can compound.

It's a lot easier to concentrate on shooting photos when you have carte blanche from your subjects. Get someone in the know—from the place where you'll be

shooting, or who is otherwise familiar with your would-be subjects—to help navigate social mores and break the ice. For this image captured in a Budapest bath, the photographer asked a friend from Budapest to act as fixer, making his intentions known as well as securing photo releases. In the end, having a Budapest native facilitate the business end really helped turn a possibly standoffish atmosphere into a joyous one.

Another pro tip? Scout ahead of time. That way, you'll have a good idea of when the sun peaks over your scene so you can be standing in the perfect spot, ready to capture the light diffusing through the sauna's mist.

088 HIGHLIGHT CLASS AT THE POOL

Look closely at every leisure destination—past the upscale pool partiers and the languorous spa loungers—and you'll see some not-so-leisurely activity going down; namely, people at work. As you sweep your lens across the scene, keep an eye out for subtle distinctions between the guests and the individuals that run the resort or condo, as in this portrait of two well-kept American ladies relaxing in a pool while a young Bulgarian lifeguard keeps watch. The photographer shadowed the young woman at work in Ocean City, Maryland, in the hopes of capturing "the cultural differences of Eastern Europeans working among people in the U.S." While subtle, the photo combines and juxtaposes two disconnected-seeming worlds—the slack-jawed opulence of the retired wealthy and the straight-ahead determinism of a new immigrant working class—in one compelling frame.

089 CATCH A FROSTY CANDID

Good photos come to those who wait—and watch. Henri Cartier-Bresson popularized the "decisive moment," and his style of 35mm candid photography owes a lot to anticipation and timing, not to mention a dab of good luck.

Fortune certainly paid a visit to the creator of this scene one cold day at Brighton Beach in England. As a large wave approached, he sensed a quiet moment coming together—a reluctance just before his friends took the plunge, visible in the cold arms and clenched fists. While his original intent was to capture all three looking out to sea, the woman got cold feet and turned as if to say, "Oh, blimey, I'm not getting into that!" The result is a humorous icebreaker—and an unscripted moment Cartier-Bresson would have been proud of.

090 POSE A CLASSICS-INSPIRED NUDE

The human form has long inspired artists of all stripes—from sculptors of antiquity to creators of 1950s-style pinup images. A common approach is to view the model's body as an artistic study in form, exploring its near symmetry, chiseled musculature, softer flesh folds, and contrasting textures from a nonerotic perspective—as does the photograph here, which takes its cues from Greek and Roman sculpture.

Of course, there's no one right way to pose a nude portrait, but here are some good guiding principles for getting started.

START SLOW If your model is nervous, begin in more neutral territory with, say, a close-up of the nape of the neck. Back views also work well, as they reveal fewer intimate areas and give novice models a chance to get comfortable.

POSITION THE LEGS All poses depend primarily on leg placement, so begin by arranging the legs and feet, and then concentrate on the arms, hands, and head. In this image, for example, the model's seated position provides a foundation for the rest of the body. Once his legs landed in an interesting V shape, the model and photographer then explored different arm and hand placements before landing in the clasped position you see here. Slight variations in head position and expression should come last.

EXPERIMENT WITH POSES Try a few different body positions—some seated, reclining, standing, and kneeling (see #42–48 for inspiration). It helps to have your model turn in tiny increments as you snap test shots to see which poses work best in your lighting. It's also a great idea to have a fine-art book or two on hand so that a model can get ideas from sculpture or painting. Try downloading a posing app to your smartphone for when inspiration runs low, too.

WATCH THE EYES Your subject's glance is essential to an image's overall feel. You can put psychological distance between the model and viewer by directing him to gaze slightly to the camera's side, or create intimacy by asking him to look directly at the lens. Or forgo showing the eyes completely—as in this image—to keep the viewer's attention on the body's graphic lines and textures.

091 BUILD RAPPORT FOR A NUDE SHOOT

Sensitivity and trust are key components of any nude photo shoot, whether you're photographing an experienced model, a client, a friend, or your partner.

MAKE IT PLEASANT Create a warm, comfortable environment with a private dressing area. Encourage changing into a fresh robe when the subject arrives so that indentations left by straps and seams have enough time to disappear.

AVOID OVERENGINEERING Keep your lighting setup simple and tweak it minimally during the shoot—maintaining focus on your subject will help put him or her at ease.

TALK BEFOREHAND Before the shoot, sit down with the model for a relaxed conversation to instill trust and calm nerves. Discuss how the session will proceed, agree on the types of poses, and talk about any props. If shooting boudoir images, go over lingerie and other apparel items. Come to a consensus on how the images will be used before you shoot.

BRING IN BACKUP For moral support, either have an assistant in the studio (with the model's permission) or suggest that your subject bring a friend along for the shoot.

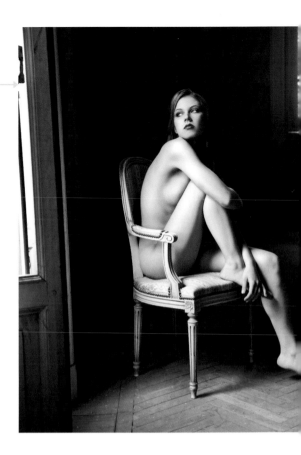

092 CRAFT A MODEL RELEASE

Technically you need a release only when using a photo for commercial purposes (advertising, posters, cards, endorsements, or trades). Even if you sell a fine-art photo or use it in an editorial context (such as newspapers, magazines, personal websites, or books), you don't need one. But if you sell to stock agencies or commercial websites, you do. Otherwise an agency or publisher might decline it—or, worse, your subject could take legal action against you. Especially when shooting a nude, play it safe by getting a release and your model's proof of age.

Photo agencies offer free, downloadable release forms, and you'll find them in consumer legal publishers' guides, too. Smartphone model-release apps let you customize and store releases on the spot. Make sure the form gives explicit permission with language such as, "I [model's name] hereby give permission to [your name] to use my photographic likeness and name in all forms and media for all noncommercial, lawful purposes." There should also be a spot for the model's printed name and signature, as well as his or her stated age and the date signed.

093 CREATE A SENSUAL BOUDOIR PORTRAIT

It wasn't too long after the camera was invented that someone discovered it could be used for sexy photos—maybe a few minutes, tops. Today, the trend is gaining mainstream appeal among women (and men) who want boudoir images as gifts or celebrations of their own physiques. Here's how to keep it classy—and create shots that make the subjects feel their hottest.

UNDERSTAND THE MOTIVATION Even if your model is just after a self-esteem boost, knowing that before the shoot will help you craft a positive experience and better photos. Ask the subject to share favorite boudoir shots so you can get a sense of what's needed.

GO FOR A LUXE LOCATION The most obvious setting is a bedroom, but it doesn't have to be your subject's. Renting a hotel room for a day could help inject some welcome fantasy into the shoot. Look for spots with good window lighting, interesting textures, and high-end details, like sleek modern furniture or gilded mirrors. Bonus: White sheets will double as a reflector.

CONSIDER WARDROBE Ask your subject to bring several lingerie and footwear choices so you can help him or her pick what works. Your model will definitely have favorites, but given your location, chosen theme, and awareness of how the lens will convey the body, you may want to weigh in.

DON'T FORGET HAIR AND MAKEUP The entire point of this shoot is to make your subject feel amazingly beautiful—especially if he or she is your client. Ensure there's at least a friend with a nice touch on hand to do hair and makeup so the subject feels pampered.

KEEP IT POSITIVE Praise your model continuously throughout the shoot, and maybe even share an especially nice image on your LCD screen to inspire confidence. Playing his or her favorite music can help elevate the mood, and try to keep your subject laughing throughout the shoot. If you're taking photos for a partner, get your model talking about how they met, what they like to do together, and so on.

094 STEP INTO THE PICTURE

Chances are, not a day goes by without your seeing a selfie on social media. But this now-notorious art form has been around since the earliest days of photography, when photographers imaged themselves to learn about exposure. We can all aim a camera (or smartphone lens) at ourselves; the trick is to make it more unique and polished than the everyday snapshots we see online.

DECIDE ON A CONCEPT Are you after a straightforward headshot for professional purposes, or a fun and flattering shot of yourself on a recent adventure? For the most successful self-portraits, it's important to just be yourself. Don't be beholden to whatever photographic trend might be in style this week—or tugged at by the temptation of an easy cliché.

LEARN YOUR OWN ANGLES Before you plop yourself in front of the camera, spend some time getting acquainted with your face in the mirror. Smile every way you know how. Run through expressions and tilt your head at varying angles to figure out what your face wears best. If you're handholding the camera (or smartphone), be mindful of how your arms look—they can provide framing for the body or look awkward and distorted.

STAGE AN IMPROMPTU STUDIO When it comes to standard headshots or pleasant but plain snapshots for social media, keep it basic. Find a good amount of diffused natural light (try near a window), a background that doesn't distract from your face, and clothing that looks sharp but isn't busy.

096 DOCUMENT THE SELFIE CRAZE

Tackle the selfie trend from a humorous angle—back on the other side of the lens. Keep your eyes peeled for people using their phones to take quick, funny self-portraits at major landmarks and events (or even minor ones). Then line up your shot so the telltale outstretched arm is visible in the frame. (Bonus points if you can get the monument they're mugging in front of in the shot). Angle from below to capture the duck faces and air kisses from a more grounded perspective.

095 TAKE SELF-PORTRAITS TO THE NEXT LEVEL

Of course, not every self-portrait should tell the story of your impeccable professional credentials or document the humble highlights of your day. Self-portraiture is also a place to explore and depict your inner life, make a political statement, or craft an amazing fantasy world with yourself at the center (see #117–119 for more ideas, too).

GET INSPIRED Self-portraits on a theme or that attempt to tell a story are often more complex than the straight-on headshot. Take some time to get inspired. Try visiting any number of photo-sharing sites for ideas. Some of them even throw weekly self-portrait contests or host forums specifically for the artful, fantastic, and bizarre.

CONCEPT WISELY Placing yourself among dilapidated Americana or triggering your camera from inside the fridge as you contemplate late-night snack options both communicate a different message. Before you shoot, think about the idea you want to convey—as well as what your role is in that message.

CONSIDER A SERIES Try using self-portraiture to weave an extended tale about yourself. It can be as simple as a daily portrait that highlights how you change physically over the course of years, or a more ambitious series that shows you cleverly camouflaged with your surroundings.

LEAVE YOURSELF OUT OF IT Some of the most evocative self-portraits barely contain us at all. Try shooting your own shadow as it lengthens across a field in the late-day light or your blurred reflection in a sidewalk puddle.

097 PLAN A WEDDING SHOOT

Responsibility can weigh heavy on the mind of the novice wedding photographer. To ease your way toward beautiful portraits, take a few preparation pointers from nuptial-photo pros. (For advice on gear, see #211.)

SET UP A SHOT LIST Even wedding warriors list out key moments they'll need to shoot: the procession, vows, first kiss, reception, and so on. So write down your own. Don't worry that it will make for boring shots—just approach each wedding milestone with your own twist. For example, photograph the first dance by crouching at the edge of the dance floor for a dynamic shot backlit by perimeter flood lights. Or take a funky group bridal-party shot from above with a fisheye lens (see #113).

CASE THE JOINT Scout the location in advance to nail down the best places to shoot. Walk around the garden, church, or temple to find the loveliest backdrops and the most eye-catching sight lines. And ask the couple which sorts of portraits they want, how the day's events will flow, and which VIPs absolutely, positively must be photographed.

BRING A WINGMAN Shooting the big picture and the intimate close-ups can be a two-person job. Snag an assistant and divvy up duties beforehand. Usually one person documents events at the altar while the other captures the overall view. At the reception, one handles crowd shots while the other focuses on individual portraits and candids.

TUNE OUT THE COMPETITION Wedding blogs and magazines are fruitful sources of inspiration, but they can tempt you to use other photographers' themes and tactics. Close the screen (or cover) and plan out your own thing.

DON'T BE A STRANGER On the big day, arrive early, learn people's names, ask questions, and listen to the answers. Gain your subjects' trust so they'll relax and you'll be able to capture unscripted moments amid the formality.

QUICK TIP

098 GO BEHIND THE SCENES AT NUPTIALS

Weddings are as much about the preparations as they are the "I do" moment. So to tell the full story, you'll need to follow the key players through the day. Try to capture the excitement in moments of preparation. You can approach this like a photojournalist by hanging back and handholding the camera, or use a more cinematic style to direct narratives. Try to chisel out a few moments alone with the bride and groom so you can catch those last introspective moments before two become one.

099 WRANGLE AT WEDDINGS

Skilled wedding photographers are part choreographer, part therapist, and part hunter. They help subjects figure out flattering poses; set subjects at ease; and keep their eyes peeled so they can pounce on tender, silly, and dramatic scenes. That's a lot of hats to wear on one head, but with practice you'll learn to balance them, too.

CHOREOGRAPH SCENES When it's time to herd people together for a group portrait, try stage-directing yourself instead of them: Shift around—or up or down—to find flattering angles on the bridal party or guests, or to screen out an unappealing background. You can still make staging suggestions, as telling subjects where to stand sometimes boosts their confidence and lets them relax. Asking people to sit down will also likely result in natural body postures and easier gestures.

CLOSE IN ON THE COUPLE At the heart of your shot list are portraits of the bride and groom. When it's time to take quiet photos of the happy pair, calm them down so they can loosen up and focus on each other. Steer them away from guest duties, and then shoo others away, too. (Or take their portraits early, before the show gets rolling.) If your couple looks like deer in the headlights, remind them to touch each other. A physically connected couple makes for an emotionally connected portrait (see #056).

HUNT DOWN MAGIC Among standard shot-list images you'll want to intersperse candids, which can feel more special than formal portraits. You'll bag good ones if you focus on expressive people—early on, seek out the most dynamic faces and keep finding them. And shoot continuously during key events, such as vows. You might kick up unexpectedly great candids.

100 POSE A BRIDAL PARTY

Shooting a wedding is a bit like playing traffic cop in a highway pileup. You somehow must compose bridal party portraits in a large crowd. Planning compositions and simplifying shots are essential techniques.

Look for and try to prepare natural groupings, such as the buffet queue, conga line on the dance floor, or pre-ceremony gathering in front of the mirror. But don't shy away from making the whole squad line up and lean in for one crisp, clear shot before they disappear into the fracas.

For clutter (think of the bridal dressing room), enlist guests to help clear it, or convert the image to B&W later (#220). Or try defocus (#121), a low camera angle, or backlighting (#126) to eliminate a jumbled background.

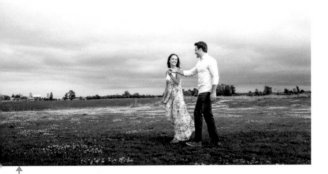

101 SHOOT ENGAGED LOVERS

Hands down, the best way to get to know a couple before their big day is at an engagement session. You get to learn about their aesthetic preferences, understand what they like (and don't like) in images of themselves, and—crucial—come to understand what's so special about them as a couple. Chat over location ideas (are they into sunsets on the beach, or did they meet in the mosh pit at a punk club?) and come up with two or three easy-to-execute story lines. Suggest they bring one casual outfit and one set of dressier duds for variety, too (see #034).

102 CELEBRATE AN ETHNIC WEDDING

Besides ushering in a change of pace from the usual union-making ceremonies, non-Western weddings often brim with incredible visuals: elaborate decor, colorful clothing, fascinating foods, and deeply moving rituals that provide a fresh view of love, tradition, and community.

DO YOUR HOMEWORK Talk with the couple in advance to understand their culture's specific customs so you'll be perfectly poised to capture, say, the groom hiding among the guests at a Nigerian wedding or guests showering the newlyweds with Jordan almonds at an Italian service. While they may seem quirky, many traditions are very meaningful for the couple and their families, so study up on their symbolism so you can do them justice.

BE A DIPLOMAT In many cultures, weddings are not just about the couple: They also signify the merging of two families in a lavish public display. Be sure to photograph family members greeting guests, and create visuals that celebrate the new bond between families.

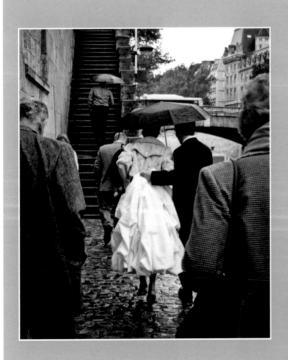

103 KEEP YOUR COOL AT CEREMONIES

Weddings are the ultimate family events—people come from far and wide, and all that love can get intense.

HERD SHUTTERBUGS Thanks to smartphones, expect to compete with other shooters. Give guests a clear window of time to take their own photos—say, after you've wrapped formal portraits—so they don't hover.

BLEND IN Sadly, you can end up intruding on moments between friends and family. Be invisible (it helps to dress as a guest) and turn on quiet shutter mode.

EMBRACE THE UNEXPECTED It may rain, or the groom's fly might be down. Realize that someday the bride and groom will laugh about these moments and treat them as the memories-in-the-making that they are.

104 POSE A POOCH PORTRAIT

Portraits of man's best friend are a joy to create for pro Gary Parker, who will photograph "any pup I hear about. I drove over 100 miles to meet the basset puppies seen here." Compelling pet photos work the same way that compelling human ones do, he says: They "nail the character, personality, athleticism, and pure beauty of the subject." Follow his key techniques when you turn your camera dog-ward.

WALK THE DOG The ideal dog-portrait setting—and the one that shows dogs at their bouncy best—is the natural world. Outdoor settings offer bright, natural light with ample areas of open shade, and they put generous swaths of uncluttered space between you and the dog, and between the dog and the background. They also let you use long, flattering portrait lenses (say, a fast-focusing 70–200mm f/2.8) and defocused backgrounds (see #187 for more gear for shooting pets). To keep the canine calm, avoid areas with people and other dogs.

GET DOWN TO DOG LEVEL Shooting a pet on its own sight level aids composition (the subject fills the frame), helps the dog relax, and lets you capture the dog's sweet, often hilarious expressions. Bring a tarp and gardening kneepads so you can flop on the ground and get just the right angle.

ENLIST HELP Take along an assistant or the pet's owner—he can aim reflectors, toss you fresh batteries, and hand you lenses while you run and jump alongside the dog, changing focus on a dime to record moments of maximum goofiness. Stick some treats in your helper's pocket—you can deploy them to attract the dog's gaze or reward it for holding a pose.

STAY SAFE In strange conditions, any dog can become aggressive. Watch for warning signs, such as hackles going up. To diffuse a tense moment, walk slowly toward the subject and place your camera on the ground. Then walk away and let the dog sniff the camera.

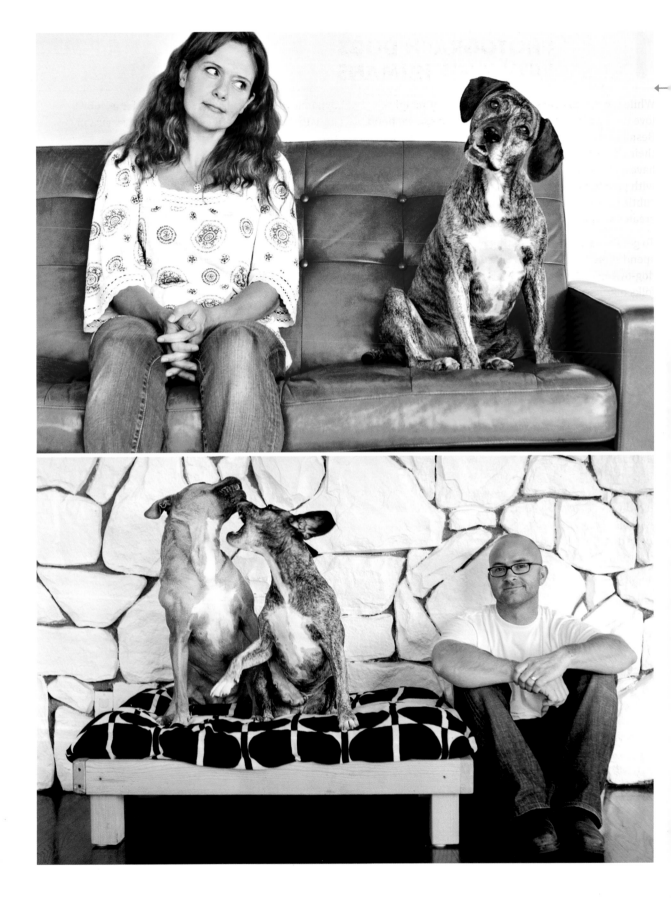

105 PHOTOGRAPH DOGS WITH THEIR HUMANS

While it probably goes without saying that people love their pets, dogs and humans share a special bond. Besides often resembling their owners, dogs get a lot of their character from who they hang out with. Plus, dogs have a particularly fascinating way of communicating with people through body language. Capturing this subtle communication in double-portrait form often creates an interesting visual juxtaposition.

To get the most out of shooting pups and their people, spend some time IDing subjects. Start by practicing with dog-owning friends. From there, try just approaching folks out walking their dogs. Look for a strong visual dynamic on both ends of the leash. As far as how to initiate that conversation, dogs themselves usually serve as pretty good icebreakers.

When you're deciding where to shoot, consider taking photos where dog and owner are most comfortable—usually, at home. Not only do homes make for a warm and inviting temporary studio space, but they can also present a variety of lighting opportunities. Of course, some dogs are better trained than others—and the dog may ultimately decide where, exactly, the shoot takes place. Just do your best to be fluid, then stand back and watch the dog and dog companion do their thing.

106 SNAP BEAUTY WITH THE BEASTS

From birds to baboons and from lions to lampreys, the natural world is a seemingly endless font of beauty. In places like sanctuaries for endangered animals, some lucky photographers get the opportunity to observe and document rare interactions between human caretakers and their otherwise wild animal charges. A lot of times, animals in captivity will exhibit an innate curiosity toward visitors, while other times fear or a certain playfulness will surface.

When it comes to capturing the wild on camera, whatever you do, respect the animals. It's one thing to take photos from behind a wall or fence; roaming among sometimes dangerous animals is an entirely different—and somewhat unpredictable—story. Even so, intimate encounters between endangered animals and the people working to protect them can be truly incredible.

If you get the opportunity to shoot somewhere humans and wild animals interact, stay alert. Besides keeping yourself safe, you never really know when an ideal portrait will present itself. In this shot, Robin Moore had been invited to visit Giraffe Manor, a Kenyan giraffe sanctuary built in 1932. One morning, a giraffe approached as a sanctuary manager opened the front door. The alert Moore hopped up and quickly moved behind her, just in time to catch this charming interspecies morning greeting.

LIGHTING
& GEAR

107 FINESSE EXPOSURE FOR PORTRAITS

A good exposure is essential for a good photograph. You arrive at one by reading the light in a scene and adjusting your aperture, shutter speed, and ISO according to the exposure triangle—a visual that helps you tweak these settings in relationship to each other to arrive at a perfect exposure.

Too little light, and your subject will be underexposed—somber with few visible details. Too much light, however, and the scene's highlights will blow out. While your camera's built-in light meter often does a fine job of measuring light and automating a suitable exposure, it can be baffled by tricky lighting situations. Here are some coping strategies.

TRY SPOT-METERING While evaluative mode is the common go-to for many scenes, portraits can present a challenge: The face is the most important part of the image, but it often isn't large enough to affect an evaluative-meter reading. Turn on spot-metering instead to measure the light on the subject's face.

USE EXPOSURE COMPENSATION Once you've taken a shot, check your histogram—never trust your LCD screen, as it isn't meant to deliver an accurate exposure reading. If you see a spike on the left or right side of the graph, consider adjusting exposure compensation by 1 or 2 stops to balance out the light—without having to change your ISO, shutter speed, or aperture. It's most important to fix any high spikes on the right-hand side; while it's okay to have part of an image appear black, a completely white area of an image contains no data, and you won't be able to fix it in postprocessing.

LOCK IN EXPOSURE This quick, tried-and-true method works best when your subject is relatively still inside the frame. Check your camera's manual to find out how to turn on exposure lock, and then point your camera at the area of the scene you would like to expose for, lock it in, and recompose for the final image.

SHOOT IN RAW We really can't say it enough. Using your camera in RAW mode will capture the most detail possible, which will allow you to more readily adjust exposure after the fact. If the shot is too dark or washed out, convert it with Adobe Camera Raw and then adjust the Shadow/Hightlight and Midtone Contrast sliders in Adobe Photoshop to arrive at a look you like.

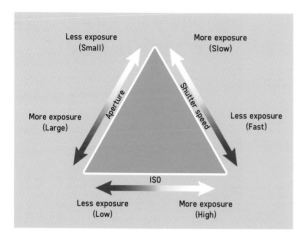

Less exposure (Small)

More exposure (Slow)

Aperture

Shutter speed

More exposure (Large)

Less exposure (Fast)

ISO

Less exposure (Low)

More exposure (High)

108 BRACKET FOR IDEAL EXPOSURE

Unsure whether your exposure settings will be up to snuff? Flick on your camera's autoexposure bracketing mode—it will fire off several shots at different exposures, using your camera's initial reading of the scene for the first blast and then shooting in preset increments (between 1/3 to 2 stops) on either side of that first exposure. It ensures you'll get a usable image when you don't have time to check your histogram.

109 EXPERIMENT WITH DEPTH OF FIELD

A portrait is about a person. Unless the setting offers clues about your subject or makes for an arresting composition, the background should be neutral—or, at the very least, not distracting. Photographers often manipulate aperture to edit a background so the subject really stands out.

Measured in f-stops, adjustments to aperture size change an image's depth of field, the amount of distance that appears acceptably sharp, without seeming blurry or fuzzy (see #005). Here are some examples of what manipulating your aperture size can do for a single scene.

SHALLOW DEPTH OF FIELD Here, a relatively big aperture of f/2.8 creates an extremely shallow depth of field, smearing the background almost completely. This treatment certainly makes the subject pop. However, some objects in the background are blurred into a large highlight, which can distract in its own way.

MIDDLE GROUND Using an aperture on the larger size (f/8) pleasantly blurs the background so that the subject is dominant but you can still tell he's in an urban setting. At this f-stop, other figures in the frame don't even divert attention from the main person of interest.

EVEN DEPTH OF FIELD The small aperture of f/32 used here creates a consistent focus throughout the image, giving subject and background equal standing. Some viewers might be distracted by all the detail—which is so crisp you can read the street signs.

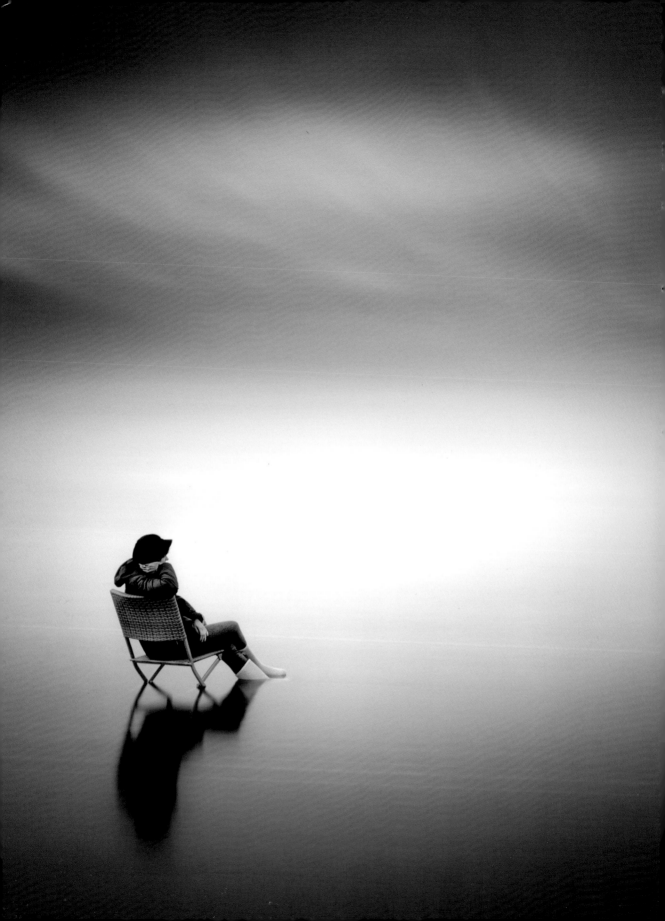

110 BLUR A BACKGROUND INTO A DREAM SCENE

To transform an ordinary portrait into a magical dreamscape, move your subject away from the camera—far, far away, until he or she is a detail in the landscape. Then lengthen your exposure time to a full minute. All the mundane detail of a natural setting (blowing leaves, splashing water) will blur out into an evocative fog that frames your subject in mystery.

STEP 1 Find an outdoor setting without the visual jumble of trees, buildings, or beachgoers. The more empty the scene, the better.

STEP 2 Wait for the right conditions, preferably morning or late afternoon on an overcast day. The soft light will suffuse the landscape and soften the horizon.

STEP 3 Bring along a DSLR with a bulb setting and a lens whose focal length will allow you to isolate your subject in a small area of the frame at your camera position. Pack a tripod to stabilize the camera during long exposures, and neutral-density filters to cut the light hitting the camera sensor. A remote shutter release will allow you to fire the camera without disturbing it.

STEP 4 After mounting your gear and composing the shot, ask the model to turn her face away from you (so her features won't blur) and hold absolutely still for the entire duration of the exposure—which ended up being 79 sec at f/11, ISO 100. Check beforehand that her pose is natural and easy to hold.

STEP 5 Fire the camera using a remote trigger and repeat the shot several times. Back home, use the Gaussian blur tool in your photo software to remove extraneous details, melt straight lines, and heighten the dreamy isolation of your subject.

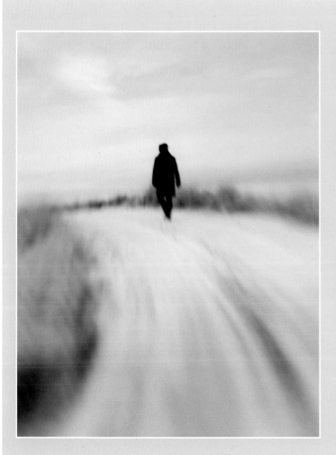

111 SHOOT FROM AFAR

An expressive portrait needn't actually show much of your actual subject—instead, you can use a natural setting and a bit of stage direction to tell a compelling story about that subject.

Many natural features—roads, steep hills, shorelines—provide visual suggestions of narrative and chronology. Consider the story you (and your subject) wish to tell: the timeline of his life? A moment of personal transformation? Should the mood be one of optimism (sunny fields) or ambiguity (cloudy skies)?

Once you've scouted a great setting, ask your subject to wear simple, dark clothes that will silhouette him and focus viewers' attentions on the landscape. To de-emphasize his form further, ask the subject to walk away from you so the camera can't record his face. Shoot as he recedes into the distance, and later pick out the most dramatic shot from the sequence.

112 FLATTER WITH DIFFERENT FOCAL LENGTHS

You can take great portraits with just about any lens—from a fisheye to an extreme telephoto—but each one creates a slightly different type of portrait. Most photographers use a fairly modest range of lenses for portraiture: 28–105mm on a full-frame camera body, 18–70mm on an APS, 14–50mm on Four Thirds (see #011 for more on picking a lens for your camera's sensor). Some people like to use fast lenses wide open—f/1.4 or wider—for a shallow depth of field. Here are a few favorite focal lengths and their effects.

WIDE STANDARD Great for environmental and street portraits, lenses with focal lengths between 28 and 35mm allow you to get a lot of context around your subject. With the camera turned to the vertical position, this length usually lets you get the whole body in the shot without having to stand too far back. The rough equivalent for an APS is 18–25mm; for a Four Thirds, 14–18mm.

STANDARD TO SHORT TELEPHOTO Lenses with focal lengths between 45 and 60mm (28–40mm on APS, 21–30mm on Four Thirds) are nice for capturing three-quarter figures. In particular, the so-called "nifty fifty"—a 50mm, f/1.8 prime lens—creates a shallow depth of field that yields crisp, distinct subjects and creamy backgrounds.

LONG Hands down, the classic portrait lens is 85mm. It gives a very flattering perspective on the face and, especially when coupled with a large aperture, lets you blur out the background to avoid distraction. The longer lens also lets you be a bit farther from your subject, which may make her more comfortable. Try a lens in a range of 75–135mm (50–90 on APS or 35–70mm on Four Thirds).

VERY LONG Any lens with a focal length between 180 and 300mm (120mm+ on APS and 90mm+ on Four Thirds) is considered very long—to the point of being nearly impossible to use indoors. Fashion and action photographers use them, however, because they do a wonderful job of compressing the background so the subject pops. They're also useful for the "Peeping Tom" or paparazzi look.

This lens creates incredibly wide convex images, offering a ridiculous 180-degree angle of view, along with barrel distortion for intriguingly bowed lines at the edges of the frame. While the fisheye lens started out as a meteorology tool for studying the "whole sky," its funky contortions have made it a hit with landscape and architecture photographers. As you can see, it's also found a cult following among extreme-sports portraitists.

KNOW THE DISTORTION ZONE Fisheye lenses cause extreme distortion for any object that's not located dead center in the frame, which can be a disaster for pictures of people. But it also plays up figures in the foreground, distancing them from the background and making them pop.

CENTER THE HORIZON Views through this lens can get hectic. Make sure your horizon is as close to that distortion-free zone as possible, and endeavor to keep a clean, defined line to avoid a confusing scene. That is, of course, unless you're after an exaggerated, rounded horizon line.

MIND YOUR FEET All kinds of fringe elements can sneak into the fisheye lens's superwide field of view—like your feet, shadow, or tripod. Using a monopod can help you keep them outside of the shot, but so will a careful scan of your viewfinder's perimeter before hitting the shutter.

GET REAL CLOSE This lens's biggest advantage? It can add humor, especially if you get right in someone's grill. Bring a fisheye to a party and you'll fit the whole room into one shot.

TRY RADIAL BLUR Want to make a room spin? Try setting a 1/25-sec shutter speed and rotating your camera 90 degrees as you shoot. You'll end up with a wide-angle view of a twisting, roiling scene.

TAKE YOUR PICK There are two flavors of fisheye. The first is a diagonal effect caused by the image's diameter covering your entire sensor (shown here). The second is circular, and it yields a round image bordered by black. Of course, all lenses make a round image, but in the case of the circular fisheye, the image's circle doesn't cover the entire sensor, creating the dark space along the edges.

114 BLUR PLANES WITH A TILT-SHIFT LENS

Meet the optical superheroes: Tilt-shift lenses can straighten tall buildings with a single shift, give you insanely deep focus without insanely small apertures, and limit focus to a single eyelash. They're popular with architectural, product, and nature shooters who strive for perfect perspective, and treasured by others for the unusual effects they can produce.

And when it comes to portraits, those effects are dreamy. The lens barrel is stationed on a pivoting mount that permits you to rotate and tilt the glass—forward or backward, or to the right or left—so it's not parallel to your camera's sensor, creating a band of sharp focus with beautiful, otherworldly blur on either side.

The width of the band depends on the range of the tilt: Big tilts create narrow streaks of focus across the frame, while a small tilt will widen the area of focus. Conversely, if you tilt or swivel the lens the opposite way—to align the focus plane with subjects at different distances from the lens—you can achieve striking near-

far focus without stopping the lens way down. You can also create magical *bokeh* (see #120) in a wide shot—shoot into a background with a lot of texture so you can see the effects of the focus plane being manipulated.

One caveat? There's no autofocus with tilt-shift lenses. It may help to avoid shooting wide open, which will make your band of focus quite narrow. Eyeball focus by getting it close and halfway depressing your shutter, then recompose your shot and trigger it all the way.

115 GO LONG WITH A PANORAMA

A prized technique among landscape-shooters who want to capture a near-360 view of an exquisite location, the panorama—a very wide-view image composed of many individual photos—has recently been making an appearance in portraits, too.

MANAGE EXPOSURE Shoot in manual mode, or your camera will automatically readjust exposure for each shot. Subtle changes in light can make corresponding areas of overlapping photos look quite different. Determine the exposure that works for your full range of shots. Again, your goal is even exposure across your series. The same goes for white balance.

USE ONE FOCAL LENGTH Each shot in your series should have the same point of view. Setting your lens to a long focal length minimizes distortion. Keep nearby foreground objects out of frame, as they're usually the ones that warp most and cause problems when you're combining shots.

AX THE FLASH Varying light levels is another cause of inconsistency among photographs.

TRY A TRIPOD While not strictly necessary, tripods do help the camera remain on the same plane throughout the series. In a 360-degree panorama, a tripod ensures that your first and last shots line up at top and bottom.

OVERLAP SHOTS Shoot each photo so that it overlaps from one-quarter to one-half of the area of the prior photo. The wider your lens, the more area you'll need to overlap to avoid distortion in the combined series. Later, in postprocessing, you can stitch the panorama together yourself by dragging and aligning all the images in a single canvas sized to the approximate pixel dimensions of the final version: roughly the dimension of a single frame times the number of component frames you're including in your stitched-together composition. Then use layer masks to blend the overlapping areas into a seamless whole. If you'd rather not do it on your own, let your software take over. For instance, Photoshop's Photomerge tool does an excellent job.

FRAME YOUR SUBJECT You've got a beautiful setting—now find a special way to include your human subject.

116 PICK A PRIME OR A ZOOM

In the grand scheme of lenses, there are really only two kinds: zoom and prime. A zoom boasts a whole bunch of focal lengths, all in one lens: You adjust the zoom ring to make the optic system inside shift position, changing the focal length without swapping in a new lens. A prime, on the hand, does not zoom; it has a fixed focal length, but is available in every conceivable focal length. While zoom lenses are incredibly convenient (allowing you to pack just one piece of glass and go), prime lenses can be lighter and cheaper, and their less complex optic systems may provide better image quality, especially in distortion control.

When it comes to portraits, primes have another plus: Their maximum aperture will be bigger than that of a zoom lens with the same focal length. The result is lovely shallow depth of field that makes subjects pop. This also makes them faster than zooms, allowing you to shoot in lower light without a boost from a flash.

117 WARP A SELFIE WITH A WIDE-ANGLE LENS

Anyone can take an attractive self-portrait. It's the rare photographer who's comfortable making himself look absurd that crafts the truly special view. Here are some tips for embracing your zany side.

STEP 1 Slap a wide-angle lens on your DSLR—the wider, the better. They can make your face look really big, which viewers also tend to find appealing in a funny/ugly way. Plus, they're easier to focus than the standard 85mm portrait lens.

STEP 2 Further the distortion with a line of clear glass bottles on a table. Hang a plain, pale backdrop behind the table and tilt a light source upward to create a slight gradient on the backdrop to act as a slight backdrop for your head.

STEP 3 Put your camera on a tripod in front of the bottles, then use evaluative metering to snap a test shot to get proper exposure.

STEP 4 Stand behind the table, remote trigger in hand. Ensure your head is in front of the backdrop's brighter area. Raise your eyes above the bottles (to contrast somewhat normal eyeballs with an exaggerated

118 GEAR UP FOR SELF-PORTRAITS

Most cameras have self-timers and often have a signal beep that counts down to when the shutter will snap—useful when you're trying to get in position in front of the lens before the shutter goes off. However, you need to reset the timer after each shot. A better option is a remote trigger: It lets you maintain your position and capture multiple poses without having to return to the camera (other than to check focus and exposure).

lower face). Now make the silliest expression that you can muster and deploy the remote.

STEP 5 Is your final image still insufficiently weird? Plug it into postprocessing software and have at it with the Distort tools, especially the Pinch tool to warp the eyes, until it's ready to scare children—or make them laugh.

⌐ QUICK TIP ⌐

119 SET UP A MIRROR FOR SELF-PORTRAITS

When you're triggering wirelessly from in front of the lens, it can be tricky to know what you look like. An articulated LCD screen can show you what your lens sees, but you'll need to be positioned close to the camera in order to make out the image. An alternative? Place a mirror behind your camera so you can see yourself as you shoot.

120 BLUR WITH BOKEH

Most photographers obsess about sharpness, but there's an equally passionate subset concerned about unsharpness. Its holy grail? *Bokeh*. This Japanese word translates roughly as "the quality of blur or haze," and it refers to defocused areas in front of or behind a sharp subject, usually formed from defocused points of light.

All you need to create bokeh is a tripod, a shallow depth of field, and a lens with an aperture that has many blades (more expensive lenses typically have more blades). The clean, wide aperture turns highlights into soft polka dots and lines into streaks. That kind of "melted" background acts as a foil for a sharply focused subject, adding interest to a picture without competing for attention.

Other tips? Rein in the distance between your camera and your subject—it will force the lens to focus closer and therefore create a shallower depth of field. It also helps to establish a fair amount of distance between the subject and the background to exaggerate the blur and really make the subject stand out. Shooting with a zoom lens? Extending it to maximum focal length will isolate the subject even more.

121 GO FOR TOTAL DEFOCUS

For a dreamlike photograph that hints at your subject but doesn't render it literally, try defocusing your lens. Just set your camera for manual focus, start with a sharp image in your viewfinder or LCD screen, and then slowly turn the focusing ring until everything's a lovely smear. When to stop? When the picture looks best to you—try it a few different ways until you like what you see.

For extra fuzz, try handholding the camera for a long exposure with image stabilization (see #137) turned off.

122 DEVELOP A FLAIR FOR FLARE

Photographers often go to great lengths to minimize flare, a burst of detail-erasing light that can spill into the lens. We buy specially coated glass, mount lens shades, and invest in all kinds of studio modifiers and flags that prevent unwelcome light from pouring back into our cameras and wiping out all the potential sharpness and contrast in an image.

Unless, of course, we do the exact opposite to maximize flare, as was done in this shot. In fact, flare has come back onto the scene for those who want to capture the look of circa-1970s snapshots. It's also great for making an all-too-earthbound environment (like the white room here) seem otherworldly. Flare can be hard to predict, but one way to use it in portraits is to have your model stand in front of the sun and then shoot into the light when it's partly obscured. Here, the French doors do just the trick (A), but your subject can also block the rays with her body.

Such brilliant backlighting (see #126), however, can produce a little too much flare, washing out detail-defining contrast and essentially erasing the model's beauty. Bringing back detail calls for a bit of front fill—in this case, a strobe (B) aimed at the long, white wall opposite the model (C). You could create the same effect, however, by placing a large reflector in front of the model and bouncing the light streaming through the windows back onto her face.

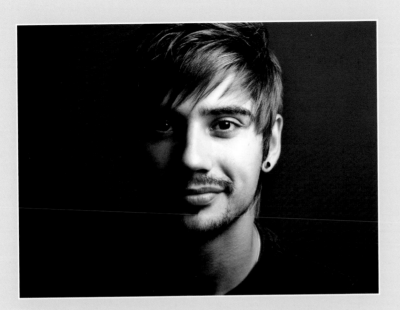

123 CREATE CATCHLIGHTS IN THE EYES

Catchlight are those wonderful, luminous white reflections in your subject's eyes that give them depth and dimension, life and spark. No portrait really does its subject justice without catchlights.

Catchlights are dependent on the size and shape of your light source, and your subject's distance and angle from it. For instance, a ring light will create a gorgeous circle of light, while a rectangular softbox will result in a more angular shape. The larger the light, the larger the catchlight. Try angling the main light to create catchlights at ten or two o'clock in the eye, and if you're using multiple lights, watch out for two catchlights, which can be overkill. (To learn how to predict catchlight location with a marble, flip to #143.)

124 LET THE EYES SAY IT ALL

Sometimes the best way to encapsulate your subjects is to show only a little bit of them—and what better feature to highlight than the eyes?

GET CLOSE There's no need to physically get right up in your subject's face. A zoom lens (70–300mm) will help you create an immensely intimate view, as in this stunning shot of vivid blue peepers.

CREATE MYSTERY This image gets further intrigue from the matching blue scarf swathed around the model's head, which conceals the face and brings out the blue of her extraordinary eyes. You can create a similar effect with a hat, a bandanna, or other props.

PINPOINT FOCUS It can't be stressed enough: The eyes have got to be in perfect focus. Use your camera's

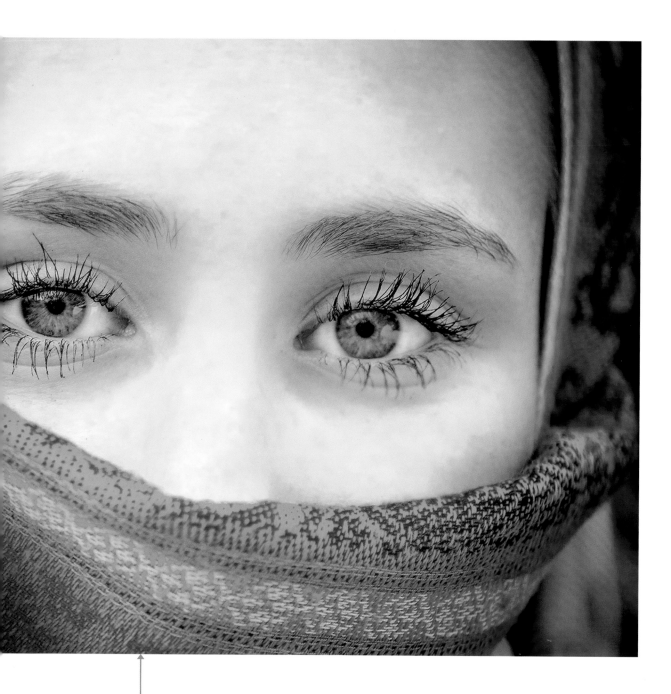

single-point autofocus mode to home in on the eyes. Halfway depress your shutter to lock it, then recompose and push the shutter button down all the way.

AVOID RED EYE Most modern cameras have a built-in red-eye function, which minimizes the crazed red flare that can take over subject's eyes when flash is in use. It's still best to skip the flash completely, but if use it you

must, keep it off-camera and far from the lens, and ask your model to look to the left or the right of the lens.

PRESERVE PUPILS If you're after an eye-pleasing portrait, avoid bright, pupil-contracting lights. Instead, try sidelighting or placing your lights above or below your subject, which will provide flattering light and keep pupils attractively dilated.

125 HARNESS SUNLIGHT WITH FOUND MODIFIERS

As anyone who's ever tried making photographs at high noon on a sunny day will tell you, not all natural light makes for lovely portraits. With overhead light in particular, shadows tend to fall harshly on the face, and people can't help but squint in the glare. While working in the golden, slanted rays of early morning or late afternoon is the best tactic, other variables often predict your shoot's timing—in those cases, you can pray for a cloud to arrive overhead and diffuse the brightness or find a patch of even shade.

But there's another option. You can soften light from the sun just as you would in the studio—only using found lighting modifiers instead of official photo gear. For example, a sheer curtain draped over a bright window can act as a scrim to create a soft, romantic light or illuminate a subject with a near-lightbox effect, as in this portrait of a little boy. Even something as simple as a white wall can modify light, bouncing it back into the subject's face when backlit. Meanwhile, shooting through tree leaves or a windowscreen can create an intriguing interplay of light and shadow. If you love the look of natural light but find that it falls too even across your subject's face, position the person near a dark fence or wall to get back some shadow and detail. The somber tones will eat into the illumination, carving and defining the facial features closest to it.

Look around when you're shooting in natural light. What materials and structures could come to your aid?

126 BACKLIGHT FOR A GOLD GLOW

Photographers are notorious for their love of the golden hour: the hour or so before sunset and after sunrise. The allure? The light comes in at a low angle, casting more flattering shadows and hitting subjects with a rich, glowing hue. It's perfect for backlighting subjects, creating a rim of light around their heads—here's how.

SPOT-METER THE FACE The most important part of your portrait is your subject, so make sure to meter for her skin tones. Otherwise, the camera will meter for the huge expanse of well-lit sky, underexposing your person of interest. To compensate for all the brightness, aim to slightly overexpose; just check your histogram to make sure you haven't blown any facial highlights.

SHADE YOUR CAMERA There's a real risk of lens flare with this lighting style. If that's not what you're after, try to stand in the shade, shoot with the sun at an angle to your camera (as shown here), or find some foliage to filter the light through. A lenshood will also cut the glare and haze—just watch out for vignetting (dark edges around an image's frame).

SEEK OPEN SKY To keep light on your subject's face, position yourself so there's open sky behind you. Otherwise, you may need a reflector or bounce card to reinstate illumination and capture details in her face.

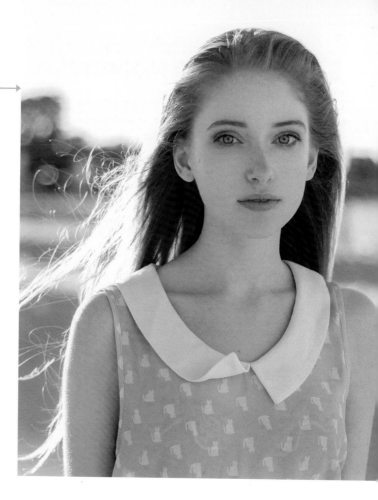

127 TRACK THE SUN WITH AN APP

If you want to harness light from the sun, you'd better figure out where and when that big bright orb will be best positioned in the sky. Try downloading a sun-tracking app, which will clue you in to details about sunset, sunrise, and the sun's path across the sky. Some apps even show you how the light will appear in your given location throughout any given day, making shoot-planning a breeze.

128 GO WITH THE SUNNY 16 RULE

Here's a classic, tried-and-true method of getting a beautiful exposure in bright sun. For starters, switch to manual. Then, with an aperture of f/16, set your shutter speed so it's the inverse of your ISO speed—let's say your ISO is 200, so you'd need a shutter speed of 1/200. Essentially, you're increasing your shutter speed as you increase your sensor's light sensitivity. More light sensitivity means that less light should come in through your shutter in order to render a balanced scene, hence the faster exposure time.

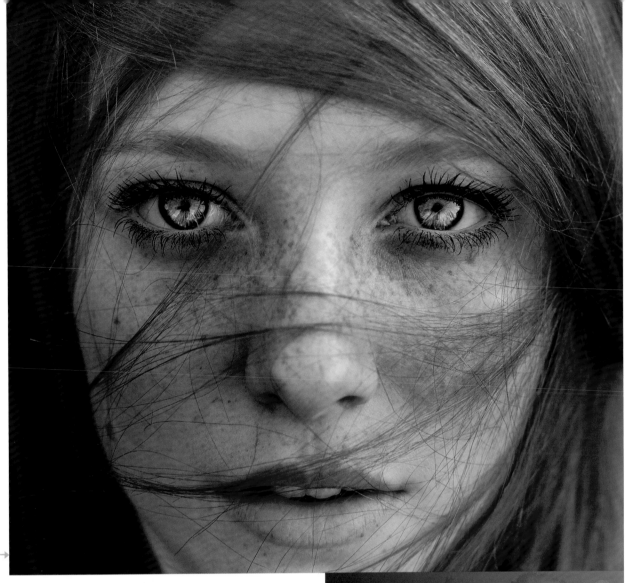

129 BOOST EYES WITH A REFLECTOR

Many photographers' go-to lighting for alluring outdoor portraits is the ambient light of an overcast day, early or late when the low-lying sun throws an overall warm cast. For this shot, the light's yellow-orange hue brings out the warm tones of the model's hair and freckles and—because it was diffuse—the lighting didn't throw shadows across her face. In some ways, it's perfect portrait light.

But it has a downside. Flat portrait lighting tends to de-emphasize a person's eyes. To solve this problem, turn to a circular silver lamé reflector. Relying on the light of late afternoon, diffused through cloud cover (A), have a friend (B) aim the collapsible reflector (C) toward your model's face to create the specular, sparkling quality to the light that helps accent the blue in what otherwise read as gray eyes.

130 DEAL WITH DAPPLED LIGHT

While graphically interesting, trees can break sunlight into dappled hot spots and shadows, creating too-bright blotches on subjects while rendering other areas a featureless black. The solution? Throw your subject completely into shade to eliminate the contrasty pools of light. A 36-by-42-inch (90-by-105-cm) panel of black foamcore board (A) on a light stand (B) near the subject will do the trick, but it will also make him appear several stops darker than the background.

To match the subject's exposure to the background, light him with a strobe (C) diffused by a 24-by-36-inch (60-by-90-cm) softbox (D). It may make the subject blend in a little too nicely with the newly brightened background, so experiment with bumping the strobe output until the exposure dims the background to make the model the picture's unchallenged subject.

The finishing touch? Defocus the background and make your subject pop by shooting with a large aperture—here, the photographer tried setting his 50mm f/1.4 to f/1.6, which grossly overexposed the background, even at ISO 160. The solution was stacked neutral-density filters (E), which cut down the light hitting the sensor by 4 stops, letting the photographer shoot at f/1.6 with perfect exposure and a nicely defocused background.

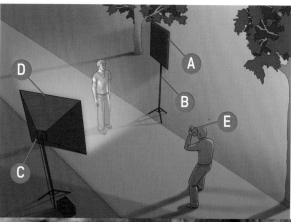

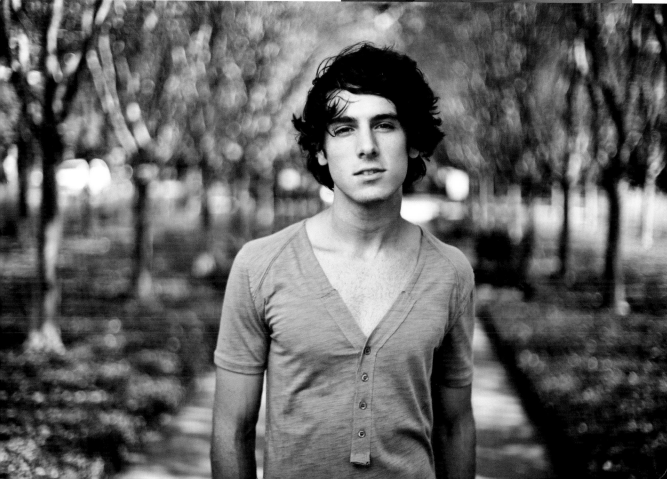

131 WHITE OUT WITH AVEDON LIGHTING

For a no-frills style that really puts your subject front and center, try the lighting technique popularized by fashion photographer Richard Avedon. If you Google "Avedon lighting," the Internet will cough up a dozen different combinations of front, back, and fill lights, often with baffles and reflectors. While lighting setups vary (Avedon himself deployed his light differently), the result stays the same: a bright-white background, even illumination across the subject, open shadows, snappy contrast, and no flare around the figure's edges. You can create this look with a roll of white seamless paper (see #049) and natural light, as the photographer did here.

If you'd like to try your hand at a naturally lit Avedon shoot (benefits: less gear to lug and more time to take photos), pick a bright morning and tape white seamless to a west-facing exterior wall. To prevent flare around the subject, coax him out from the background, but not so far that he steps into direct sunlight. Here, an exposure of 1/160 sec at f/5.8 and ISO 500 captured the blanched-out effect. To prevent skin tones from blowing out, try closing down a ½ stop over the spot-meter reading recommended by your camera. A word of advice: When the main light is too high, it results in a bright head and face, and lighting that quickly falls off for the rest of the figure. A strategically placed reflector is a great fix.

132 KNOW YOUR LIGHTING RATIOS

A lighting ratio describes the quantity and quality of light in a shot. It uses increments known as stops to indicate the amount of light in highlights compared with the amount in shadows. In a portrait, the ratio's first number describes the key or main light that falls on the illuminated side of the subject's face (the highlight side), while the second number describes the shadows or fill light on the other side (the shadow side). The farther apart these two numbers are, the higher the contrast. Knowing the ratios—and compensating accordingly—lets you heighten or mute detail, depending on your artistic objectives.

You can arrive at a lighting ratio by setting your camera's built-in meter to spot-meter and then measuring the light on both sides of the face, but it's often easier to use a handheld incident light meter. Both will return a light reading in f-stops: f/1, f/1.4, f/2, f/2.8, f/4, f/5.6, f/8, f/11, and so on. Crucial info: Each full stop is double (or ½, depending which direction you go on the scale) the amount of light over the previous one. So when you're adjusting your ratio (either with a reflector or by adding fill flash), you'll need to do the math to determine how much darker to make the shadow side.

A 1:1 ratio is flat: Both sides of the face return the same light-meter reading. Achieve this ratio by putting a reflector close to the subject so that no shadows appear on the face. It's great for babies and small children, as even light means it doesn't matter which direction they face.

In a 2:1 ratio (often used in images of women), one side of the face is twice as bright as the other. Meter the highlight side—let's say it's f/8. Adjust the reflector on the shadow side for an f/5.6 reading, which is one stop down (or half) the amount of light on the highlight side.

For an 8:1 ratio using the same reading of the highlight side (f/8), quadruple the difference between the two sides' readings: f/2. The result? A much darker shadow side—good for dramatizing subjects (especially men) or creating a slightly harsh feel.

133 MIMIC DUTCH MASTERS WITH WINDOW LIGHT

Surefire lighting can be all yours with the leanest of budgets. Window light, after all, is free, and during daylight hours is almost always available. Portraitists—both of the photographic and painterly variety—have long loved the light produced by a north-facing window because it serves as a large, flattering light source even on days of harsh sunlight. You can't pick it up and move it around, of course, but otherwise it's as effective and flattering as a pricey softbox.

One of the best ways to experiment with this lighting technique is to turn it on yourself in a dramatic self-portrait, like the one you see here. Start by seeking out a good window (A)—while north-facing is best, almost any window will do if you schedule the shoot for an overcast day. The best windows for the job are usually outfitted with a black-out shade (B) that you can lower to control the light. If you're after a somber sensibility, position yourself between the window and a dark drape (C). (Conversely, you can brighten the shadows by placing a white reflector opposite the window, which will bounce light back onto the darker side of your face.) The rest of the setup is familiar to any teenager with a smartphone—just extend your camera (D) and shoot.

To adjust the contrast, move closer to or farther from the window. The closer you are, the starker the difference between highlight and shadow, especially if the background is black as it is here. To reduce the lighting ratio (see #132), move away from the window and adjust exposure accordingly. Here, evaluative mode did the trick, delivering up an exposure of 1/40 sec and f/4 at ISO 80.

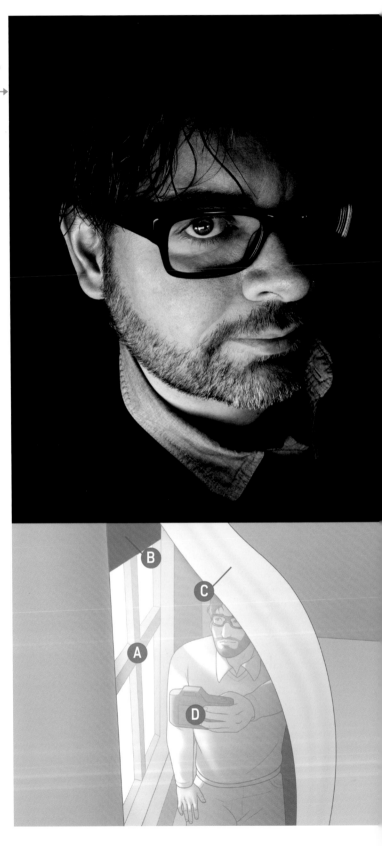

134 CAPTURE NIGHTLIFE WITH MIXED LIGHT

Let's say you've got a subject enjoying a pool game under different-colored neon lights, or a couple enjoying a candlelit dinner by a wall of moody blue sconces. Both sound like cool shots—until you try setting exposure and white balance for scenes with different light sources.

DO A QUICK RECON Snap a quick test photo to pinpoint the different light sources and see how they render. Is the dominant lighting incandescent, fluorescent, or a wall of windows? Are there accent lights, like table lamps? What are the various lights' color temperatures and directions?

ELIMINATE WORST OFFENDERS If you can, close the blinds or flick a switch to minimize dueling lights. Or move your subject so he or she is lit with one light source, relegating the other lights to the background, if possible.

GO CUSTOM Since you're surrounded by various color temperatures, you need to define a clear white to render your subject (and the environment) faithfully. Use a color-checker or a gray card to set a custom white balance for your scene, noting you will need to reset it if you make any adjustments to the lighting.

FLATTER WITH FLASH Even if you've decided on one light source, its angle and quality may not do your model justice. Accessory flash to the rescue. Add a gel in the color that matches the dominant light source, then use it to direct better light onto the subject.

OVERPOWER LIGHT Another tactic is to blast your flash to mask the weaker light. Set a white balance for the preferred light and gel your flash in the same hue. Place it near the light you're matching, and manually control the flash's power to outdo the offending light.

SHORT LIGHTING Fantastic for making faces appear long and slender, this lighting style puts the side of the face that's turned toward the camera in more shadow. It's also known for its moody, low-key vibe (see #153). To achieve it, position your subject so that the light hits the cheek farthest from the camera.

BROAD LIGHTING The exact opposite of short lighting, the broad style orients the subject so his or her far cheek is in shadow and the one closest to the camera is in full illumination. This creates a large—"broad"—area of light that may pleasantly widen faces that are on the narrow side. It's a go-to technique for high-key portraits (check out #154 for an example).

135 GO WITH BROAD OR SHORT LIGHTING

Generally speaking, it's not considered a good move to fire a flash or studio strobe head-on at your subjects. Besides hitting them in the eyes with a lot of light that's sure to make them squint, direct illumination tends to flatten out features and blast out skin tones. You need to angle that light to sculpt your subject's face with light and shadow. Enter short and broad lighting—two ways to turn your models toward the light (either studio or natural) that will create compelling dimensionality. Either style will work with any traditional lighting setup, such as loop (see #150), Paramount (#163), or Rembrandt (#161).

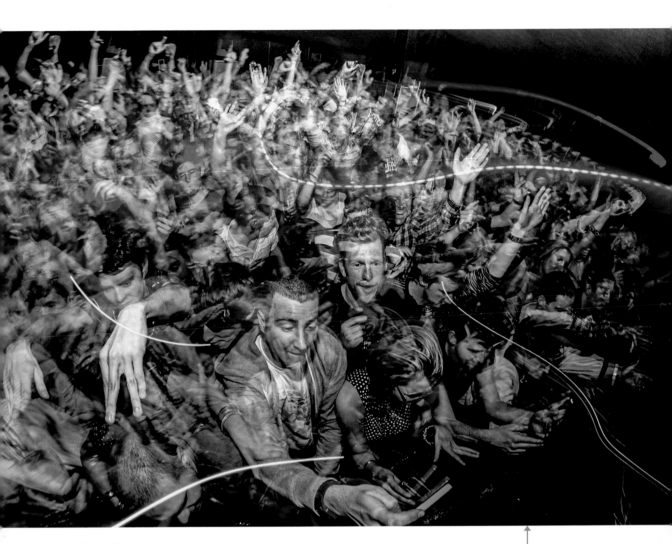

136 SHOOT IN RAVE LIGHT

Stroboscopic flash lighting has lots of great uses—not the least of which is stoking your creative juices. It's most often used to capture movement, as in the classic multipop renderings of golf swings or pirouetting dancers (check out #194 to see what we mean).

But when photographing pulsing, gyrating crowds of electronic music fans (especially those wielding colorful glow sticks), stroboscopic lighting can perform another useful function: making clubs look hot. Because each pop of light produces a separate exposure, individual dancers can appear two or three times in a single image, if only as a blur of waving arms and bobbing heads. These multiple images can fill any empty space, exaggerating both the size and energy of a crowd—which, of course, venue owners love.

You can produce this effect with an on-camera flash—or try befriending the lighting technician and ask for a signal before the venue's stroboscopic lights start to fire, as the crafty photographer did here. Since his main illumination was the club's ceiling-mounted strobe lights, he benefited from a larger and more even light source than an on-camera flash would have produced.

An accessory flash mounted in his hotshoe did come to his aid, however. Fired at 1/4 power, it added front fill light to the rapt faces of the crowd. Opening the shutter at least three times per strobe burst is bound to guarantee you a nice selection of shots. Other tips, if you want to go stroboscopic? Keep the camera steady so that each exposure overlays the last, and use small apertures and low ISOs to prevent overexposure.

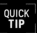
137 WORK IMAGE STABILIZATION

As a rule of thumb, you shouldn't handhold a camera when shooting at shutter speeds slower than the equivalent focal length of your lens. So when working with a 50mm lens, you'll need a tripod to shoot slower than at a 1/50-sec shutter speed—which is a pain, if you're somewhere (like a dark concert venue) that doesn't allow tripods. As a stopgap, switch on your camera's or lens's image stabilization feature, which corrects for shakes in low light.

138 ROCK A CONCERT

The screeching guitar, thumping bass, roaring crowd, and wild onstage antics—live music is a total blast to shoot, whether you're there as a rabid fan, serious photographer, or both. It also presents some real technical scrapes, as venues are notoriously dark, and it's often hard to find a good vantage point of the stage. Here are some tips for nabbing encore-earning images.

FIGHT LOW LIGHT In the dark, fast prime lenses (with an aperture of f/2.8 or faster) are your friend. While many venues restrict flash, you may be able to fire an off-camera unit at low power, such as 1/8 or 1/16.

CRANK IT UP Bump up your ISO and use exposure compensation to adjust for lighting changes. Or set ISO to automatic and manually lock in shutter speed and f-stop settings so the camera adjusts light sensitivity. If you can't use flash, your shutter speed will be slow, but 1/60 sec is the low limit. Noise is better than blur.

SET YOUR APERTURE WIDE For tight shots of musicians, turn on aperture-priority mode and base your exposure on a spot-meter reading of their faces. For wide shots, use evaluative metering to get the proper exposure, then shoot in manual to keep that setting locked.

KEEP IT FOCUSED When shooting in burst (continuous) mode, continuous autofocus will keep up with the musicians' moves. Watch videos of the band's shows so you're ready for every headbang or high kick.

TRY A COMPACT If you can't bring a DSLR or ILC into the venue, bring a camera that's small enough to pass through security without problems. Ideally, it should feature an ISO of at least 3200, a fast (f/2.8 or higher) lens, and an image-stabilized zoom.

PACK IN MEMORY Bring plenty of media cards and shoot a ton—try working in burst mode—for a better chance of nailing a great shot.

ZOOM IN An image-stabilized telephoto zoom (70–200mm) is useful for tight shots and shooting from a distance. But lenses much longer than 200mm will be unwieldy in a crowd.

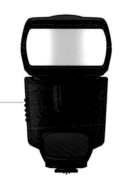

139 MAXIMIZE AN ACCESSORY FLASH

Chances are, your DSLR's onboard, pop-up flash isn't doing your portraits any favors—typically, it creates nasty shadows, blasts away fine details and contours, washes out skin, and makes eyes flash red. You can always set your camera to manual, aperture-priority, or shutter-priority modes to control your flash's output, or try on an accessory flash: an independent lighting unit that fits into your camera's hotshoe and can be synced to fire with your shutter release. You can either set your system to manual and control your exposure and output, or—if you're using a TTL (through-the-lens) flash, let the camera do the work for you.

BOUNCE IT For best results, you'll need to modify the light from your accessory flash once it's mounted in your camera's hotshoe. The easiest way is to tilt and swivel the flash head and aim it at the wall, ceiling, or reflector, spreading the light out and bouncing it onto your subject. For starters, try a 90-degree angle on your flash. (Make sure it's a neutral-hued surface to avoid strange color temperature.) This technique does cause a loss of light; try raising your ISO and getting close to your subject if your flash unit doesn't auto-adjust to your liking.

GIVE YOUR BOUNCE A BOOST Nicer flash units come equipped with a bounce card, a piece of white plastic built into the flash head that reflects light onto the subject when the flash is tilted up. It's great for fill light and for adding catchlights. For a DIY version, use a rubber band to attach a piece of white index card around the back of the flash head.

DIFFUSE IT For lovely, soft light, go with a mini softbox modifier. You can improvise one with a piece of tracing or tissue paper outfitted over the flash head, too.

140 UNDERSTAND FLASH FALLOFF

Flash is all fine and good, except when it "falls off": fails to reach far enough to illuminate distant objects. It's not as if the light rays lose steam, but they spread out as they travel and become less concentrated.

The beam from a flash unit is cone shaped. Shoot a relatively close object and most, if not all, of the light cone will cover it. But as you move the flash farther away, a smaller portion of the light cone hits the subject, as more of the light sprays wide of it. At a great enough distance, the flash's light becomes imperceptible to the eye as well as to a sensor or film. Even worse? Flash falls off at the square of the distance. In plain lingo, this means that if you move twice as far away from your subject, you get only one-quarter the illumination on the subject. Triple your distance and you get only one-ninth the light.

Solutions? You can make the light cone narrower. If you have an accessory flash with a zoom head, setting the head to tele position will do this. You can also set an accessory unit close to your subject and fire it from a distance via wireless trigger.

141 WRAP AROUND WITH A RING LIGHT

A circular flash tube that fits around the front of a lens, the ring light got its humble start as a dentistry tool. Today, it's regarded as a nifty gadget that—while famous for its even, glamorous, all-over lighting—has also endeared itself to macro enthusiasts, pro party shooters, and creators of goofy candids, as evidenced here. Often sold as a stand-alone flash unit, you can also opt for one of the popular (and economical) adapters on the market that transforms illumination from a standard speedlight unit. Bear in mind, however, that the cheaper versions tend to have a 1- to 2-stop drop in light output.

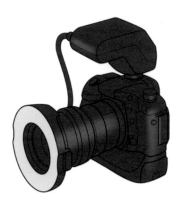

Since the light comes from all around the lens, it fills in almost every place you'd expect to see a shadow—making this light a hit with high-fashion portraitists. When it's close enough to the subject, you get an all-over glow, plus a unique, ring-shape catchlight in the eyes. Many love the extra sharpness it lends to detail, as it tends to amplify specular highlights (the finer details that emerge when flash is in play). It also creates a uniform, halolike shadow around the subject when he's positioned dead center in the frame.

While the ring light's most standard use is as a key light, you can try using it as a secondary light or even a rim light (see #166) coming from behind the subject.

142 MAKE YOUR OWN ADJUSTABLE SNOOT

If you've ever wanted to control the broadness of your light, look no further than this simple build using a 9-by-12-inch (23-by-30-cm) sheet of black craft foam. Secure it to your flash with Velcro wrap, and adjust the foam's shape so it's open wide at one end, a consistent circumference the entire length of the foam, or tightened into a cone at one end. Bonus? Get two foam sheets (one black, one white) and adhere them to each other. The white side can function as a bounce card.

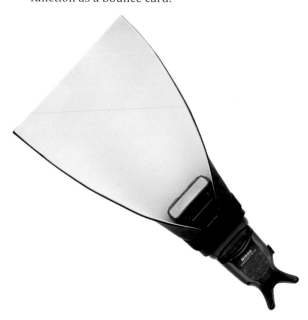

143 USE A BLACK MARBLE TO FIND CATCHLIGHTS

If you're having trouble visualizing how incoming light will look on your subject's eyes, you can use a black marble to see where the reflections will show up. Simply hold the marble in the circle created by your thumb and forefinger, mimicking an eye socket, and rotate it toward your light source until you see the catchlights you like (usually at ten or two o'clock). Then position your model with his or her eye at the same location and angle to the light.

144 RIG A FLASH GRID WITH CARDBOARD

Focus your accessory flash's light with a DIY grid made of cardboard scraps, craft glue, and a rubber band. To make it, cut cardboard pieces that are as long as your flash is wide. Make sure you have enough strips to cover your flash head when they're positioned one after the other over the light. Next, glue the strips to each other and let them dry. Finally, trim excess glue, and then simply affix the cardboard block to your flash head with a rubber band. Give it a test flash—you'll see light funneled through the cracks in the corrugation.

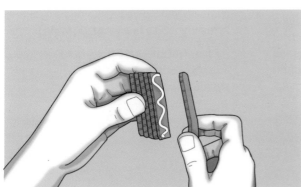
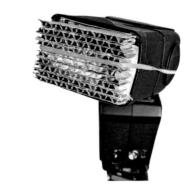

145 ASSEMBLE A DIY REFLECTOR

As far as photo gear goes, reflectors aren't likely to break your bank. But if you're looking to cut costs across the board (or need to travel but don't want to lug this unwieldy piece of gear), here's a dead-simple reflector that you can make with two pieces of white foamcore, black matte spray paint, gold and silver metallic spray paint, and—what else?—duct tape. To assemble, spray each side of the foamcore with a different paint, leaving one side white. Then tape the two pieces together on both sides of the long edge, silver to black and gold to white. Trim the excess and amazing light is all yours.

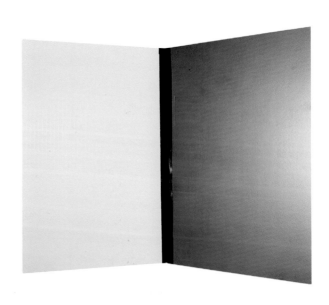

146 DECODE REFLECTOR COLORS

What's with the many different-hued sides of your everyday reflector? Here's a cheat sheet.

SILVER Most beginners start with this side of the reflector, as it doesn't affect the image's color too much and can be used in sunlight or low-light conditions.

WHITE Perfect for too-bright days, the white side offers nice fill without overdoing the highlights (as a silver reflector might in bright light).

GOLD Careful with this side, as it can radically change your image's color temperature. It's best used to give a warm cast to subjects in the shade or who have darker skin. It can also help replicate the golden hour.

BLACK This reflector color comes in handy for injecting shadow into an image, especially if the light is too even and you'd like the subject to look more dimensional.

147 SHOOT THROUGH A TRANSLUCENT UMBRELLA

This mostly white light umbrella is often called a "shoot-through" umbrella because it goes between the light source and the subject. The translucent white material scatters the light rather than focusing it, resulting in softer illumination and shadows, as you can see in this portrait (shot with a large translucent white umbrella and a single strobe positioned at camera right). Because of its ability to throw light all over a room, the shoot-through umbrella is one of the most forgiving lighting modifiers, making it appealing to beginners or shooters who need to work in a hurry. The light does, however, maintain some distinct directionality, so you can't just throw it anywhere.

You can buy a 32-inch (80-cm) shoot-through umbrella for less than the cost of a large pizza, so having one in your kit is pretty much essential.

One caveat: Because of its shape and translucence, you can sometimes get a "hot spot" near where the center of the umbrella is pointed. You don't want that to land directly on your subject's forehead or it may cause an unpleasantly bright highlight, so mind the positioning. Also remember that the closer you position the umbrella to the subject, the softer your light will be. Often, going bigger gives you more options, but if you're using a small flash, you might have trouble filling the whole thing with light.

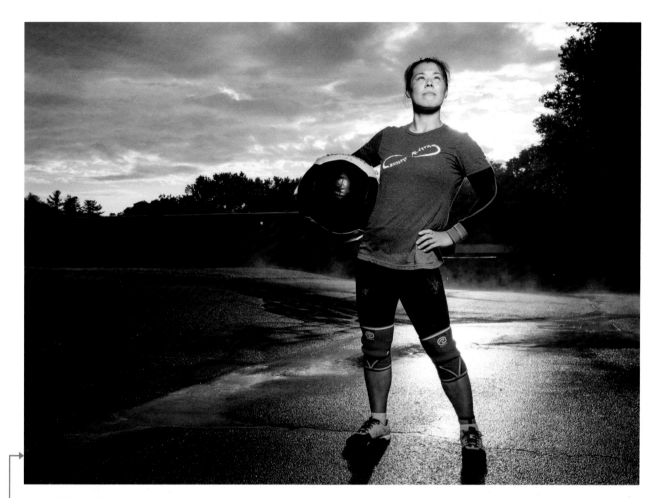

148 TRY A REFLECTIVE UMBRELLA

When you fire a flash into a reflective umbrella, almost all the light bounces directly back at the subject. A deeper umbrella produces a tight, focused beam that is very intense at the center and falls off quickly, as you can see here with this heroically lit crossfit athlete. Meanwhile, a shallow umbrella throws a wider shaft of light (which is great for illuminating groups).

The working distance of an umbrella is around twice its diameter and closer. If you're using a very deep parabolic umbrella, the beam may be tight enough that you need to back the reflector up significantly to get sufficient coverage. If you're using an especially shiny reflector, mind the placement, as the shadows created by the directional light will be sharp and pronounced. As for size, a 43-inch (110-cm) umbrella should be just fine.

Use a shoot-through translucent umbrella when you're after soft, diffused light.

Go for a reflective silver umbrella when you need to intensify your light for a more spotlit effect.

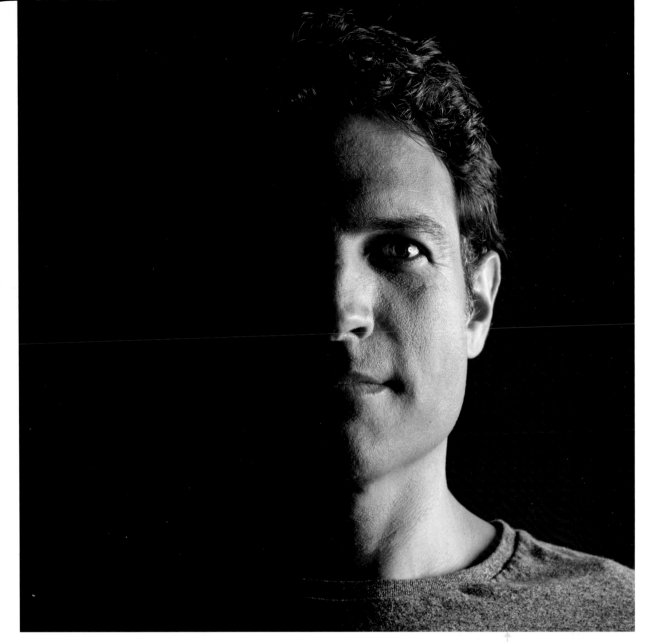

149 MAKE IT AN EVEN SPLIT

When it comes to split lighting, the name really does say it all. This technique uses light to divide your subject's face into equal halves: One side is lit, the other is in shadow. The effect is dramatic and often considered flattering to masculine subjects, though don't let that constrain you.

The setup is as easy as the concept: Position your light source 90 degrees to the subject's left or right. You can also experiment with placing it slightly behind his or her head. The amount of space between the subject and the light source really depends on the person's facial features, so try various distances to discover the most agreeable. Bonus points for managing a catchlight in the shadowed eye, too.

One pain about this lighting scenario? While you can use it with any facial view (full, three-quarters, or profile), you'll need to adjust the light position if your subject moves his face.

150 SUPERLOOP YOUR SUBJECT

In the glory days of Hollywood, loop lighting was the great rival to Paramount, or butterfly, lighting (see #163). As with its sister classic lighting setup, it takes its name from the shape of the nose shadow when the subject looks at the camera. The result is a small, downward-angled "loop" of darkness to the side of the nose that doesn't touch the shadow of the cheek. Today it's one of the more popular types of lighting, as it's easy to execute and flatters most people.

When it comes to setup, position the key light far and high from the camera, maybe 30 to 45 degrees from the camera-subject axis. Set the key well to the left or right of the camera, and high. Use the nose shadow as your guide to how high you want it.

If you'd like to add a fill light (not shown), opt for a focusing spot at its softest, most defocused setting, or a concentrated broad (a reflector between 6 and 10 inches [5–25 cm] wide). Using a broader, shallower reflector of 12 to 16 inches (30–40 cm) will create a softer light. As with Paramount, you normally want the fill as bright and close to the subject as you can get without creating conflicting shadows.

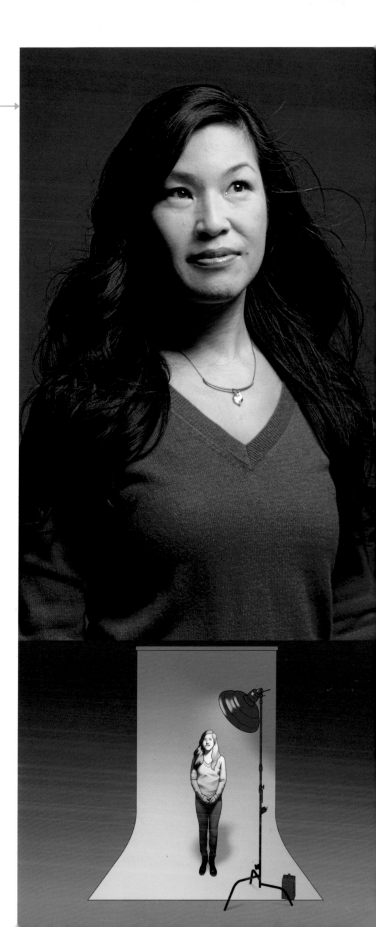

QUICK TIP

151 BLOW HAIR AROUND

While it may seem cheesy, adding a little air will create welcome movement in your subject's tresses, taking the pressure off the poses. While many photographers swear by an assistant wielding a blow-dryer or other specialty tool, you can get great results with a simple box fan.

152 FLATTER SKIN

Use lighting and exposure to beautifully render skin of all tones and ages.

EXPOSE DARKER SKIN Your camera tends to overexpose dark skin. To fix it, put your camera on manual, then use exposure compensation to underexpose by up to 1 stop. Side fill helps wrap light around the face, creating highlights.

SMOOTH OUT SKIN Zap zits, scars, and wrinkles by putting main and fill lights just above your camera—one to its left, one to its right. Avoid side fill, which tends to "moonscape" a bumpy complexion.

POSITION LIGHTS With older subjects, keeping lights at eye level will minimize crow's feet, laugh lines, and other hallmarks of age.

OVEREXPOSE SLIGHTLY Combining high-key lighting with backlighting, soft focus, and slight overexposure can be especially effective in blowing out blemishes and wrinkles.

154 GO BRIGHT WITH HIGH KEY

High-key lighting lends an airy feel to portraits—the style's bright illumination eradicates shadows and limits tones, creating a soft, slightly blown-out look.

SELECT THE RIGHT SUBJECT This technique works well for romanticized portraits, such as this beauty shot, and images of children that highlight their innocence.

WHITE OUT THE SCENE White or light gray seamless paper creates a pristine background. Ask your subject to dress in similarly pale hues. (Or go bare.)

OVEREXPOSE A LITTLE Your histogram (see #004 and #107) should be high at the right side. But don't overdo it and blow out important details.

LET THERE BE LIGHT Optimally, you'll have light sources aimed at your background to keep it evenly lit, plus a key light set to one side to illuminate your subject and a fill light on the other to decrease shadows. Use multiple reflectors to bounce light into all shadowed areas.

KEEP SOME COLOR To prevent your subject from being totally washed out, try a little eye makeup to deepen the eyes and lipstick to give color to the mouth (see #037).

153 CRAFT A BROODING LOW-KEY PORTRAIT

On the opposite end of the spectrum from high-key lighting, this technique's murky tones create drama and intrigue.

CHOOSE APPROPRIATE SUBJECTS Low-key lighting works best with somber, enigmatic, or even dangerous subjects.

PAINT IT BLACK A dark background is crucial—if you can, host your shoot in a light-tight spot. Your subject should also wear black (or nothing), and stand at least 3 feet (1 m) in front of the backdrop.

LIMIT THE LIGHT A single light source will do for this style—either window light or an off-camera accessory flash aimed on the subject from one side. A grid (see #169) or snoot (#175) can focus the light.

PROVIDE BOUNCE A silver reflector opposite the light will define your subject's far edge.

UNDEREXPOSE SLIGHTLY Set as low of an ISO as possible—it will keep the image dark and noise-free—and a fast shutter speed. Open up your aperture wide and snap a test shot, then narrow the aperture incrementally until you've reduced the ambient light in the frame to your liking.

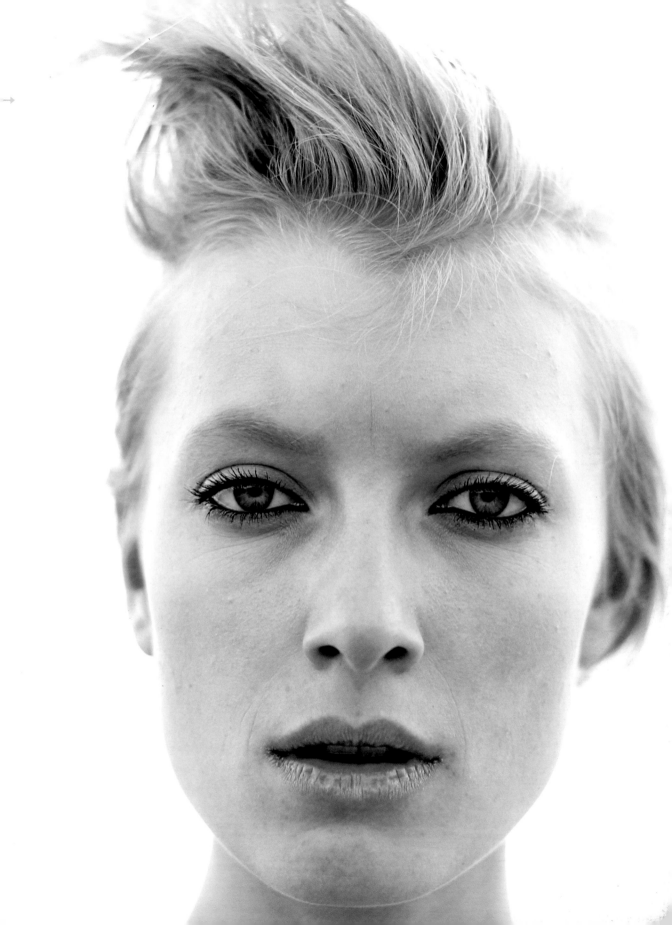

155 DIFFUSE WITH A SOFTBOX

Portraitists swear by this modifier because it reduces contrast and shadows and conceals problem skin. It works by enhancing your flash's small bulb to the size and shape of the front of the softbox. Some models have a closed back into which the light fires, reflecting light forward and adding additional softening. Others have an opening at the back through which the flash fires forward, letting the front panel and inner baffles handle all the diffusion. This last type offers even light but requires more power, while the former needs less oomph but can cause dreaded hot spots. The working distance of a softbox starts at two times the diagonal measure of its front panel. In real life, however, you'll likely find yourself moving it in closer than that.

The assortment of softboxes available today is a bit staggering; you can get a nearly unlimited selection of sizes, shapes, materials, and diffusion options. A small softbox will offer an improvement over a bare flash in almost every case, but many people choose to go a bit bigger, opting for a 2-by-3-foot (60-by-90-cm) or a larger 3-by-4-foot (90-by-120-cm) model. There's also a very popular 50-by-50-inch (125-by-125-cm) square. Why is bigger more popular? Because it mimics that coveted window light we photographers love so much.

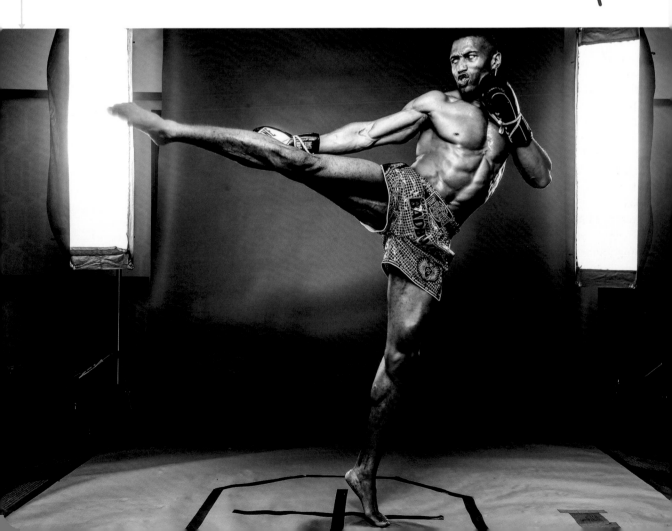

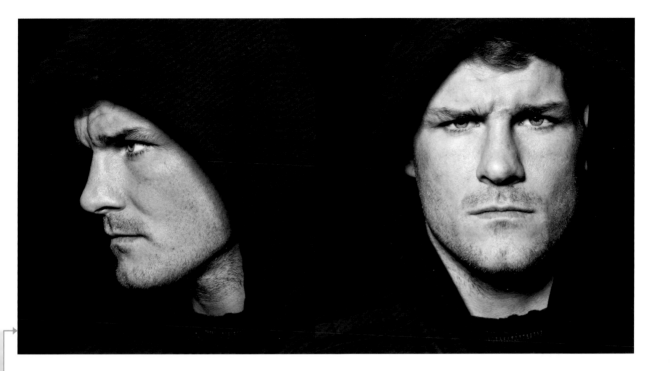

156 ILLUMINATE WITH A BEAUTY DISH

As the name suggests, this lighting modifier is a godsend for portraits, so go ahead and get it up close and personal with your subject. A metal bowl measuring between 16 and 28 inches (40–70 cm), the beauty dish has a hole in the back that the light source shines through. The light hits a deflector plate and bounces back into the edges of the dish and outward onto the subject. This path effectively grows the overall light source, producing a lively and vibrant light without the harsh shadows that you might get from a bare bulb. Photographers sometimes accentuate the muscles of athletic subjects by shooting downward with a beauty dish. Fashion shooters also tend to keep one close—it does an excellent job of highlighting makeup details. Here, the character of this burly fighter is enhanced by the dish's deep shadows with softer edges.

A medium-size model with a removable plate is your best bet for getting started—it offers the most options in terms of lighting arrangements. Many photographers like to place a grid (see #169) over the beauty dish in order to keep the light as directional as possible. You can also swap out or remove the dispersion plate, and some come with a sock that can be placed over the dish's front, making it function like a small, round softbox.

QUICK TIP

157 LINE UP YOUR BEAUTY DISH

There's a sweet spot when you're working with a beauty dish: You want to position it so the reflective panel is directly aligned with your subject's face. Otherwise, the shadow of the dish's rim could appear in your portrait.

158 HACK TOGETHER A RING LIGHT

Love the slick, high-end illumination of a ring light (see #141) but want a smaller smartphone model for portraits on the go? Here's how to build your very own out of a cheap phone case, ring-shape LED camping light, black spray paint, and Velcro—all for about US$15.

STEP 1 Take apart an LED camping light (which you can find easily online) and hit it with matte black spray paint. (You can mask the holes from the inside with tape to prevent the LEDs from being splattered with paint.)

STEP 2 Cut a length of heavy-duty Velcro to the width of your smartphone case. (It's best to have a dedicated case for this gadget, as you won't want to use your modified case for daily texting, emailing, and the like.)

Cut the Velcro so it is long enough to extend from the inner hole of the light's ring to the outer edge.

STEP 3 Adhere the hook side of the Velcro to the back of the light. To make it easy to turn it on without destabilizing it, position the Velcro so that the light's "on" button will be directly underneath the phone when the two are attached.

STEP 4 Put the Velcro's loop side on the smartphone case so it aligns with the hook side on the light. Then stick the case to the light.

STEP 5 To use your new ring light, hold it close to your subject. If you're in a bright space, turn down the lights or close the curtains to let the light do its thing.

159 MAKE A SALAD-BOWL BEAUTY DISH

A professional-grade beauty dish (see #156) will set you back in the dollar department. This DIY model, however, runs the cost of a big old metal mixing bowl and aluminum pizza pan, plus a few nuts and bolts and a spare flash-mounting bracket.

Essentially, you're modifying a 16-inch (40-cm) bowl to accept a flash head, then using an 8-inch (20-cm) pizza plate as a deflector that will bounce the light back into the bowl. You'll need a power drill and rotary tool; medium- to fine-grit sandpaper; matte spray paint in black and white; three 20-threads-per-inch (20-threads-per-2.5-cm), ¼-by-3-inch (0.6-by-7.6-cm) round, slot-headed machine screws; nine 20-threads-per-inch (20-threads-per-2.5-cm), ¼-inch (0.6-cm) jam nuts; and three ¼-inch (0.6-cm) SAE washers. You'll also need machine screws and jam nuts appropriate for whatever flash-mounting bracket you've sourced.

STEP 1 Create a paper stencil based on your flash unit's head. While a large hole will allow for various flashes to fit inside the bowl, a custom one keeps light from spilling out the back. Make a second stencil for the mounting bracket that you'll use to connect the flash to the bowl.

STEP 2 Using the flash-head stencil, mark your cut on the back of the bowl. Then use the mounting bracket stencil to determine where to drill for the ¼-by-3-inch (0.6-by-7.6-cm) machine screws that will secure the pizza plate to the inside of the bowl, as well as whatever screws, nuts, and washers are needed to attach the mounting hardware to the bowl.

STEP 3 After you've marked out the mounting holes and flash opening, make the holes with a rotary tool outfitted with a metal-cutting wheel.

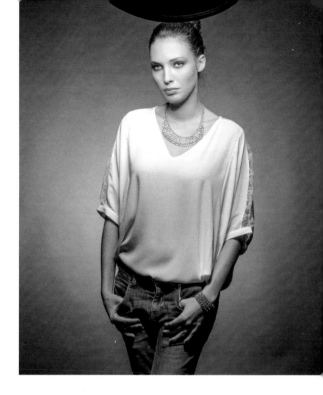

STEP 4 Rub the mixing bowl and pizza-dish deflector down with sandpaper, then wipe them down with denatured alcohol.

STEP 5 Cover the flash opening and the drilled holes on the back of the bowl with masking tape. Then paint the bowl's interior with a flat white spray paint. Repeat on both sides of the deflector. It'll take about three coats, allowing 20 to 30 minutes between coats so they each can dry.

STEP 6 Move the tape to the inside of the dish so that the flash opening and mounting holes are covered again. Coat the back of the dish with flat black spray paint.

STEP 7 Safeguard your paint job against chips with a few coats of protective finish. Let dry.

STEP 8 Using the holes that you drilled earlier, attach your pizza-box deflector to the inside of the mixing bowl with your three ¼-by 3-inch (0.6-by-7.6-cm) machine screws and matching jam nuts and washers. Once you've installed the deflector, attach the mounting bracket to the bowl with the appropriate hardware.

STEP 9 Attach the flash to the mounting hardware and give it a go! To fine-tune, adjust the deflector's position in the bowl by tweaking the distance of the jam nuts from the flash unit until you obtain optimum light.

FLASH UNIT

SALAD BOWL

PIZZA PLATE

REPURPOSED MOUNTING BRACKET WITH HARDWARE

160 POWER LIGHTS WITH A CAR BATTERY

Shooting in remote locations presents you with all sorts of intriguing subjects, as well as some pretty frustrating problems, like how to power your studio strobes when you're nowhere near an outlet. Besides carting a small generator, look into getting an adapter that converts the DC power from a car battery to the usable sine wave that most electronics require.

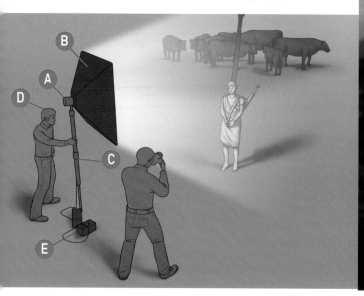

161 TAKE REMBRANDT LIGHTING INTO THE FIELD

When lighting portraits, you can accentuate the shape of a subject's figure, bring out the texture or drape of the clothes, or—as in environmental portraits—adjust the light so that the subject and background are of equal importance. Or you can light for character, as in this arresting image of an Ethiopian cow herder, whose dignity is depicted through Rembrandt lighting and spotlighting.

Favored by painters for centuries, Rembrandt lighting is widely considered one of the most flattering forms of lighting for portraits. Throwing half the face in shadow, it simultaneously suggests the shape of the head while injecting shadows—and with them, a sense of mystery. You'll recognize it by the clear triangle of light that lands on the subject's cheek.

To create this light, set up a strobe head (A) inside a softbox (B). It helps to recess the head deeply

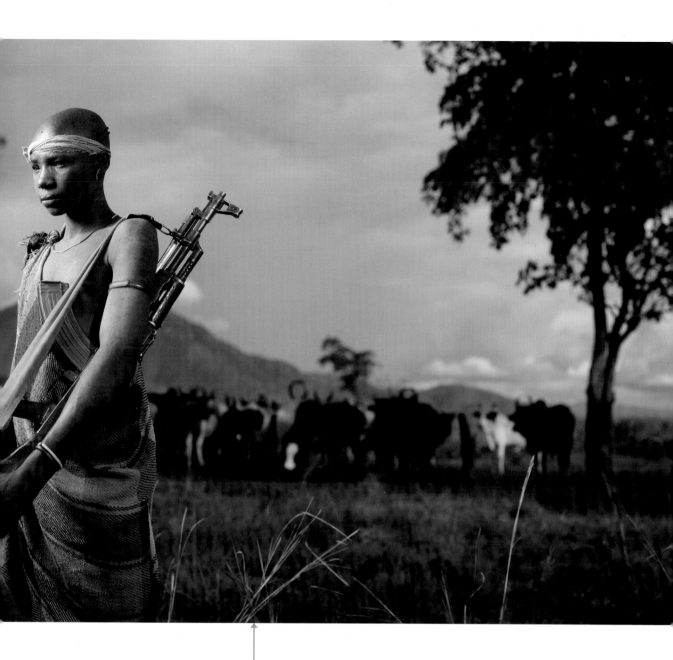

inside the box—this will produce a slightly more contrasting light, with controlled spill and faster falloff that illuminates little of the immediate foreground. Mount the softbox—here, it's on a monopod (C)—and, if you can, have an assistant (D) position the softbox slightly off-camera on the left side, aiming the light so that the shaded side of the subject's face is toward the lens. Powering the strobes is best done with a power pack (E), but the photographer here got a boost from a car battery, too (see #160 above). To showcase the subject and allow the thirteen-year-old to stand out from—and transcend—the surroundings, the photographer spotlit by underexposing the background by 2 stops, but properly exposed the subject with his lights.

The result? A portrait in which lighting in the field helps heighten—almost venerate—a rarely presented subject and make character the photograph's main message.

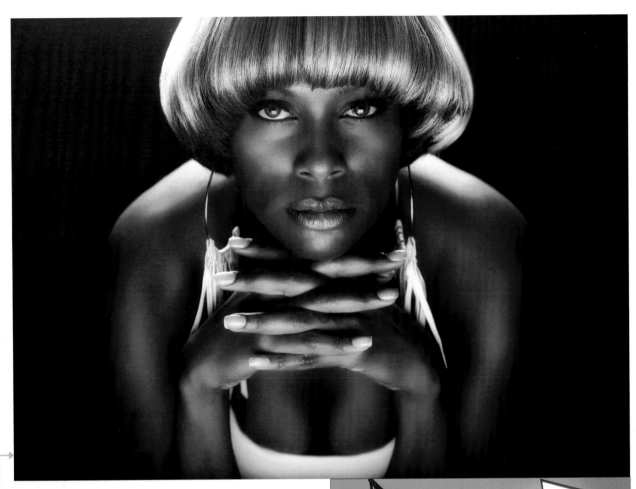

162 COMPLIMENT WITH A CLAMSHELL

Famous for bathing models in a warm and becoming allover glow, this classic studio lighting setup is known as a "clamshell." The technique gets its name from two lights (usually housed in softboxes) that are set up to create a V shape, lighting your subject's face from top and bottom and forming a configuration that resembles, yes, an open clamshell. This setup fills in shadows that accentuate wrinkles and imperfections, so the subject has smoother skin—and you have less editing later.

To try this style of lighting, set the main light (A) on a stand so that it's above your subject, aimed down at her. Then place the fill light (B) below her and angle it upward. Both lights should be as close to your subject as possible, and leave very little space between them— their diffusion panels should nearly touch. If the lights are stationed too far apart, shadows will start to creep in, especially in the middle of the frame.

While clamshell lighting is often great for 1:1 lighting ratios, a 2:1 can create dramatic shadows on the subject's neck and chest, as it did here. For a glamorous boost, set up a reflector (C) behind the model, which will cast an additional glow over her hair and shoulders. A roll of black seamless paper (D) can increase the portrait's up-close-and-personal feel.

163 GO HOLLYWOOD WITH PARAMOUNT LIGHTING

Some styles of lighting are so useful—one might even say, so clichéd—that they have their own names. Paramount lighting (named after the famous film studio) is also known as butterfly lighting, after the supposed resemblance of the nose shadow to a butterfly when the subject is looking straight at the camera. Useful and easy, this lighting style flatters those with nice cheekbones or narrow faces.

Set the light (A) above the camera (here, we housed it in a beauty dish—see #156) as close as you can get to the camera but well above it. Use the nose shadow as your guide to how high you want it.

To open up any unwanted shadows under the eyes, position a reflector (B)—here, we just used a simple piece of white foamcore. Or you can put a fill light below the face and just outside of the frame. You want it as bright and close to the subject as you can get without creating conflicting shadows.

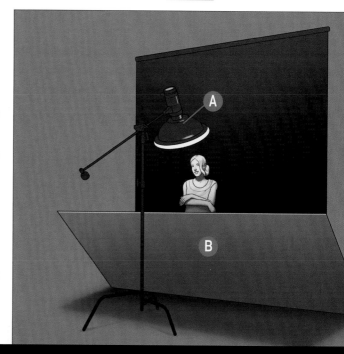

164 SET OFF A SILHOUETTE

A stark, blacked-out figure against a bright scene packs a graphic punch—and a nice hint of mystery, too.

SET UP YOUR BACKLIGHTS When working in the studio, place two lights so they create even light across a simple white backdrop, or position a single light source so that the subject's body blocks it. If you're outside, set your subject up in front of the sun or other large light source.

DEFINE OUTLINES The subject will appear as a flat black shape with hardly any detail, color, tone, or texture, so a distinct angle—say, a profile view—will help your subject's main features stand out. Keep poses simple, and be sure to avoid overlapping shapes that merge into a dark blob.

TWEAK EXPOSURE When shooting in auto mode, you can expose for the background instead of the subject by pointing your lens at the brightest part of your scene and depressing the shutter halfway to lock in that exposure, then compose and push the shutter all the way. Shooters in manual mode can use evaluative metering to expose for the background—unless the subject and foreground are the largest elements in the composition. Switch to spot-metering, lock the focus so it's over the bright background, and meter from that spot.

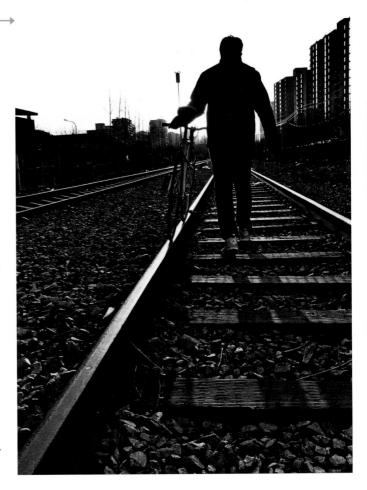

165 MAKE GHOSTLY EFFECTS

To make your silhouette portrait even more enigmatic, ask your subject to stand behind the background, as in this photograph, which was shot through a frosted glass bathroom door at a grainy ISO 1600. Try other transparent surfaces—such as plastic, vellum sheeting, or sheer curtains—or skip the barrier, clear the space of clutter, and shoot at wide apertures to throw the fore- and backgrounds out of focus. It helps to screw a soft-focus filter onto your lens and convert to monochrome afterward.

166 CREATE DRAMA WITH A RIM LIGHT

Rim light traces a thin line of illumination along the profile of your subject, emphasizing the body's outline and detaching it from the background. Sometimes rim light is used in combination with other lights; other times, it's the sole illumination in an image, leaving everything else to the imagination.

To achieve this look, you'll need one light angled at 45 degrees and set to the side of your subject, either slightly behind or in front of the subject. A softbox will diffuse the light for a more natural spill, like you see here.

You can also double the rim—and the drama—by placing two equally powered key lights opposite each other, often with a snoot (see #175) or barndoor modifier to focus their light. For a touch of illumination on your subject's face, try a front fill positioned higher than the key lights.

QUICK TIP

167 WAVE A BLACK FLAG

Photographers talk a lot about modifying light: diffusing it, directing it, bouncing it. But what about just blocking it? That's where a flag comes in handy. A black opaque cloth stretched across a rectangular frame, a flag can be used to block a light source, hiding whatever falls in the flag's shadow. Try using multiple flags to focus light, or use one to prevent lens flare or control spill from ambient sources.

168 SET UP A PHOTO BOOTH

People just love photo booths. So why not help party animals shoot themselves?

STEP 1 Pick a camera. An old APS-C DSLR with a kit lens is a great choice for a shoot like this. The 18mm focal length (28mm full-frame equivalent) should be wide enough to cover the backdrop at close range. You'll be at or around f/11 to keep everyone in focus, so no need for a fast lens.

STEP 2 Pour on the light! A 7-foot (2-m) parabolic umbrella in reflective white (see #147), placed about 7 feet (2 m) from the background and slightly behind the camera to the right will cover the entire space and make everyone look good.

STEP 3 Pick a background. Cloth backdrops are easy to transport, but seamless paper is cheap and never needs ironing. Plus, when someone inevitably spills a cocktail on it, you just cut off the stained piece. Fashion gray is a good color.

STEP 4 Use a studio unit. A shoemount flash with a sync cable can typically dish out enough light, but a dedicated studio strobe is ideal. Because it doesn't use batteries, it will recycle more reliably throughout the night. And its modeling light will help out the camera's autofocus system.

STEP 5 Set up a wireless trigger so that guests can fire the shutter themselves. Avoid a wired remote release—a cord is an accident waiting to happen.

STEP 6 So that guests can see how the images look, use a card or device that beams photos to a tablet. Or just use a cable (keep it short!) to tether to a laptop, which will also let you make small prints on site using a portable printer. It's the ultimate party favor.

169 FOCUS LIGHT WITH A GRID

Sometimes a photograph benefits greatly from narrowly focused illumination, much like the beam of a theatrical spotlight hitting a solitary actor onstage. To restrain the spill of light so it lands only on your subject's face, try a grid: a simple disk made of metal or plastic honeycomb that comes in varying sizes and densities. It attaches directly to the front of a light, and you can stack a few in order to magnify their effect on the beam.

Grid spots range from 10 to 40 degrees, which refers to their angle of coverage. The larger the angle, the more

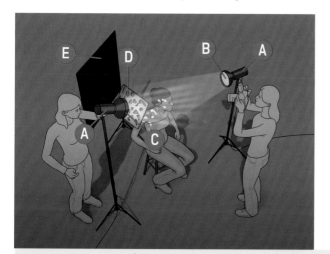

sweeping the illumination; the smaller the angle, the more constrained the beam of light. If you want to hit your subject with the full power of your light source while keeping the background relatively dim, a grid will help you by keeping the light moving in a straight line—as in this alluring portrait.

To create it, both strobes (A) were outfitted with grids: the light on the model's left with a 5-degree grid (B) and the one on her right with a 10-degree grid (C). The lacy effect is thanks to a "cookie" made of die-cut paper (D; see entry #170 below). A black backdrop (E) positioned close behind the model furthered the intimate, film-noir feel.

Beyond basic strobes, grids are also manufactured to outfit beauty dishes and softboxes (called egg-crate grids). They're also commonly used on backlights because they prevent the beams from hitting the edge of the lens and sending flare across the photo. Using a grid often requires you to be a little more precise with the positioning of your light. Since there's no spill light to work with, it's somewhat easy to miss your subject. Even a little bit is very noticeable.

170 ADD ATMOSPHERE WITH A COOKIE

After a glamorous, old-school Hollywood vibe in your lighting? Tack on a cucolaris, also called a cookie: a gobo modified with slats or irregularly shaped holes that create mesmerizing patterns of shadows on your subject's face, as at left.

To use, fasten your cookie in front of a light source using a stand. The effects vary wildly—your finished image can look as if it were shot through lace, tree branches, or blinds, depending on the pattern and the distance that it's set from the subject. Cookies can be purchased, but you can also create your own by cutting holes in cardboard or foamcore. (More adventurous DIYers may try lasercutting a pattern into plywood.)

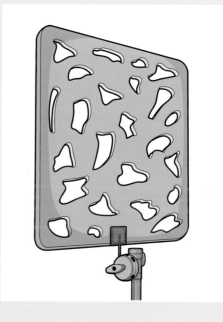

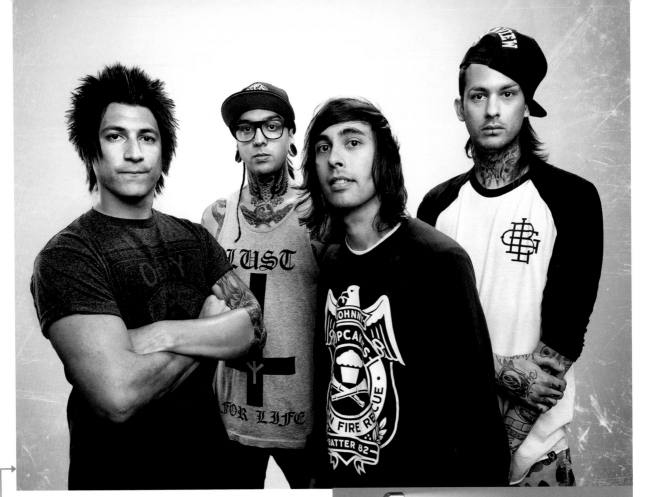

171 AMP IT UP WITH THREE LIGHTS

While a key light will "find" your subject, and a second fill light can open up or shape the shadows caused by the main light, two lights can sometimes fall short. That's why three-point lighting is probably the most common form of studio portrait lighting today.

In this portrait of the rock band Pierce the Veil, the key and fill lights both handle the subject, as they do in most three-point setups. A monolight set inside a 7-foot (2-m) softbox (A) acts as the key, illuminating the band from the front, while the weaker fill light is provided by a 47-inch (120-cm) octobox (B) positioned above and to the right of the crew, sidelighting and eliminating shadows cast by the key.

The third light is the backlight, and it's the wild card in three-point setups. It can illuminate dark hair against a black background or act as a "kicker light" to accentuate a subject's edges, but in this case it fulfills the duties

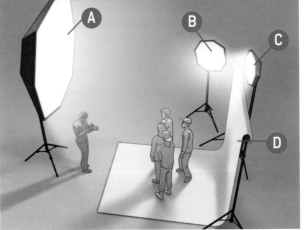

of a rim light, creating an outline around the subject without casting any shadows on the front surface (see #166). Placed directly behind and aimed at the back of the subjects, the 35-inch (90-cm) octobox (C) outlines each band member with white light, making it easier to extract them from the white seamless background (D) and place them on a textured color using software.

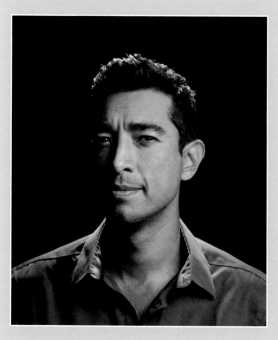

173 HIGHLIGHT TRESSES WITH A HAIR LIGHT

If you've ever tried shooting a person with dark hair against a black backdrop, you've likely encountered a common bugaboo among studio portraitists: The subject's hair seems to disappear against the background. Enter the aptly named hair light, a backlight that illuminates a subject's coif, giving it texture and helping it stand out against the darkness.

To achieve a hair light, put a third illumination source on a boom directly behind your subject and aim it down at the hair. Focused with barndoors or a snoot (#175), it will draw attention to the color, style, and texture of the hair, as well as separate the head from the background.

172 MAX OUT WITH FOUR LIGHTS

In four-point lighting, your subject is illuminated by three lights playing all the familiar roles: main (A), fill (B), and back (C). So what does the fourth light do? It illuminates your background, adding a suggestion of character, mood, or ambiance to your portrait. Place your fourth light (D) immediately behind or to the side of your subject, and aim it toward the backdrop (E) to emphasize its color and texture. By lighting part (but not all) of a background, you can also create intriguing shadows or falloff.

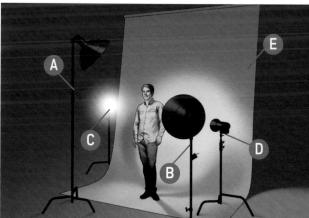

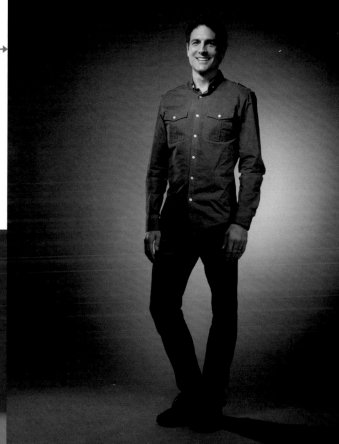

174 INJECT COLOR WITH A GEL

When it comes to lighting, it's important to know that different temperatures appear as different colors to our eyes and, even more so, to our cameras. For instance, incandescent lights look orange or yellow, while sunlight and most camera flashes are hotter and look like true "white" (see #018 for more background information on color temperature). Affixing a gel—a thin piece of colored acetate—in front of a light source's beam can correct the illumination so it looks true white or introduce a dramatic splash of color, as it does here.

There are hundreds of different kinds and colors of gels. One type balances scenes and prevents ugly mixed light. The most common of these is called a CTO, which can warm up a flash and make it more closely resemble the output from everyday light bulbs. There are also specific gels that help counteract casts from fluorescent lights, which can render as ugly green or purple.

Another type of gel adds color to a scene. Instead of evening out the light, it makes the light more striking. In the example below, a dark blue gel is used with a bare, neutral-colored flash to add a pop of color, while a small silver reflective umbrella at camera right acts as the key light. Pro tip: Using a grid in conjunction with a gel is often a good idea—you get your desired hue in a defined area, rather than a blob that can throw unpleasant color across your whole image.

Gels come in just about every hue you can image. Order a sample book, which contains hundreds of small, flash-head-size pieces for you to try out. You can cut larger sheets of your favorite colors and cut them down as needed, too.

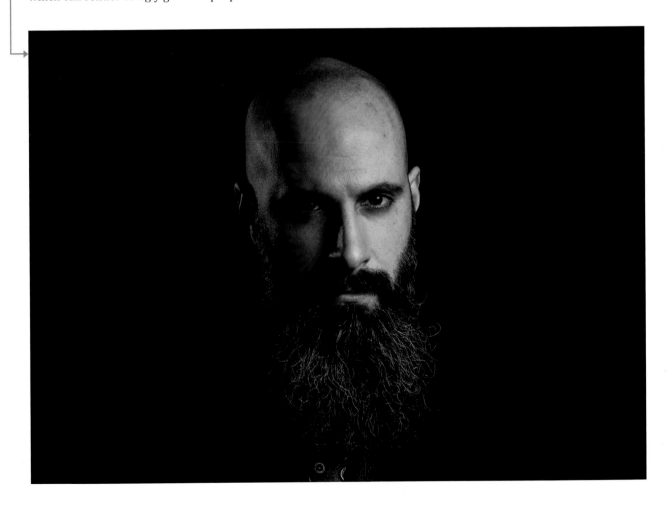

175 SPILL LIGHT ARTFULLY WITH A SNOOT

Behind the adorable name, a snoot is a rather useful little lighting modifier. Consisting of a simple black tube (often with adjustable width), it comes in handy for creating a small, concentrated pool of light on a very specific part of a scene. It's very much like a spotlight and can even mimic a flashlight beam.

A snoot can pump up a portrait's drama when used as a key light, making the face very bright and then letting the light drop off quickly around it. A more common use, however, is as an accent or detail light. If there's something in a scene that you want to draw someone's attention to—such as the lovely clavicle and bustline here—throwing a small pool of light at it can be just the thing. It can also help to break up an otherwise flat area by giving it some texture.

You can buy dedicated conical snoots that vary in light production depending on the size of the opening, the length, and the taper. Since adjustability is a plus, some crafty photographers make their own snoots out of moldable black material or even paper (see #142). Barndoors, like the ones you typically see on movie hot lights, can also help to funnel light in a specific direction while giving you more control over your direction and the width of your beam.

176 HACK A KITCHEN LIGHT

Who says lights need to be off-camera? Add a dose of cool with a visible illumination source, as in this portrait of Olympic biathlete Dominik Landertinger, created with a 12-inch (30-cm) circular fluorescent tube salvaged from an overhead kitchen fixture.

HACK YOUR LIGHT To adapt the tube for your purposes, attach a household plug to the tube's electrical connections with wire cutters and electrical tape. Warning: If you aren't comfortable with basic electricity, enlist a friend. If there's a crossbar (used for mounting the tube), cut it off with a rotary tool.

USE THE RIGHT CAMERA A fluorescent tube isn't as powerful as a flash, so you'll need to shoot with a camera that performs at high ISOs, like 640 or 800.

FINESSE THE DISTANCE The closer the light is to the face, the brighter the circular catchlights will be. Your shutter speeds can be faster, too. Moving the tube too close, however, can eliminate catchlights entirely.

SHOOT A LOT Of course, household fluorescents aren't photography tools. They flicker, which affects exposure, and their color temperature changes. Shoot a lot to obtain well-exposed images. What other found lights could you modify for photographic purposes?

177 MAKE IT RAIN LIGHT

Sometimes putting a light in a truly unexpected place creates a captivating image. In this image, the innocent mood of little girls frolicking in the yard at dusk with their umbrellas might have been killed by a full-on blast of flash (see #139 for more information on wielding a flash unit).

Instead, the photographer mounted his speedlight inside a studio umbrella and fired it with a wireless remote, turning the umbrella into an eerie streetlamp of sorts. The biggest challenge? Balancing the flash output with the ambient light for the perfect exposure.

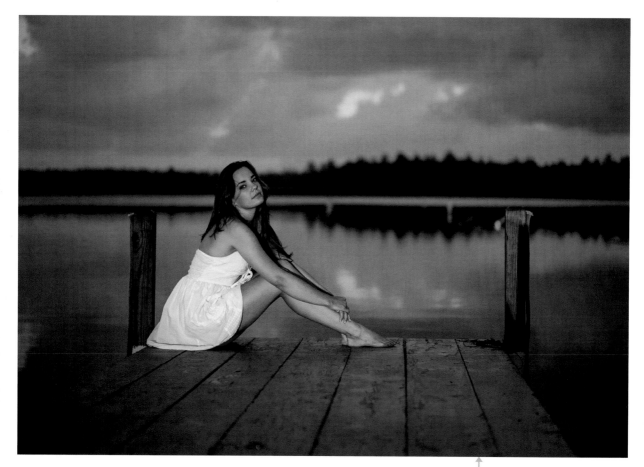

178 LIGHT A PORTRAIT WITH CAR HEADLIGHTS

For an intriguing portrait at dusk or even during outright nightfall, try an unexpected light source: the headlights of your automobile.

STEP 1 Scout a location. Of course, you'll need to shoot in a place where your car is permitted, but you'll also need a fair amount of room to maneuver your vehicle to line up the subject with the light.

STEP 2 Your car's headlights have two settings: high- and low-beam. This isn't a lot of variation, so your most effective technique for changing the light intensity is to drive the car closer or farther from your subject. Here, the vehicle was about 30 yards (27 m) from the subject on the dock with the car's high beams on. It can help to have a friend in the car to move it back and forth.

STEP 3 Position the car so your lights line up with your subject, which can be tricky. Consider uneven ground, which will move the light beam up and down.

STEP 4 Get yourself out of the light. Try standing close to the car between the headlights to cut down the shadows that you cast. Or, as the photographer did here, try standing a little off-center to the right on the dock, with the model standing to camera left.

STEP 5 Fiddle your exposure to keep things sharp in dark conditions—here, a shutter speed of 1/60 sec on a handheld camera and ISO 160 did the trick. In darker situations, try ISO 320 and pop the camera on a tripod, and shoot between f/1.4 and f/2.

STEP 6 There's a wide variety of things that can affect the color of the light thrown by your headlights: the amount of dirt, the kind of bulb, and even the moisture in the air. Bringing a gray card is a good idea. And, of course, you can set the white balance to auto and adjust in postprocessing. If you don't like the headlight's color temperature, you can use gels, but you'll need fairly large sheets to cover the lights.

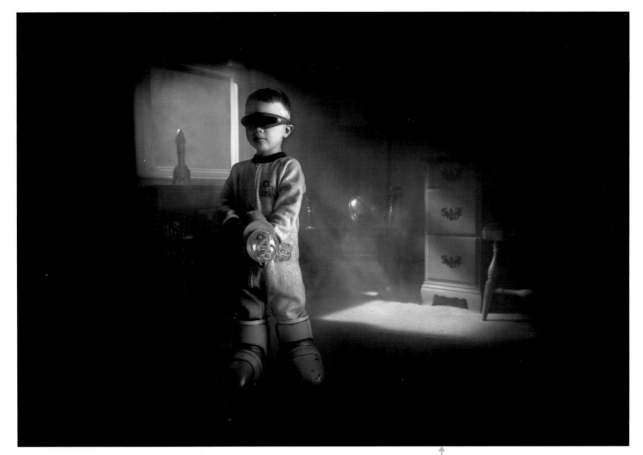

179 SEND A KID ON A SPACEMAN ODYSSEY

Who doesn't need to get in touch with their inner kid? Here, a father's fantastical, larger-than-life vision of his son as a space cadet takes on an innocent vibe that says tons about children's imaginative inner lives. You too can craft an adventure story for your subject.

PROP IT RIGHT This shot is meticulously planned—but not extravagantly budgeted. Think about which objects could help convey your subject's daydream, and then scour eBay and secondhand stores. The tiny astronaut here already owned the spacemen-themed pajamas and toy ray gun, so he just needed boots, goggles, and a rocket-shape piggy bank (seen on the windowsill).

CREATE OTHERWORLDLY LIGHT Match an adventurous story with adventurous lighting. To mimic the moon and illuminate the background, the photographer mounted a strobe on a 25-foot (8-m) stand outside his son's second-story bedroom window, using a blue gel to achieve the chilly "moonlit" effect. Meanwhile, a small softbox and a grid lit his main subject.

SHOOT AND SHOOT AND SHOOT Even in a controlled and highly stylized environment, working with kids still presents challenges. Keep your camera rolling so you don't miss unscripted moments.

180 ADD MOOD WITH FOG

To re-create the misty atmosphere that you see here, rent a fog machine from a party- or events-supply company. Or you can purchase fog in a can, a cheaper and more portable alternative. These tools will help you safely mimic smoke, haze, steam, or beams of Hollywood-style light in your images.

181 RE-CREATE A MAGICAL CHILDHOOD SCENE

Some stories are too good to make up—but you can always re-create them. Case in point: this young girl reading to a rapt audience of stuffed animals well after her bedtime. After stumbling upon this charming scene late one night, her parents planned a shoot to reverse-engineer the adorable moment for the camera.

PREP LIGHTS IN ADVANCE When you're working with children, time spent fiddling with gear is time lost—your subjects will grow bored. So experiment with your lights before the model is called on set, using a stand-in for the child. Sometimes, this could require a morning or even a full day to finesse, as this shoot did.

FAKE AMBIENT LIGHT To provide a main light source that appeared native to the scene and create a spotlight on the child, the photographer sneakily stashed a flash in a small reading lamp (A). Meanwhile, a 7-foot (2-m) softbox (B) hovered above the scene to bring out details in her audience, and a blue-gelled strip light (C) to the subject's right created that moody, midnight-blue vibe. An orange

gel over the flash in the reading lamp balanced this blue cast with a warm pool of light. Meanwhile, a 1-stop neutral density (D) filter toned down the brightness caused by the light's closeness, creating the snug, enchanted feel of a secret story time.

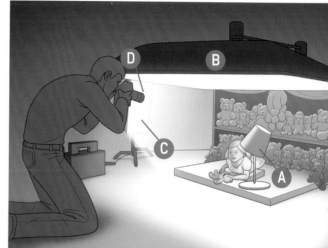

182 ROCK A PRAM CAM

Yes, your eyes do deceive you: This is not an infant in a turbo-charged hot rod doing 100 miles per hour (160 km/h) around the Indianapolis 500 track. Instead, it's a clever shot of a kid safely tucked into his stroller as he's pushed down a grocery-store aisle at a reasonable speed. It does borrow some technical specs from automotive photography, however, in that it's a so-called "classic rig shot": an image created by dragging the shutter of a camera that's clamped to a moving car, resulting in a sharp subject and blurred background. You can play with this trick and portraits using a bicycle, kayak, stroller (like you see here), or anything that goes.

STEP 1 Before you head to your location, do a few trial runs with the camera and correct lens mounted with hardware to your chosen vehicle. Try an ultrawide lens to capture plenty of background—the blur there is what makes these images so compelling. Don't forget to tuck in Junior for the test shots, too.

STEP 2 Scout a background that will look nice when smeared by the slow shutter speed and fill the sides of your composition from top to bottom, as the supermarket aisle's dense shelving does in this photo. It also helps that the aisle had long, horizontal aluminum stripes (for displaying product prices) that added structured streaks to the motion blur. Other nice ideas: a canopy road, illuminated tunnel, or downhill lined with picturesque fences. Just be safe!

STEP 3 Find the exposure. While this photo looks like the baby was on a fast breakaway, it's actually the slow shutter speed of 1 sec that gives the illusion of speed. An f/13 aperture allowed for enough depth of field to make both the kid's shoe and his face relatively sharp. Bright overhead lighting also helped out, allowing for ISO 100 and a noise-free image. Experiment with exposure until you get it, and encourage your subject to keep his or her face still during that 1-sec exposure.

183 PHOTOGRAPH NEWBORNS

New babies are pretty precious things—tiny and charmingly smushed, they make strange, entrancing gestures and faces as they blink and stretch their way into the world. But they don't stay that way for long, which means you should schedule your shoot in the first two weeks of the child's life. Most babies at this age sleep through anything, so you'll have much more freedom to position one than you will an older baby. Aim to arrive about an hour after they're fed, as that's when they're most agreeable, and stage your session in a warm room so they're cozy and comfortable. Get blankets and fabrics with great textures, and place the baby in and on whatever you can find—baskets, mixing bowls, cushions.

As for gear, we recommend having a macro lens on hand to get in really tight on those amazing details: impossibly small feet, sweet eyelashes, chubby rolls. Made for close-up focusing and intense magnification of even the tiniest details, macro lenses can capture a feature at the same size on the camera's sensor, creating a 1:1 ratio. And if the wee babe gets the hiccups? Turn your camera to burst (continuous) mode so you don't miss a single little chirp.

184 PICK CAMERA SETTINGS FOR KIDS

Motion is a kid's natural element—if you need an excuse to get a fast-focusing DSLR, children are definitely it! A few handy camera tricks will help you keep up.

FIND FACES Let your camera's face-detection tool automatically focus on and expose for the face. Otherwise, place your focus point on the subject's eyes. Use continuous autofocus for subjects on the move.

SKIP THE TRIPOD A handheld camera gives you more freedom to follow kids. Activating image stabilization on your camera or lens will help keep handheld shots steady.

CHOOSE EXPOSURE SETTINGS In most candid kid shots, autoexposure is the way to go. For more careful setups in which you want to control depth of field, try aperture-priority. For fast-moving family fun, shutter-priority is the better option. Just make sure the ISO is high enough allow a blur-preventing shutter speed.

CAPTURE MOTION Besides shooting in burst (continuous) mode to catch action and fleeting facial expressions, use a lens that lets in a lot of light (f/2.8

or lower) so you can set a fast shutter speed and rely on ambient light without flash.

GO NATURAL One way to keep a relaxed atmosphere—and soft look—is to shoot in diffused natural light. If there's not enough in your scene, use continuous (hot) lights or flicker-free fluorescents. Add bounce with an umbrella or diffuse the light with a softbox (see #148 and #155).

185 JUMBLE ADS AND PEDESTRIANS

Try adding brilliant shots of color and funky juxtapositions between city denizens and billboards to your street scenes, contrasting the artificial consumer world—and the larger-than-life models—with the real people who pass below.

STEP 1 Bring a moderate-length, supersharp telephoto lens to avoid linear distortion. And leave your tripod at home—shopping-district sidewalks are too crowded to use one.

STEP 2 Look for street-level ads in shopping districts where construction barricades are plastered with huge chain-store posters. Pick ads that are either entirely sunlit or completely in shadow. Contrasty light and mixed shadows can jumble your composition. Long, horizontal ads rich with bright color are the strongest choices.

STEP 3 Wait for your actors. You may need to hang out for an hour until a billboard's graphics are complemented by just the right passersby appearing in front of it.

STEP 4 Shoot with your camera held parallel to the ad to bypass keystoning (distortion in which a building seems to lean backward). Frame out the ad's edges to lend an all-encompassing, even surrealistic mood to the image, and plan to heighten color and sharpness in postproduction.

186 TRACK FACES WITH AUTOFOCUS

Tracking (aka "continuous" or "servo") autofocus modes can help you document quick-stepping passersby, and face tracking can keep people heading toward you in focus. If you have a manual focus lens with a depth of field scale, you can shoot quickly, remain inconspicuous, and keep your eyes on the scene by zone focusing. Without using your viewfinder, aim your lens at your subject and eyeball the distance. Then set your aperture and focus ring so that the depth of field scale indicates that everything you want in focus falls within the distance range indicated. Using an aperture between f/8 and f/16 should give ample depth of field.

187 GEAR UP FOR PET SHOOTS

When photographing pooches in the studio or on location, it's best to go easy on the equipment. Man's best friend can get intimidated by all the flashing lights, noisy shutters, and expectations to stay still and look at the lens. Still, being able to select and work gear to your advantage is crucial with these lovable subjects.

FOCUS ON THE EYES In some respects, photographing dogs is not so different from photographing people. For example, their eyes need to be in sharp focus. For pets, it's likely that your autofocus will latch onto the snout, which will be closest to the camera. Instead, switch on single-point focus, which will allow you to select the dog's eyes from a grid of possible focus points. To get pets to look at you, have a noisemaker on hand.

GRAB THE ACTION For pooches on the go, set a fast shutter speed and, if you're not in especially bright light, bump up your ISO to compensate. You may also want to try shutter-priority mode, starting off with 1/500-sec exposure. It also helps to switch to continuous (tracking) autofocus in order to keep up with those lightning-fast romps and leaps.

LIGHT THEM RIGHT Consider coming equipped with a standard studio setup and its portable lighting equivalents. Regardless, quick-recycling lights mean more shots per minute—important due to pets' limited patience. If you're working with an accessory flash, pair it with a modifier or bounce it off the ceiling to avoid making the pup's eyes flash yellow or green. Many pets are nervous of strobes—try giving a treat with each shutter snap and flash bulb, or opt for continuous lights.

CAPTURE BLACK BEAUTIES Making portraits of dark dogs often proves difficult—in natural light, you can lose their eyes and fur texture, while flash can wash out their coats' rich color to a dull gray. To bring this information back, use soft fill flash with a reflector or a softbox-encased strobe. You can also tweak exposure compensation to correct for overexposure of a dark dog.

CRAFT CLOSE-UPS Try isolating the canine of the hour on a pedestal to prevent him from wiggling out of frame. Make sure he's far from the background, then switch to aperture-priority mode and home in at your lens's widest aperture for a smoothly blurred background.

189 FREEZE THE CAT WALK

Dary Sime describes herself as an opportunistic photographer—and she's also a vocal animal lover. So when she came across this barn at a farm in Iowa, her eyes went first not to the building's rustic textures, but to its inhabitants. "My attention is automatically drawn to the furred and feathered," she says. "The cats came out of the barn onto the catwalk, one after another, setting themselves up for a perfect shot."

Sime aimed her zoom lens at the barn, waiting for the cats to file out. She made her exposure on a Nikon D80 (1/1250 sec at f/9, ISO 800) at just the right moment.

188 SNAP A CAT

Trying to photograph cats is a lot like trying to herd them—great for laughs, but usually unproductive. Here's how to kick up the quality of your kitty captures:

USE THE RIGHT GEAR Work with the longest lens possible: sometimes a 50mm f/1.2, but more often a 70–200mm f/2.8. The latter will nail a moving cat from across the room in good existing light. A wide-angle zoom (e.g., 16–35mm f/2.8) will also allow you to zoom in and out, if needed, once the cat is comfortable with you. Cameras with high burst rates are mandatory, at least five frames per second.

BE PREPARED To get that one cool photo of a kitty, work just like a *Sports Illustrated* photographer capturing the key play that wins the game. Be prepared to reach—never put your camera away.

PATIENCE IS KEY You can't make terrific cat photos in a hurry. Make time to linger, perhaps for hours, waiting for Kitty to decide on her own to come out from under the bed.

PREP YOUR PET If the cat will be attracted to snacks or treats, going light on the kibble before the shoot

can help ensure a more attentive subject. To use treats effectively, tease the pet by concealing one in your hand, making sure the cat knows it's there. For group portraits of a pet and its owners, these expressions can suggest affection between human and animal.

INCLUDE COMPELLING BACKGROUNDS They should be clean and well lit, just like backgrounds for human subjects. Try walking a circle around your subject to locate a nice background element. Photographing cats where they shouldn't be (like under a rug!) can work, but a simple black backdrop can show off feline beauty, too.

190 PAN WITH YOUR CAMERA FOR SPEEDY SUBJECTS

Panning—rotating with your camera to track motion—can produce captivating shots of a sharp subject against a blurry background, conveying action instead of freezing it dead.

SELECT A LOCATION Look for a homogeneous background but not a solid color. Position yourself so that the subject's line of travel will be parallel to your camera's imaging plane.

SET THE SHUTTER SPEED Use manual exposure or shutter-priority mode. Try out shutter speeds from 1/125 sec down to 1/8 sec.

GO MANUAL Your camera's autofocus may go in on the background instead of the action.

PIVOT WITH YOUR CAMERA Aim your feet where you think the pan will end. Next, twist from your hips to point your camera toward the oncoming subject. As he or she speeds by, unwind while holding the camera level and supporting the lens with your hand. Track the subject until the shutter closes.

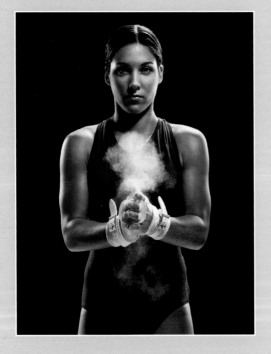

191 CAPTURE SPORTS STARS IN PREP

Photographing an athlete making the crowd go wild is every sports photographer's aim, but so is illuminating the quiet moments that come before the great goal, fierce knockout, or deft and dazzling high-bar routine.

Look for—or stage—a subject taking a few seconds to rally for a big shot. Here, a focused, determined stare and dramatic puff of chalk tells viewers that the subject is ready for action, but so could closed eyes during a stretch, attentive nods during a pep talk, or a tight, tense face as an athlete wraps a vulnerable joint.

This portrait was captured with a 50mm f/1.4 lens and an exposure of 1/250 sec at f/11 and ISO 100. Two monolights outfitted with beauty dishes create the heroic lighting that helps do the moment justice.

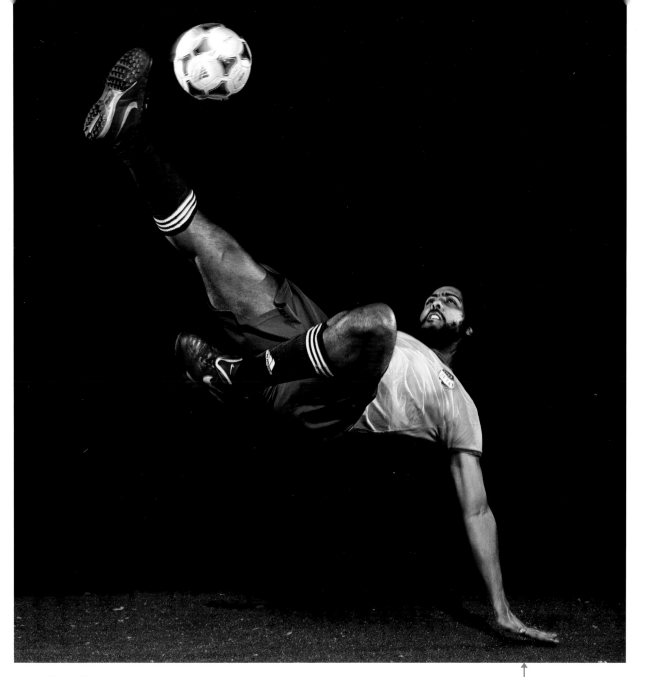

192 FREEZE FAST ACTION WITH FLASH

Want to stop a crisp kick? Your flash—the built-in unit or, even better, an accessory shoe-mount unit—is the go-to choice in low light when you can't use high shutter speeds to hit pause on dramatic action.

The key concept is that the lower the flash's power, the briefer its duration: Accessory units can fire at 1/50,000 sec or even faster, which makes them ideal for nailing powerful bicycle kicks, like you see here.

To get the fastest possible bursts, crank up the ISO as high as reasonable and put your flash close to the subject. (A remote trigger with an off-camera flash will help you fire without disturbing the scene.) If you can, try a multiflash setup for more three-dimensional lighting. Here, five flash units ring the soccer player, with a teammate just outside the ring throwing him the ball. Luckily, he's got a pretty controlled kick!

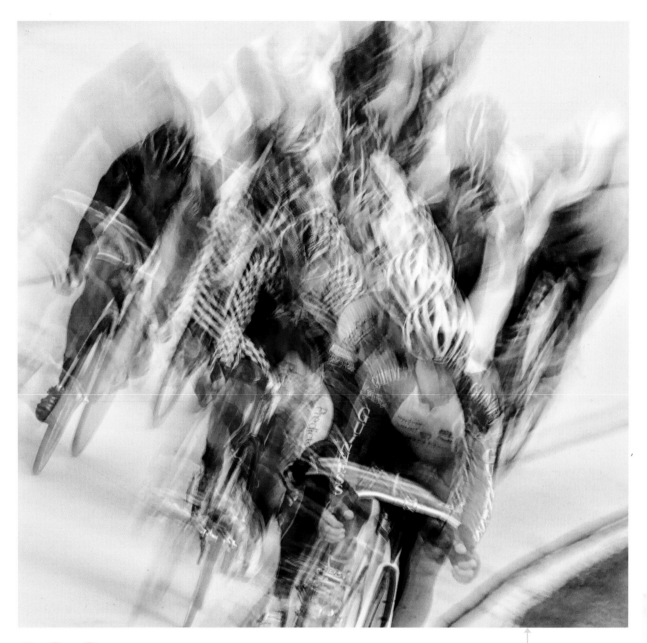

193 JOSTLE THE PELOTON

Often the winning strategy for an outstanding athletics portrait isn't a single strategy at all. Instead, it results from many clever tactics combined to fascinating effect.

Take, for instance, this unusual and interesting image of a pack of cyclists on a velodrome. To create it, the photographer perched on a walkway near the velodrome's periphery and racked out his 100–400mm f/4.5–5.6 zoom, then pulled back as the riders advanced toward him. Panning and tilting the camera during the relatively long exposure (1/13 sec at f/16, ISO 400) scrambled the peloton, smearing their graphic uniforms and helmets into an intriguingly patterned motion blur that perfectly captures the constant jockeying for position crucial to the sport.

194 SMEAR MOTION WITH SHUTTER SPEED

Portraits needn't capture a single, precisely defined moment. Instead, you can use techniques that transcend viewers' usual visual expectations. Motion blur is one such technique—it can make familiar subjects seem mysterious, and it lends both lyricism and life to a portrait. It's best used when you're shooting subjects who know how to move well (such as the dance troupe in this image) and who would look their best in kinetic portraits rather than traditionally posed, static ones.

DEFINE A ZONE To keep motion in the frame, ask your subject to limit movements to a certain space. Mark it with tape lines so that your subject can easily keep within the area. Now her movements can fill the entire frame across a single exposure.

START THE TIMER Set your exposure—3 sec or longer will work—and communicate it so your subject knows how long she can move. After each shot, share the images so she can see what works. Then she can replicate her successful gestures, tweaking them to attain the ideal shot.

MERGE WITH SOFTWARE Even with these controls, motion-blur shots can be unpredictable. Search through your images after the photo shoot to find ones that you can strengthen by layering into composites. The abstract dance portrait here is two shots that together produced more dynamic punch than either could on its own.

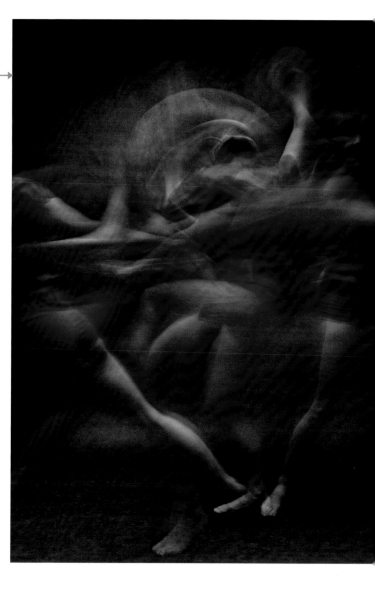

195 GO FOR BACKWARD BLUR WITH TRAILING SYNC

Mixing flash with a slow shutter speed can render moving subjects sharp against a blur of movement—a phenomenon called ghosting. While dynamic, ghosting has one glitch: Since flash synchronization occurs at the start of an exposure, forward motion seems to travel backward, extending the blur in the wrong direction. Luckily, there's an easy remedy: Set your flash to trailing sync (also called second-curtain sync), which fires the flash near the end of the exposure and blows ghosting out behind your subject. Experiment with 1/8- to 1/30-sec shutter speeds—the faster your subject, the longer the blur trail. To capture truly frenetic action, pan with your subject at a speed slightly slower than his own velocity, and an especially streaky, smeared background will appear.

196 CAPTURE EDGY SPORTS WITH GRITTY LIGHT

Roller derby squads are known for their fierce, devil-may-care, and performative moves out on the floor, which makes photographing them a blast. Not so fun? Popping your subjects off the cluttered, horribly lit background found in most roller rinks—in this instance, a very dark, visually noisy gym with nasty sodium-vapor lighting.

The solution? First, get your squad illuminated. A monolight (A) bounced into a convertible diffused umbrella (B) did the trick. The light will be soft—large enough to light the whole group—yet directional enough to leave some dramatic shadows and keep the team's edgy character.

Next, to tackle the issue of a hideous location, set a relatively small working aperture (f/13), dimming most of the background to pitch black. While this will surely tame the ghoulish sodium-vapor color temperature and background clutter, it may also cause your subjects to vanish into the shadows beyond, as do parts of the black-clad amazons here. Try lighting the backdrop (i.e., the floor) with an unmodified strobe (C) inside a 7-inch (17.75-cm) reflector. The pool of light will separate the team from the all-black background.

Last, to accentuate the skaters even more, add a monolight (D) with a grid spot to serve as a subtle rim light, gelling it a cool blue to create contrast against the warm-toned flooring.

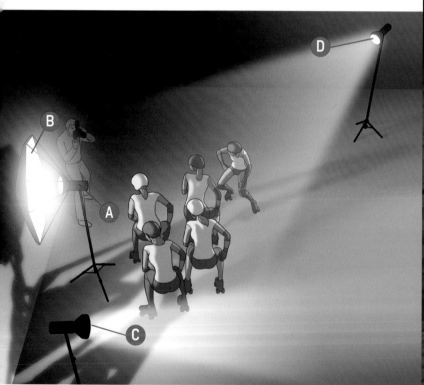

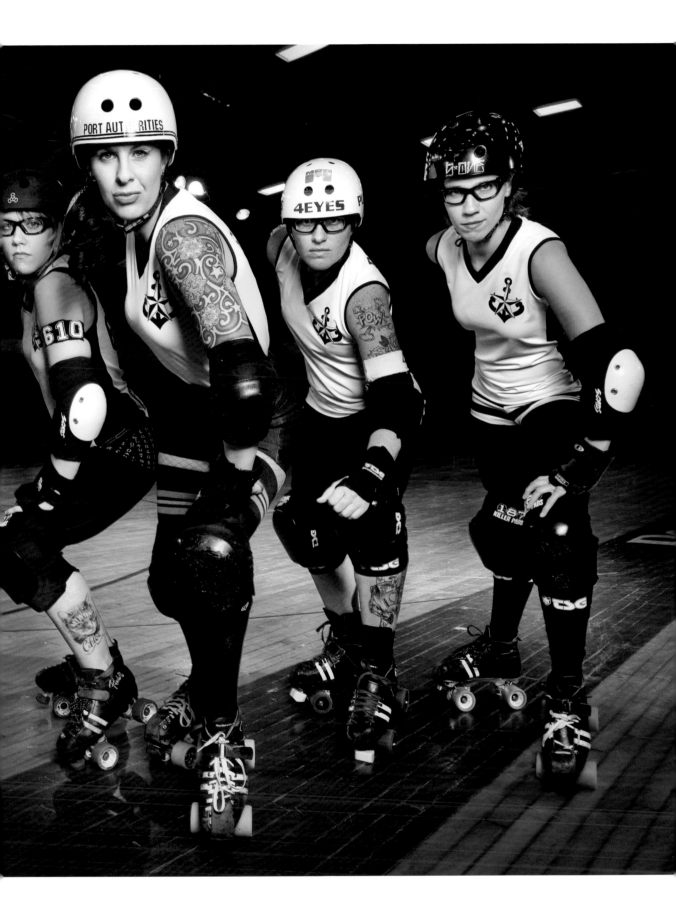

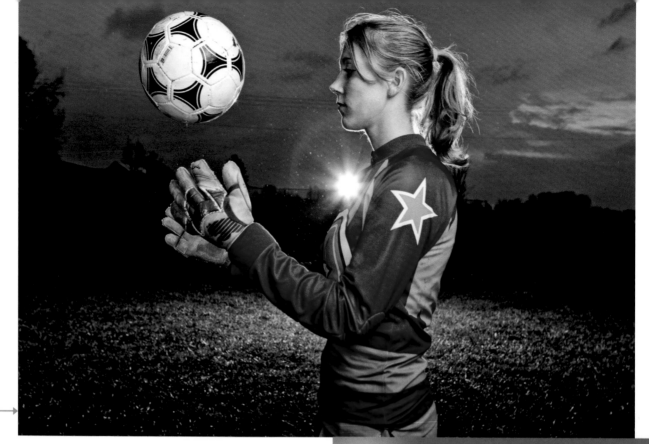

197 MAKE AN ATHLETE POP OFF THE FIELD

We've all been there: You're trying to photograph someone outdoors and the light just stinks. Take, for instance, this photograph of a star high-school soccer player at dusk, created under raining cloud cover, depressingly dim ambient light, and a soggy blue cast. A straight snapshot produced a flat portrait without color, texture, detail, or presence, with the young athlete blending sadly into the drab distance. Most important, the scene lacked the necessary depth.

Luckily, strobes came to the rescue as sunlight substitutes—a technique you can try next time you're in a flatly lit scene with a would-be heroic subject. For the distant horizon, underexpose the scene to exaggerate the twilightlike gloom and bring out texture and detail in distant clouds. To bring life and color to the midground and create a central hot spot for the subject, place a bare strobe head (A) on a light stand (B) almost behind the subject, creating a pool of clean, bright daylight midframe, bringing out visual texture in the grass and goosing the grass's color. The midground light will also etch a bright white line around the subject's

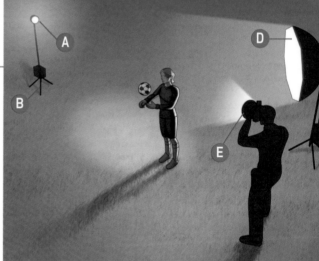

face, neck, and hair, electrically defining her profile and popping her forward off the distant dark.

As for a main light, mount a strobe (C) inside a softbox (D) in front and so far afield of the subject that it functions as a sidelight, sculpting the folds of the uniform. To balance out the lighting, a ring light (E) mounted to the camera will fill shadows created by the sidelight so you can see that casual, yet expert toss of the soccer ball in an evenly lit scene from left to right.

198 GO LONG WITH A TELEPHOTO LENS

Sports fans looking to snap amazing images of their favorite sports stars in action, don't fret: A telephoto lens can get you almost as close as the sidelines. And if you want to imagine that you feel the sweat flying off the field, try renting a supertelephoto for the day.

When working with such long lenses, start your shutter speed at about 1/1000 sec, as these beasts tend to really exaggerate movement. For certain shots, you may get away with 1/800 sec or 1/640 sec, but that's a different type of action, because it's not as magnified by the telephoto lens. This image of airborne Red Sox outfielder Manny Ramirez rushing to the plate was created with a 400mm f/2.8 lens at 1/800 sec at f/2.8, ISO 1600.

QUICK TIP

199 SKIP THE CHIMP

When you're shooting live sports events, the action doesn't stop after your exposure. So pausing to check your LCD after capture to ensure you got the shot—humorously called "chimping"—all but guarantees that you'll miss the next one. To break the habit, try covering your LCD with a piece of paper so you develop the confidence to keep your eyes, as they say, on the ball.

200 TAKE A COMPACT FOR A SWIM

The easy availability of reasonably priced, good-quality gear has made the prospect of underwater portraits accessible to a lot of people—even to folks just looking to catch a few summertime candids in the family pool. Great for taking both stills and video while completely submerged, waterproof compact cameras are the perfect tools for capturing casual pool shots. Find one equipped with a wide-angle lens and close-focus capability and you're practically a deep-sea diver.

One bonus to shooting poolside is natural light: The shallow depth all but guarantees that the sun's rays will reach your subject. And composition underwater is equal parts challenging and fun. Try aiming for the bubble explosion that follows an afternoon cannonball, or shoot a partially submerged, distorted subject from just below the surface. You might also try photographing right at the surface, catching a lap swimmer's form both above and beneath the water level.

Odds are the pool down the street or in your backyard isn't deep enough to host Olympic high divers. In that case, a relatively cheap waterproof compact camera should be safe under the surface, as the watertight limit is 10 to 33 feet (3–10 m) for most models. If you're shooting in a deeper pool, use your strap to prevent potential damage caused by drops. Finally, before you call it a day and put your gear away, be sure to rinse your camera with plain water to wash away corrosive chemicals.

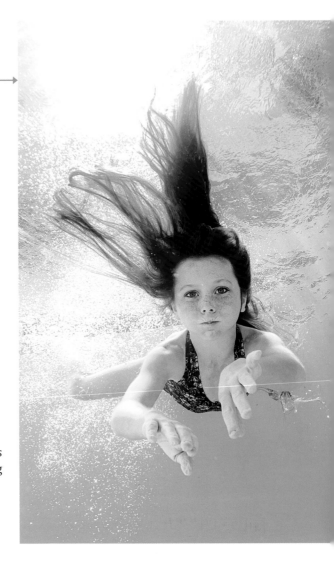

201 OUTFIT YOUR DSLR FOR UNDERWATER USE

For great underwater portraits, you and your DSLR are just going to have to get wet. Use these tips to keep your gear—and yourself—safe in the water.

GET A HOUSING Underwater housings are built for specific DSLR models, and most are manufactured from high-strength plastic (polycarbonate) or aluminum, with aluminum being more rugged and costly. Whatever you choose, be sure it's tested at the depth at which you intend to shoot.

USE AN EXTERNAL MONITOR Trying to peek through a viewfinder or at an LCD with a dive mask on is not ideal. Use a waterproof external monitor for the easiest view.

CHOOSE LENSES Water's density—about 800 times that of air—can impact sharpness, contrast, and other image attributes. For the best shot, get close with a wide-angle or macro lens. A prime lens can help, too, especially if you can't access a zoom ring through your housing. Keep your lenses safe with a lens port—a clear pressurized bubble that fits into your camera housing.

BE SAFE Attach your gear to your body with the wrist straps and leashes that surfers use—if you get socked by a wave in the sea, you'll likely drop your camera. Be safe, too: You should be a strong swimmer, snorkeler, or diver, and you should never go in after a shot alone.

203 CRAFT ARTISTIC UNDERWATER VIEWS

The floating figure with billowing hair and flowing wardrobe is a popular visual trope of underwater portrait photography. In fact, one of the main reasons some photographers shoot underwater is because of the zero gravity look it can create. Hair, seemingly weightless, assumes an ethereal, drifting quality. Flowing garments, too, can take on a life of their own.

Even so, the floating look isn't the easiest one to achieve, let alone capture. To avoid underwater blunders, let your subject grow accustomed to the way her hair and clothing moves before shooting. Don't just ask a person wearing a dress to jump in—it can result in a skirt essentially swallowing your subject and an almost comical struggle to right the garment.

Of course, the floating subject isn't the only boon to shooting underwater. Your own weightlessness, as a photographer, can be an asset. Being underwater allows you to approach your subject from nearly any angle. Where it could take some serious labor and set construction to take a shot from on high in the studio, when you're underwater, you can simply swim higher than your subject and shoot downward. Just be aware of the shadows that your own figure might cast.

202 KEEP YOUR UNDERWATER HOUSING IN TOP SHAPE

To keep your underwater housing tight and your camera protected, consider these tips—and always follow the manufacturer's instructions.

KEEP YOUR O-RINGS CLEAN Even a tiny grain of sand can cause a leak. Follow the housing manufacturer's suggestions for when and how to clean, lubricate, and change O-rings. If you're heading on a dive or beach shoot, always bring a backup set.

CHECK FOR LEAKS Before using your housing (or after it's been sitting in the closet for a while), test it. Submerge the housing, without the camera, in water—ideally at least 33 feet (10 m) deep—to check for leaks. Electronic leak detectors, which let you know when you've sprung a leak while diving, are available for most underwater housings.

AVOID DRIPS Before you get in the water, double-check all closures. When you surface, avoid inadvertently dripping water on your camera by drying the outside of the housing with a soft cloth before opening the case.

SOAK POST-USE After a dive, soak your housing in fresh water overnight, working the buttons and levers to rinse away salt. Avoid leaving the housing in the sun.

204 RIDE A WAVE WITH A SURFER

The thrill of catching a rad swell isn't just for surfers—it can be for photographers, too.

PRACTICE ON LAND Quell the urge to dive in after the first surfer who zips into his wet suit. Instead, start by shooting from the beach or the pier with a 70–200mm f/2.8 telephoto lens, which will compress the background and make the surge of water and its rider stand out. Shoot perpendicular to the waves to capture the full impact of the onrushing liquid. You can also try a wide-angle lens and a low angle at the water's edge to emphasize the height of the wave.

TAKE THE PLUNGE Head into the water only if you have a waterproof housing and strong nylon tether for your camera, understand the surf pattern, and are an excellent swimmer. It's also key to learn how sets of waves behave in your chosen location and to be comfortable composing and exposing surf shots. Big waves may be great for surfers, but they can create dangerous situations for photographers.

GO TOTALLY TUBULAR For killer shots straight into the barrel of a wave, fill the frame with water by using an ultrawide-angle lens—or even a fisheye (see #113)—and holding your camera close to the waterline. Not only does this technique allow you to capture the full body language of the surfer riding the wave, it can also be a great way to make a small tube look powerful, magnifying its visual impact.

MAKE FRIENDS Surfing has its own particular culture, which is often closed to outsiders. Many want to protect the waves they love from the masses. You'll have an easier time if you start out photographing friends who ride the boards. If you're trying to break the ice with some new surfing acquaintances, try offering prints of your images as a sign of good will.

205 ILLUMINATE UNDERWATER PORTRAITS

When shooting underwater, your biggest challenges are darkness and loss of color. Most underwater camera housings don't permit the pop of your camera's flash, and its light likely wouldn't be strong enough anyway. The colors also disappear the deeper you go, with red vanishing first at 15 to 20 feet (4.5–6 m), followed by orange, then yellow, and the rest of the colors in the visible spectrum. So when you shoot with light trickling down from the surface, your photos turn out blue and black.

The fix for both? Waterproof external strobes. Two will define your subject's shape and add details, but even one will boost up most scenes. Plus, one strobe is lighter when swimming, and it will likely cause less pesky backscatter (reflections off the surface). Mount your strobes to your camera with an articulated arm (just be sure the mounts work with your camera's underwater housing). You can also recover warmth in your images by choosing the cloudy setting or by creating a custom white balance with a white diver's slate.

But sometimes inky darkness is just what you're after—take, for instance, this dramatic, lurking-in-the-depths portrait of a lacrosse player, which was created largely with natural light. For a similar effect, try lining the pool's bottom with a white backdrop—it will bounce ambient light from the surface back up onto the subject. Conversely, a black backdrop behind the athlete is to thank for the moody darkness, creating the illusion of a deeper submersion. To avoid drowning out your subject's features, try holding an underwater flashlight just out of the frame and angling it so it grazes the cheek.

206 SCALE GREAT HEIGHTS FOR A PORTRAIT OF A CLIMBER

Photographing daredevils often means being a bit of one yourself. That was true in the creation of this image, which captures one of the first mountaineers to ascend the Arch of Bishekele in Chad. Sometimes the photographer clambers right alongside the climber, dangling from rock faces to get the shots, but you don't have to put on a harness to start shooting.

GO WIDE The key to a good wide shot is to bring as much of the landscape into the image as possible, giving it scale and mimicking the tininess many feel in nature. Wide shots require some hiking, though, so pack light.

PROTECT THE GEAR Rocks are the mortal enemies of glass. And while your lens is tougher than you might expect, certain situations certainly call for extra protection. Look for protection filters, which are made from ultrahardened, optically transparent glass that won't scratch after a reasonable encounter with a rock.

GET UP While it's possible to shoot from the ground, the perspective limits your pictorial potential: You'll come away with a bunch of butt shots. Seek out higher ground alongside your subject, or arrive at the ascent first to document your adventurer coming over the wall.

CAPTURE WOWING MOMENTS Seek out moments in which the climber seems to commune with the space, as in this assured glance up the cliff face.

Whether you gently float along on flat water or fly down jaw-banging whitewater rapids, a fantastic way to capture your subject immersed—sometimes literally—in nature is a rafting excursion. Coming home with great photos (not to mention a dry camera), however, takes special preparation. Here are some tips for successfully photographing rafting trips.

ASK QUESTIONS Rafting companies specialize in safety, not photography, so it's up to you to inquire about the needs and restrictions of bringing extra gear such as waterproof cases and tripods. Guides don't have time to offer photo advice, so visualize a shot list beforehand. (Check out the rafting company's website, where the company may have posted footage of the rapids.)

BRING THE RIGHT GEAR Waterproof compacts are great for the roughest rapids, but also bring your DSLR, along with a waterproof housing (see #201) and carabiner clips for securing your gear to raft lines.

BE PREPARED Always be ready to shoot, as there are no second chances when you're tumbling down the river. You may need to shift quickly from rowing to shooting modes, and being able to easily pivot at the waist to capture the expressions of your fellow adventurers is a must. Look to see who the water's pouring on—that's likely your shot! Try to mix up the shutter speeds in the rapids to capture a variety of water effects.

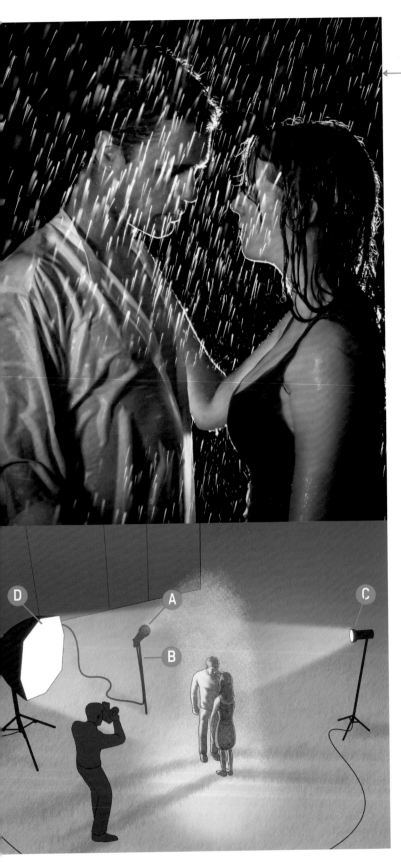

208 FAKE A RAINSTORM

For a rain-soaked, film noir–esque portrait of desperate lovers in a storm, you'll need to do a whole lot of tinkering with your lights—and have a whole lot of towels on hand! Two good tips: Try a few dry runs to nail poses before you let the water run loose, and hold your shoot on a warm summer night. Otherwise, you'll spend hours cloning out goosebumps.

To create the effect of rain, start by duct-taping a garden house with an adjustable sprayer attachment (A) to a rod driven in the ground (B) in your yard. With the sprayer aimed upward, adjust its output so the falling droplets simulate rain. A stand-mounted strobe head and reflector (C) will backlight the drops, while a second strobe in a softbox (D) frontlights the models, both fired by a wireless trigger. Backlighting increases the risk of lens flare, so make sure your light source is off to the side or directly behind and blocked by the subject.

Crucial safety concern: Water and electricity don't mix. If you're shooting with studio strobes outside, your outlet should be a ground fault circuit interrupter (GFI). This will kill the electricity instantly if water causes a short circuit.

209 DIY A LENSHOOD

Costly rain gear—watertight Gore-Tex rain sleeves and moisture-proof hard cases—can keep your camera dry. But there are cheap and cheerful ways to ward off raindrops, too. Cut a hole large enough to fit snugly around your camera lens into the bottom of a clear plastic bag, then seal it with a rubber band. Snip two more holes in the bag's sides to thread your camera strap through. Put your hands through the open end of the bag to manipulate camera controls. Clear, elasticized shower caps also make decent gear covers.

210 SHOOT STREET SCENES IN THE SNOW

Most street photographers work with available light or an on-camera or handheld flash at most, but it's entirely possible to incorporate more large-scale studio lighting into your anonymous scenes—and during a Chicago blizzard, to boot. The lyrical, snowflake-specked image here obtained its dramatic backlighting from a speedlight positioned on a light stand directly behind passersby on Michigan Avenue, creating a halo effect when triggered with a slow shutter speed (typically 1/8 sec and f/5.6, ISO 160 or 200, using ¼ flash power).

To attempt a similar shoot on a snowy evening of your own, set your strobe up on the street and find a good vantage point immediately opposite it. Tweak your camera and strobe settings in manual mode throughout a number of practice shoots, capturing whoever walks into the frame as your test subjects. Once you've got a handle on your settings, wait for the right person to walk by at the right moment, and then trigger your strobe and shutter to render the silhouette in front of a cinematic array of white pinpoints against black.

211 GEAR UP FOR THE BIG DAY

The essence of a wonderful wedding portrait is intimacy: a photo that shows a moment of true emotion between the couple or among their loved ones. To make the most of such unpredictable times, you don't need piles of equipment—just a few tried-and-true tools that will keep you light on your feet.

PACK THE BASICS Bring at least one DSLR with great low-light capability, plus a fast f/2.8 zoom. Some photographers like to pack two camera bodies outfitted with wide and telephoto lenses so they're ready for anything. Preset your cameras so you'll be ready to capture off-script kisses and tears.

LINE UP YOUR LENSES A 35mm and 50mm serve for basic portraits. Got a sideman? Ask him to stow others—perhaps a 35mm f/1.4, 50mm f/1.2, 24mm f/1.4, and a 85mm f/1.2—in a backpack.

LIGHT IT SIMPLE A reliable shoe-mount flash (see #139) is likely all

you'll need, especially if the wedding is outdoors and you require only fill. If you're concerned about light, seek out adjustable packs that will ramp up to 600 watts.

PACK EXTRA MEMORY Bring as much as 150 GB even if you don't think you'll use it all. Carry an extra card in case of glitches, too.

METER THE DRESS Underexposing the bride's white dress is a perennial problem. To capture its details without turning it gray, spot-meter it and then bump your exposure up a stop or 2 if needed.

CHOOSE A FOCUS A single-point autofocus works well for portraits during formal sessions, vows, and

toasts. For processions and dancing, try tracking (aka, continuous) autofocus for moving subjects.

SHOOT IN RAW It's better to take a sharp, noisy image at 1/500 sec and ISO 6400 than it is to take a low-noise, blurry one at 1/30 sec and ISO 400. Do noise reduction when you process your RAW photos.

212 SET UP A FASHION STUDIO

Making people look good enough for *Vogue* takes a little doing—and usually a lot of gear. Borrow, rent, or (if you must) buy the following tools:

GO FOR STROBES If you'll shoot movement (such as a model jumping or dancing), studio strobes and a power pack that's capable of high-speed output will help you freeze that action. You can use continuous output lights if you don't plan on having your model move around a lot—just be sure to give him or her breaks, as it can get hot under them.

CHOOSE LENSES A fast (f/1.4 or f/1.8) 85mm lens is, by many, considered the optimum portrait lens. Depending on the size of your studio space or location, consider stocking a 70–200mm f/2.8 lens as well—fashion photographers love them for their background-compression superpowers.

MODIFY LIGHT Even more crucial than your lights are the modifiers that shape their output. Umbrellas are portable and cheap, and can be used to reflect or diffuse light depending on their material (see #147–148). Perhaps the most useful, softboxes create amazingly soft light (see #155). Also stock a beauty dish, which fashion portraitists swear by for creating a concentrated spread of illumination over the face (#156).

GET SUPPORT Lighting kits come with stands, but if you buy lights separately, you'll need additional supports. Add sandbags for stability and an assortment of clamps and gaffer's tape to secure it all.

SYNC IT UP Tether your camera to a laptop so you can check your shots as you work.

213 SHOOT STREET STYLES

If you're after fashionable subjects without the fuss of styling and staging, hit the areas of your hometown where the fashionistas tend to gather: high-end retail spots, clubs, art galleries, and runway venues. If you're fortunate enough to live in a spot that hosts its own fashion week (even if it's not on the scale of, say, New York or Milan), station yourself outside the runway venues to snag shots of the well-heeled as they flit between shows. Try to find a nice background—an outside wall or urban space you can blow out with a small aperture—or go with the flow and capture the whole crowd.

A benefit of shooting street style is that you can pack a lighter gear bag than you would for a runway, studio, or location shoot. Come equipped with a nice 70–200m f/2.8 lens, or a nice prime like an 85mm f/1.2 or f/1.4, and you're set.

214 FIND NEW FACES AND FRESH FASHION

Editorial fashion photography is a rarefied world—high-end shoots require access to designer apparel, modeling and styling talent, and talented wardrobe stylists and hair and makeup artists. Most photographers do their fashion shoots at studios or on the streets, strategizing to locate models and clothes even if they don't have VIP all-access passes.

FIND MODELS Friends often happily serve as models, but it can get tricky. To widen your available talent pool, try contacting small local modeling agencies to ask about beginners who might need headshots.

SCORE CLOTHING Unless you've got direct access to a design house (or a friend who is an up-and-coming designer), you'll need to hunt couture in thrift stores and fabric shops. But the constraints of a budget—and the serendipitous finds you'll score—can actually help you create wonderful images.

TRADE AND BARTER TALENT Often what makes a fashion image compelling is the beauty of the model. Seek stylists and hair/makeup artists who are looking to build portfolios, then share the resulting images—it's a win-win situation.

215 CAPTURE THE CATWALK

When shooting a catwalk, it's just you, your camera, and a stream of glamorous subjects. With a small window of time to shoot, you need to get it right the first time. Here are a few tips for making the most of runway shoots.

GET A FOOT IN THE DOOR Shooting fashion shows usually requires an in. Small local shows offer excellent opportunities to hone your skills, and newbie photographers can often score decent seats there.

NAB THE HOLY TRINITY Once you're in the pit, there are three must-have shots: head-to-toe, three-quarters, and a close-up of the face and upper body. Make good use of your zoom. Ideally, aim for the full body as the model steps out, three-quarters as the model approaches you, and the close-up at his or her nearest to you.

SWEAT THE DETAILS Snap a model as she retreats; sometimes the back of an outfit is surprisingly intricate. Beyond the garments, designers put a lot of effort and thought into styling. Zoom in tight for close-up shots of hair and makeup, footwear, and jewelry. Even a zoom on an interesting textile or pattern can make a good shot.

AVOID THE SOLES If there's one view you don't need to capture for posterity, it's the soles of a model's shoes. Ideally, catch a model with the front foot flat on the ground, arms at the side, eyes open and looking straight ahead. Pace the model's walk. If it helps, count the model's steps. Note that male models have bigger feet and tend to show more sole. Also, models look down when they turn, so try to shoot before they do. (See #062 for more on shooting shoes.)

DON'T GET CAUGHT SLEEPING At the end of the show, designers often show their faces. Stay on your toes; some of them will just peek out quickly. Also, keep an eye out for celebs in the crowd. While you need special credentials to shoot the front row at some high-end fashion shows, you can often get some good shots from the photo riser before or during the show.

216 GET RUNWAY READY

The best runway photos capture both the model at his or her best and the garment at its most flattering. Here are a few things to consider when you're working to close the gap between your audience and the world of high fashion.

STREAMLINE GEAR CHOICES In the pit, there's barely enough room for photographers. Keep gear to a minimum. Your camera, a telephoto zoom (70–200mm with a teleconverter for full-frame cameras), and a monopod should be all you need. You'll also need a flash unit outfitted with a small softbox or bounce card to avoid harsh direct flash.

SET WHITE BALANCE Check your white balance (and exposure settings) before the show starts. A good rule of thumb for most shows is adjusting the Kelvin temperature to between 3,000 and 3,200K. If lighting is mixed, consider auto.

SHOOT MANUAL Shows at places like New York Fashion Week are usually fairly well lit; a shutter speed of 1/250 to 1/500 sec at f/4 works well. To get these settings, adjust your ISO accordingly. Of course, always be prepared to change quickly and intuitively; lighting can be uneven from one end of the runway to the other.

CHOOSE THE RIGHT FORMAT If using post-processing software after the fact is important, shoot RAW. If you're working on quick turnaround—say, your editor wants images online minutes after a show finishes—shooting high-resolution JPEGs might be best.

FINE-TUNE FOCUS If your camera's autofocus tracking can keep up with models in motion, continuous shooting might serve you well—and will get you a lot of shots to choose from. Conversely, single-shot autofocus lets you decide exactly when to trigger the shutter, giving you more control. Of course, manual focus is also possible: Prefocus on a specific spot on the runway and shoot when the model steps into frame.

GO WITH CENTER-WEIGHTED METERING Center-weighted metering tends to work well at runway shows, especially if the background is very dark or very bright. In some situations, a slight underexposure can drop the venue's background into black, making the audience disappear altogether and creating a dramatic shot.

217 SHOOT BACKSTAGE AT A FASHION SHOW

If you can get behind the scenes at a runway show, by all means do. People love seeing models getting dolled up for the big show in the midst of all the last-minute mayhem. (Again, try working a contact at a small local show.) Once you've made it past the runway, shoot with a wide-angle zoom like a 24–70mm lens, a flash, and a flash diffuser (a piece of cheesecloth attached with a rubber band works great). Keep an eye out for shots that reveal how "real" models are: texting, sipping lattes while they wait on hair extensions, or teetering in the notorious one-size-fits-all sample shoes.

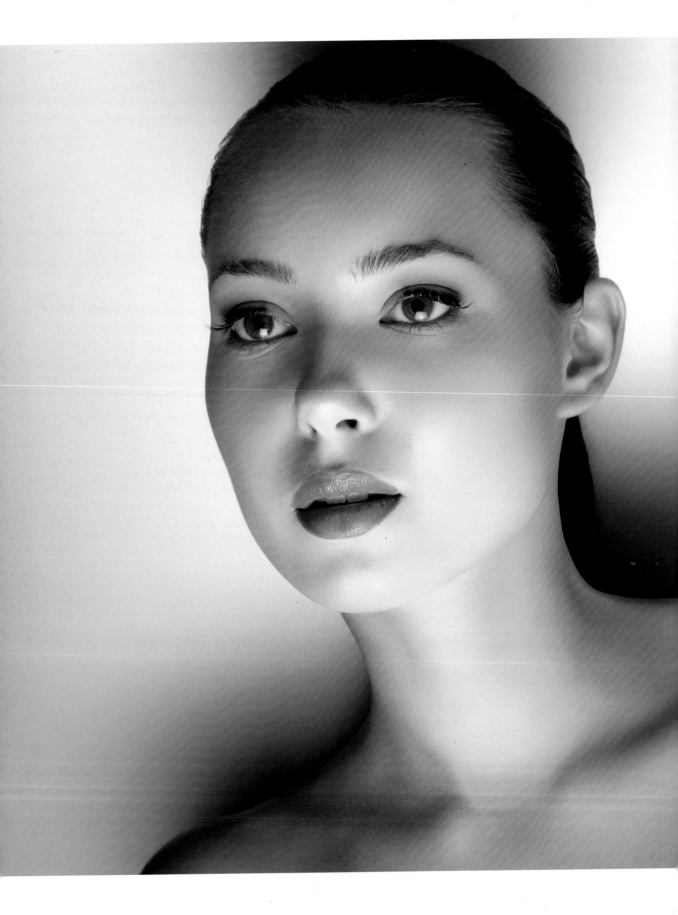

For beauty lighting, photographers typically place their main light just above the camera and aim it straight into the subject's face, so it casts little or no shadows on the visage. So why not challenge yourself to try a different tactic: a style of portrait lighting known in the movie industry as "horror lighting," but for the purposes of a beauty portrait.

In this scenario, the chosen lighting creates the opposite effect that typical studio setups yield. The illumination comes from below and, at its most horrific, casts dark shadows from the subject's cheekbones up into the eye sockets, turning your model's face into something ghoulishly skull-like.

To make horror lighting work, you first need the right model. Models are often prized for prominent cheekbones, but for this style of lighting, less prominent works better. Place your main strobe in a small softbox (A) to concentrate the dramatic shadows behind the model and create intimacy, mounting it on a low light stand (B) below the model. To fill in the shadows that the low-angle light created in the eye sockets and forehead, set up a large white reflector (C) above the model. Finally, hanging a silver metallic backdrop (D) will create a strong gradation. Just be careful using metallic backgrounds, as color from your clothing or the room could bounce off it, too.

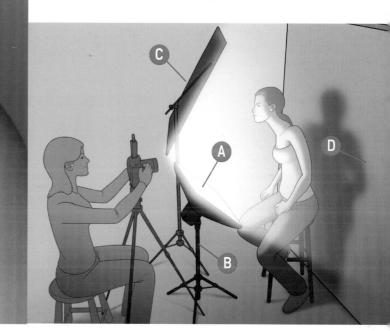

219 RETOUCH WRINKLES, TEETH, AND EYES

While no portrait technically requires retouching, if you're looking to make people look like the best possible version of themselves, a few tweaks help.

STEP 1 Since one of the most important features of a portrait tends to be the eyes, work to make them pop. In Adobe Photoshop, duplicate the background layer and name the new layer Eye Whites. Then, set the Dodge tool to midtones with Exposure at 50 percent. Zoom in real close and dodge the whites of your subject's eyes.

STEP 2 Duplicate your Eye Whites layer, naming the new layer Teeth. Grab the Color Picker by double-clicking on the color swatches in the toolbar. To select one of the teeth's whiter tones as the foreground color, use the dropper. Create a new blank layer and change its Blend Mode to Screen.

STEP 3 Like a virtual dentist, grab the Brush tool and brush your subject's teeth until they're shiny white. If

they start to look cartoonish, lower the layer opacity. Then go to Layer > Merge Down to blend the Teeth layer you created in step two with your whitened teeth layer.

STEP 4 To tackle any blemishes, create another new blank layer and name it Blemishes. Choose the Spot Healing Brush, checking the box for Sample All Layers and choosing Content-Aware. Zoom in close to remove any unwanted pimples, moles, or other imperfections.

STEP 5 Create another blank layer, naming it Wrinkles. Choose the regular Healing Brush and set it to Sample Current and Below. Next, sample a smooth patch of your subject's skin. From there, just paint over whatever wrinkles you'd like to erase. But go easy. If your work ends up looking too smooth, go to Edit > Fade and turn down the effect. A lot of times, simply shortening wrinkles, rather than erasing them, goes a long way in terms of making a subject look younger.

220 CONVERT PORTRAITS TO B&W

Black-and-white images have an unbeatably classic feel—plus, they can camouflage skin imperfections and harmonize clashing hues. The best place to begin is to take a great color image. When you have a good starting point, the variety of tones in color helps inform what should be bright and what should be dark in your eventual monochrome.

ADJUST TONAL RANGE Be sure your color image contains true black and true white by creating a Levels Adjustment Layer in Photoshop. Drag the white triangle inward until it's flush against the beginning of the histogram. Repeat with the black triangle. If necessary, brighten or darken midtones by dragging the center triangle left or right.

USE THE B&W TOOL In Photoshop, click the Black & White button in the Adjustments Panel, and then hit the Auto button. Select the hand tool and place it on your image. Drag right on a tone to lighten it, left to darken it. The B&W tool also has a series of filters and presets. If you're looking for gritty, try the High Contrast Blue Filter. If soft is your goal, try a red. Play until you find the right tool for your image.

221 HARNESS LIGHTROOM

Photoediting software is a powerful portrait-polishing tool. In fact, most of the images you see—whether online or in print form—have been touched by some form of software. From making subtle touch-ups to already gorgeous shots to reinventing images so they have an abstract bent, a whole host of programs exist to help hone your photographic vision. While Adobe Photoshop is certainly the most popular and vigorous, Adobe Lightroom is cheaper and great for straightforward photoediting needs. With easy color adjustments, touch-up tools like spot removal and red eye removal, and crop tools, it really has the basics down. It's also non-destructive, meaning that whatever experimentation you might make to an image happens, essentially, to a copy of that image—leaving your originals untouched.

223 EXPERIMENT WITH FILM

If you've been shooting with a DSLR and would like to try out (or get back to) film, there are many options. Recent and current film SLRs have autofocus, autoexposure, autowind and rewind, and auto setting of ISO—everything a DSLR has, except the instant gratification of seeing your photos on the spot. On the spectrum's other end are vintage and modern film cameras that are strictly manual focus and exposure. Try one for the experience of making all settings yourself, instead of leaving it to an electronic brain.

Start with color-print films, which give the most leeway and are forgiving of errors of up to several stops. They also allow you to scan them to a digital file that you can edit, share, and print. B&W films give good latitude, too, while color-slide (or reversal) films offer the least latitude but capture crystal-sharp images and rich saturation. Frame carefully, and mind the depth of field—there's no LCD to check your work after the shot.

222 PIN YOUR EXPOSURES

A simple pinhole in a closed box—no lens or sensor or flash required—can form an image, as people have observed for thousands of years, via a dandy principle known as the rectilinear propagation of light. And photographers have long used this phenomenon to create soft, out-of-focus, nostalgic portraits. If you'd like to capture a dawn-of-photography look, set aside your DSLR and build your own pinhole camera.

STEP 1 Find a cardboard box or tin container with a tight-fitting lid. Paint it inside and out with matte black paint, and let it dry.

STEP 2 Cut a small square of tinfoil. Poke a hole through it with a no. 10 sewing needle, rotating the needle to ensure the hole is smooth and circular.

STEP 3 Now use scissors to cut a 1/4-inch (0.6-cm) hole in the bottom of your box or can—put it at the bottom of the "camera," opposite the lid. Tape the punched tinfoil square inside the camera, aligning the two holes.

STEP 4 Cut a small flap of black paper and tape it over the hole on the outside of the camera. (This will act as your shutter, allowing you to control exposure length.)

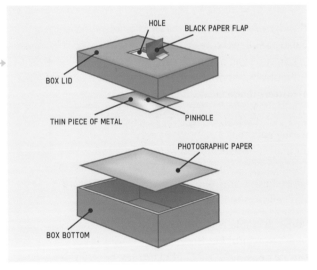

HOLE — BLACK PAPER FLAP
BOX LID
THIN PIECE OF METAL — PINHOLE
PHOTOGRAPHIC PAPER
BOX BOTTOM

STEP 5 Time to load the camera! Ordinary fast photographic paper is the easiest choice. Carry the paper and box into a dark room, plus a flashlight with a piece of red cellophane taped over its light. Cut a sheet so it fits inside the camera lid, and tape it in place, emulsion side toward the pinhole. Close the box firmly.

STEP 6 Round up your subject, and get him into an easy-to-hold pose. Set the camera on a flat surface facing him. Carefully lift the black-paper "shutter"—it should stay open for about two minutes—and capture your image.

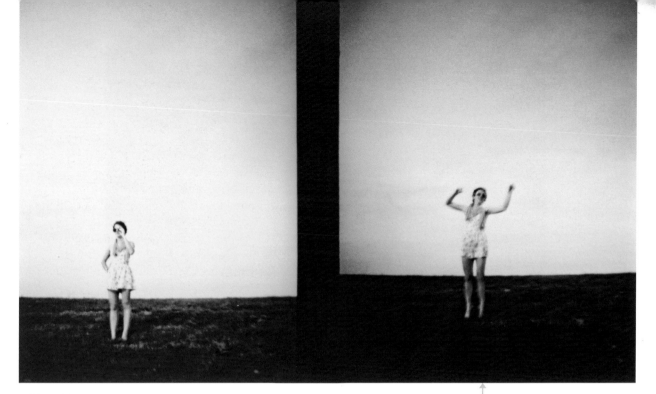

224 MAKE LO-FI PORTRAITS

Lomography, another term for lo-fi film shooting, is mostly a process of happy accidents. But a few tips come in handy as you make your way through the world of lo-fi. For starters, shoot in color to exaggerate the bright hues of flowers, neon, and storm-lit skies.

Cross-processing slide film (getting it developed in the wrong solution) further distorts color and heightens oddball contrasts. Color effects vary among films: Cross-processing Fujichrome Astia or Sensia gives you a red effect, Provia and Velvia, a green one. Konica films give you yellow, and Kodak, blue.

One lo-fi staple is the Holga, a medium-format toy camera invented in Hong Kong in the 1960s. It's a simple beast with two light settings, two shutter speeds, and four focusing modes. Shooting with its plastic 60mm f/8 lens, you'll get images with soft focus, blurred or trailing colors, and heavy vignetting. Or try a similar gadget, the Diana. Another plastic roll-film snapper, the Diana fell out of production in the 1970s, but it has been resurrected as the Diana Mini-35mm and the Diana +. The latter boasts a panorama mode and can even be turned into a pinhole camera.

For modern takes on retro photography, check out new plastic cameras such as the Blackbird Fly 35mm. Or you might want to look into apps like Instagram and Hipstamatic for camera phones.

Have fun and be sure to shake things up as you shoot—unlike with your fancy DSLR, feel free to vibrate the camera, jostle it lightly from hand to hand, or spin it on the floor. Professional photographers love to modify cheap cameras for uniquely peculiar or pretty results; in fact, some enthusiasts believe that the more you beat up a Holga, the more spectacular the images turn out. Remember, it's the serendipitous "flaws"—such as double exposures, light leaks, and color shifts—that make lomo images so arresting.

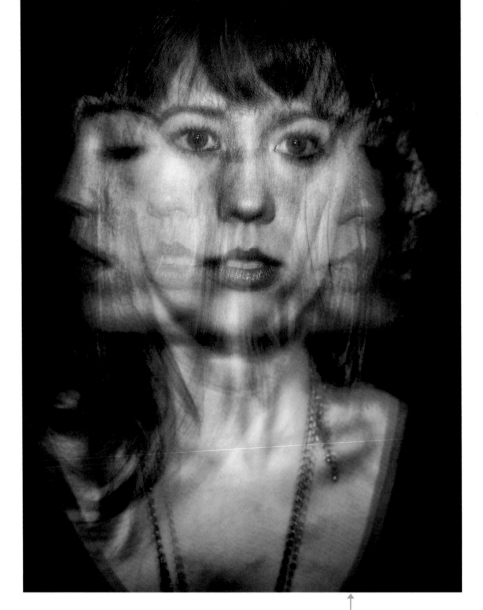

225 TRY A LIGHT GUN FOR STROBOSCOPIC EFFECTS

An instrument used to examine machines for faulty parts, a light gun can fire off hundreds of pops per second. Unlike a shoemount flash with a stroboscopic mode, a light gun lets you adjust frequency but not brightness. Plus, since many flash units operate off AC current, slow recycle times are often an issue. For the photo here, the light gun's *pop-pop-pop* output froze five images of the subject as she rotated during a single 8-second exposure. Want to try stroboscopic portraits yourself? Here are some pointers.

USE BLACK BACKGROUNDS You'll avoid background clutter double-exposing over your subject's face.

KILL THE LIGHTS Let the bursts from the strobe gun be the sole light source.

LOCK COMPOSITION ON A TRIPOD Handholding may result in subject-cropping camera motion.

STOP THE LENS DOWN You need enough depth of field to compensate for subject movement.

USE A REMOTE TRIGGER It will prevent you from bumping the camera in the dark.

GO CHEAP While a light gun can cost as much as a high-end flash, simpler devices—like those used in dance clubs or airport runways—can be less expensive.

One surefire way to amp up the creativity in your portraits is lightpainting, a technique in which "doodles" made with flashlights, off-camera flashes, LED strips, sparklers, or any other light source create mesmerizing streaks and patterns of light in a long-exposure photograph. The possibilities are endless—you can produce childlike stick-figure sketches in absolute darkness, abstract geometric patterns in a dimly lit forest, or sophisticated fashion shots with colorful motion, like you see here.

STEP 1 Mount your camera to a tripod to prevent shake during your long exposure.

STEP 2 Choose your "light brushes." Pretty much anything goes here—a bare bulb, glow sticks from a party, or even a candle. Just remember that the size and color of the beam (and the way you use it) will determine its effect. For a hint of color, try taping a gel to your light source of choice. In order to bring color to the light's movement, the photographer who created this image used yellow and cyan gels on two continuous light sources to the left and right of the model.

STEP 3 For your first forays into lightpainting, it's best to work in near-pitch black, including a dark background. This way, you can play around in a controlled space, which will result in a very dark image with your light brushes providing the only sources of illumination. But if you want to actually see a figure, as you do here, you'll need to light the scene. This was achieved with a softbox-covered flash set to front-curtain sync, which provided the pop of flash necessary to freeze the subject (see #195 for information on this tactic's close cousin, second-curtain sync).

STEP 4 Set your exposure time. In manual mode, set a low ISO and a midrange aperture (f/8 or f/11). You'll have to experiment with the shutter speed, since the timing will depend on how much light you add to the scene. This image only required a 0.8-sec exposure, but often lightpaintings take 2 minutes and up.

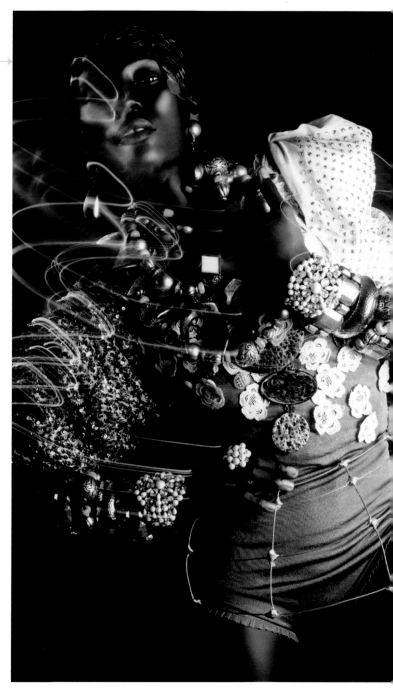

STEP 5 Open your shutter—time to shine, squiggle, or trace light over your background. You can draw a literal picture, make rhythmic gestures that result in a pattern, or simply highlight a part of the scene with broad strokes. You can also try moving the camera during the exposure instead of the lights if you're brave enough to handhold, as this photographer was.

227 SHOOT THROUGH A PRISM

In an age swimming in off-the-shelf digital special effects, it's refreshing to come across experimental analog camera techniques that breathe life into images. Take, for instance, "prisming," which involves holding a small prism in front of a lens while shooting. The technique results in a variety of effects, from rainbows to triangular shapes to Holga-esque light-leak looks (as seen here). The effects are entirely organic, changing from frame to frame, and pretty much impossible to repeat from scratch in digital postprocessing.

The ideal prism for this technique is a 6-inch (15-cm) equilateral prism made of glass, and it works best with full-frame DSLRs outfitted with a 50mm f/1.4 lens (though a 24mm lens works well, too). When positioning the prism in front of the camera, think about the direction of your light sources. You can achieve light-leak effects when the illumination comes toward the camera, while reflections are generally more interesting with strong sidelight. Turning a prism on its side and shining a light on it will introduce wild triangles of flare. Look for textures as you shoot: In this portrait, the prism reflected the branches and leaves from above into the lower half of the frame, wrapping the couple in color and masking the muddy ground below.

Crucial tip: Use your camera's live-view mode to see your actual exposure as you change settings—it'll take out a lot of the guesswork.

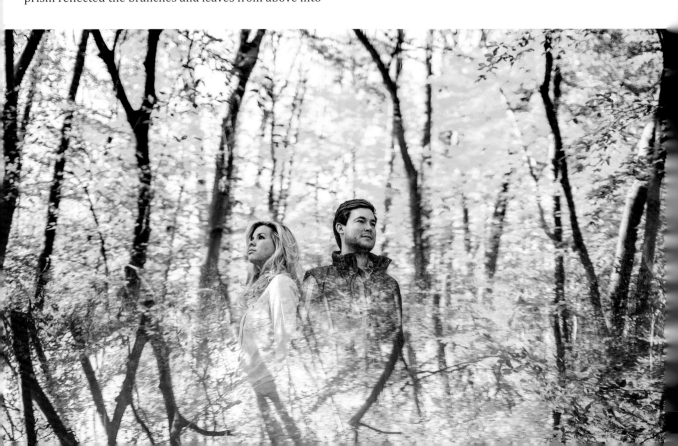

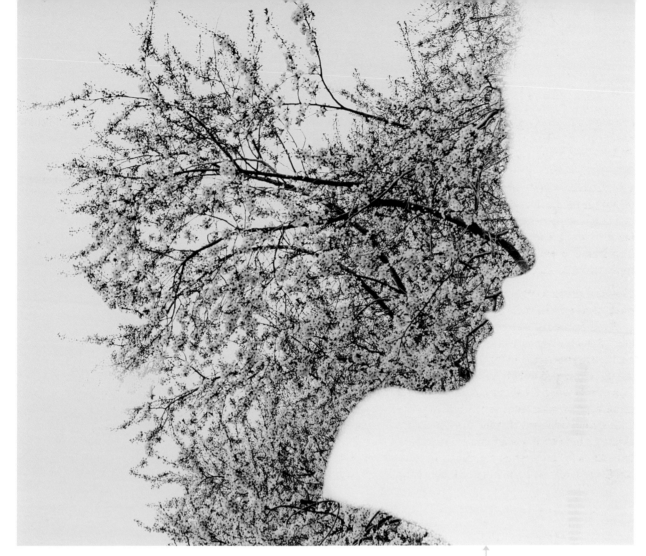

228 DO A DOUBLE TAKE WITH MULTIPLE-EXPOSURE MODE

Readers who protest that digital special effects are not their cup of tea, this one is for you. It's an in-camera project hearkening back to the film era, and it doesn't necessarily require computer time. Your camera's multiple-exposure mode does the grunt work of merging two frames, automatically filling the second, textured image into the black areas of the silhouette.

STEP 1 Shoot the silhouette against a white sky or a studio backdrop. When shooting outdoors, a low camera angle helps get a clean, uncluttered background. Try shooting about an hour before sunset on sunny days. You can line up the dimmer afternoon light behind your subject and, with proper exposure, produce no flare.

STEP 2 Find the background texture. Color helps, as do line and complementary shapes. As with the silhouette,

find a texture that can be captured cleanly on white.

STEP 3 When you've found a great texture to place within the silhouetted figure, you're ready to make the composite. Dig through your camera's settings to find the multiple-exposure mode. Select it and switch your camera to live view. Select the base silhouette on the memory card. It will be displayed on the LCD screen.

STEP 4 With the silhouette displayed on your camera's LCD screen, aim your lens at the textured subject. The texture will appear within the black silhouette. Finesse the texture's effect by adjusting camera angle, zoom, and exposure settings. When the texture overlay complements and fits within the silhouette, fire away. Your camera will automatically merge the two.

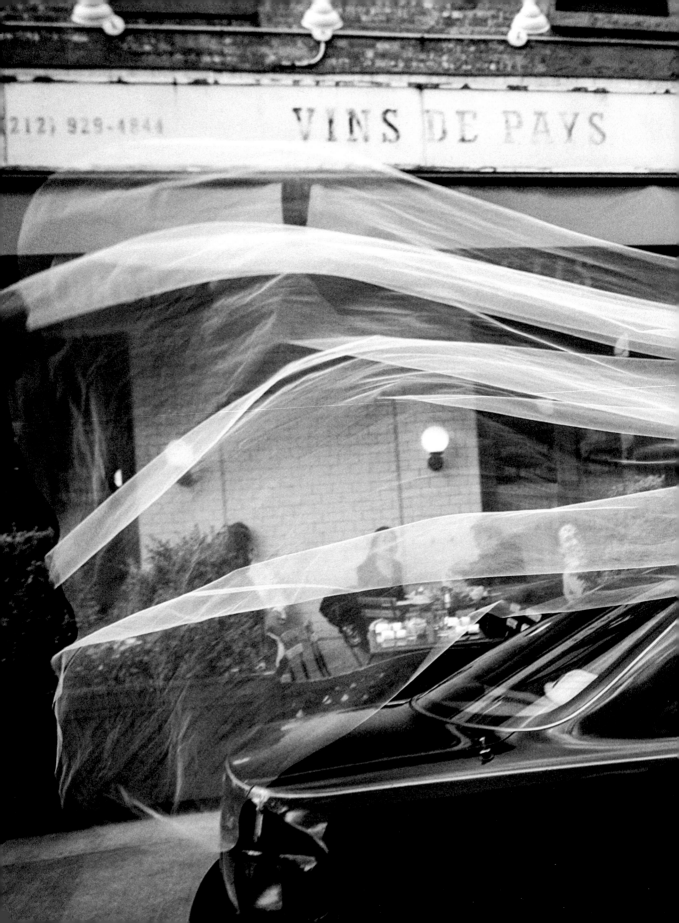